In this collection of critical essays, Barry Schwabsky reexamines the art produced since the 1960s, demonstrating how the achievements of "high modernism" remain consequential to it, through tensions between representation, abstraction, and language. Offering close readings of works produced by several generations of European and American artists, he begins with an analysis of the late period of two Abstract Expressionists, Philip Guston and Mark Rothko, who saw their own success as a failure of reception and who came to question radically their own work. With the core of the book focused on Michelangelo Pistoletto and Mel Bochner, major figures of Arte Povera and Conceptual Art whose works in a variety of media demonstrate a deepening critical engagement with modernism, Schwabsky also studies the work of emerging artists, such as L. C. Armstrong and Rainer Ganahl, who continue to examine modernism's legacies.

# THE WIDENING CIRCLE

# CONTEMPORARY ARTISTS AND THEIR CRITICS

SERIES EDITOR:

Donald Kuspit, *State University of New York, Stony Brook*

ADVISORY BOARD:

Matthew Baigell, *Rutgers University*
Lynn Gamwell, *State University of New York, Binghamton*
Richard Hertz, *Art Center College of Design, Pasadena*
Udo Kulturmann, *Washington University*
Judith Rossi Kirshner, *University of Illinois, Chicago*

This series presents a broad range of writings on contemporary art by some of the most astute critics at work today. Combining the methods of art criticism and art history, their essays, published here in anthologized form, are at once scholarly and timely, analytic and evaluative, a record and critique of art events. Books in this series are on the "cutting edge" of thinking about contemporary art. Deliberately pluralistic, the series represents a wide variety of approaches. Collectively, books published in this series will deal with the complexity of contemporary art from a wide perspective, in terms of both point of view and writing.

## *Other Books in the Series:*

*Art into Ideas: Essays on Conceptual Art,* by Robert C. Morgan
*Building-Art,* by Joseph Masheck
*The Education of the Surrealists: The Gold of Time,* by Jack J. Spector
*The Exile's Return: Toward a Redefinition of Painting for the Post-Modern Era,* by Thomas McEvilley
*Looking at Art from the Inside Out: The Psychoiconographic Approach to Modern Art,* by Mary Mathews Gedo
*Signs of Psyche in Modern and Postmodern Art,* by Donald Kuspit

# THE WIDENING CIRCLE

## Consequences of Modernism in Contemporary Art

BARRY SCHWABSKY

CAMBRIDGE
UNIVERSITY PRESS

PUBLISHED BY THE PRESS SYNDICATE OF THE UNIVERSITY OF CAMBRIDGE
The Pitt Building, Trumpington Street,
Cambridge CB2 1RP, United Kingdom

CAMBRIDGE UNIVERSITY PRESS
The Edinburgh Building, Cambridge CB2 2RU, United Kingdom
40 West 20th Street, New York, NY 10011-4211, USA
10 Stamford Road, Oakleigh, Melbourne 3166, Australia

© Cambridge University Press 1997

First published 1997

Printed in the United States of America

Typeset in Janson Text

*Library of Congress Cataloging-in-Publication Data*
Schwabsky, Barry.
The widening circle : consequences of modernism in
contemporary art / Barry Schwabsky.
p.   cm. – (Contemporary artists and their critics)
Includes bibliographical references and index.
ISBN 0-521-56282-1. – ISBN 0-521-56569-3 (pbk.)
1. Modernism (Art).   2. Postmodernism.   3. Art, Modern – 20th
century.   I. Title.   II. Series.
N6494.M64S38   1997
709'.045 – dc20                                                96-25470
                                                                    CIP

*A catalogue record for this book is available from
the British Library.*

ISBN 0-521-56282-1 hardback
ISBN 0-521-56569-3 paperback

# CONTENTS

v

# CONTENTS

# CONTENTS

# ILLUSTRATIONS

# PREFACE AND ACKNOWLEDGMENTS

As the subtitle of this collection implies, I am less interested in notions of postmodernism than in the idea that the achievements of what has been called "high" modernism, particularly (but not exclusively) abstract art, remain consequential for the art of the past three decades. Among the consequences of those achievements is their inimitability. The art discussed in this book struggles with questions about what to do *after* – even when, as in the case of the late work of Philip Guston and Mark Rothko, it is a question of what to do after one's own contribution to what has been described as "the triumph of American painting." Another, related question is the following: What is the situation of the artist in relation to the cultural materials, at once forbiddingly inert and threateningly dynamic, with which and against which she works? One of the reasons abstract art interests me so much is that it seems to present such questions in a particularly naked way. But I have no sense of its having "replaced" or rendered obsolete any art of representation. I am astonished that there still exist critics who can speak, for instance, of "the prohibition on chromatic expressivity that history imposed on painting, which historically followed the prohibition on

pictorial representation"[1]: the history I understand is no god in a machine and hands down no commandments.

THE ESSAYS in Part I of this book focus on the unstable dialectic between abstraction and representation, whereas in Part III the introduction of language as a third term – *il terzo incomodo*, as the Italians say – defers any conceivable synthesis. The "interlude" which is the middle section (Part II) of *The Widening Circle* reflects my special interest in contemporary Italian art. These essays illuminate by resituating many of the issues explored in the sections of the book that concentrate on American art, or on the work of artists whose lives and careers have been closely involved with the American art scene. This middle section also includes the only essay that departs from my chronological focus on the last three decades, but the degree to which the art of Filippo de Pisis, thanks to his ambivalent relation to the *avanguardie storiche*, in which he nonetheless played a small role, anticipates concerns of more recent artists will, I think, be clear.

In our time the artist works without the benefit or limitation of a given or preformed language. There are many languages available, but they may be mutually incomprehensible, and no historical necessity has elected any of them – not abstraction, not art-as-concept, not the discourse of the body – the master language or metalanguage that would assure shared meaning or the certainty of correctness. What continues to drive art is the urgency to make contact. That is the critic's situation too – at least, it's been mine. By acknowledging its necessary quantum of arbitrariness, by revaluing the hazardous leap of interpretation in the face of what George Steiner has called the "maximalization of art's semantic incommen-

surability in respect of the formal means of expression,"[2] criticism has a chance of facing down the corruption, decadence, or just boringly eclectic subjectivism that always threaten to take the field when criteria are vague.

For that marvelous critic Fairfield Porter, really a man of the 1930s, the great subject of art was work – in the first instance that of the making of the art object itself, and through that, work in general.[3] It's wonderful to me that no one would imagine this by looking at his paintings – but looking at his paintings after you know it is to see them a bit differently. For me I suppose the great subject is, rather, desire: the aspiration or longing on behalf of which the work is undertaken, or thanks to which the labor of necessity may be transubstantiated into the labor of love. Perhaps this tendency to see art in terms of desire and the embodiment of desire is what has led me to see in it, as Porter saw something like the traces of class struggle, traces of the sort of gender conflicts that feminist critics have brought to our attention (just as my concern with the heretical arbitrariness of interpretation has led me to borrow from studies of the Kabbalah). I agree with Porter that "accurate impressionist criticism is the kind that communicates to the reader of a magazine what the character of a painter's work is," as well as that "criticism creates an analogy, and by examining the analogy you see what the art essentially is."[4] It transcends its occasion only to the extent that those analogies are self-sustaining, in which case it can continue to illuminate its subject even as history carries them both into transformed contexts.

To speak of analogies may be to say that criticism is a fundamentally *symbolist* genre. In any case it is a genre of peculiarly hybrid specificity, being easily distinguishable from aesthetic theory, art history, or journalism, although nourished by all three and in-

forming them in turn, but at the price of leaving its most essential judgments unstated and the narrative of its own developing self-consciousness implicit. For that reason, more than the other genres I have named, criticism depends on its readers, who in turn must be criticism's critics.

My most astute critic has been my wife, Carol Szymanski, and to her go my deepest thanks. This book would not have been conceived without the encouragement of David Carrier and might not have been brought to term without that of Paul Mattick, Jr., two philosopher-critics whose insights have often challenged and stimulated me. Particular gratitude – for the chance to talk, over the years, about much of the thinking that has found its way into this book – is also due to Carol Greene, Faye Hirsch, Frances Lansing, Ross Neher, Archie Rand, Susan Wanklyn, and John Yau, as well as many of the artists whose work is discussed here. Editing *Arts Magazine* was the best learning experience a critic could ever have. I would like to thank Paul Shanley, its publisher during my tenure, for giving me the opportunity to do so, and all my colleagues there for their help, but especially Bill Jones, Clair Joy, and Deborah Gardner-Gray. My predecessor as editor of *Arts Magazine* was also the first person to publish my art criticism; I thank Richard Martin for allowing me to educate myself in public. Nor would this book exist without the other magazines in which much of this work first appeared, and whose editors I cite here: Michael McTwigan and Jennifer Ditsler, of *American Ceramics*; Jack Bankowsky and Sheila Glaser, of *Artforum*; Elizabeth Baker and Meyer Raphael Rubinstein, of *Art in America*; Catherine Millet and Myriam Salomon, of *Art Press*; Matthew Collings, of *Artscribe*; Marie-Ange Brayer of *Exposé: Revue d'Esthetique et d'Art Contemporain*; Helena Kontova and Giancarlo Politi, of *Flash Art*; Josefina Ayerza, of *Lacanian Ink*; Jacqueline Brody, of *Print Collectors Newsletter*; and Suzanne Ra-

mljak, of *Sculpture*. Equally to be thanked are directors of galleries that commissioned some of these essays for their catalogues: Pierre Huber, of Art & Public, Geneva, and Nina Nielsen, of the Nielsen Gallery, Boston, as well as Massimo Kaufmann and Marco Cingolani, who were kind enough to publish the opening essay in what was not a catalogue to "Documentario 2" but rather a book of independent essays accompanying the exhibition of that name. Most of the essays have been revised for this publication. In so doing I have tried to remain true to my frame of mind at the times of their original composition, so far as I can reconstruct it, but my main concern has been for correctness, and in some cases to restore passages cut for reasons of space.

# I

# Abstraction,
# Representation . . .

# 1

# THE WIDENING CIRCLE

## Abstraction and Representation in Contemporary Art and Criticism

Once again, at least in the hothouse province of the New York art world, we have been debating the tension between what some us are embarrassed at still having to call "abstraction" and "representation."* No longer, however, is this primarily a debate that can be situated within the confines of any one medium; for instance, it is not a question of abstract painting versus representational painting. Instead, there has tended to be a presumption – inaccurate but strong – that this is basically a debate between painting, on the one hand, and conceptual or installation-based work on the other; so that here abstraction is taken to more or less correspond to the practice of painting, whereas representation is carried on through arrangements of texts, objects, and photographs.

*This chapter is a revised version of an essay orginially published in *Documentario 2*, ed. Marco Cingolani and Massimo Kaufmann (Milan, 1993), and is based on talks given at roundtable discussions at the John Good Gallery, New York, April, 1992 and at the XII Jornadas Inter- nacionales de le Critica sponsored by CAYC Centro de Arte y Comuni- cacion and the Asociacion Argentina de Criticos de Arte, Buenos Aires, August 28, 1992. Therefore I owe special thanks to John Good and Jorge Glusberg for their kind invitations to participate in these events.

In any case, I seem to hear the buzz of a lot of potential questions swirling around the conjunction of the terms abstraction and representation today. Among them are questions of how abstract art is, or can be, or should be, represented. I don't only mean, though I partly mean, how it is to be represented in the medium of criticism, in exhibitions, and so on – though that is interesting and difficult enough. I am also thinking, for instance, of how an abstract artist – a term that makes me very uncomfortable, but never mind – might represent her artistic project to herself as she is in the midst of it, a representation that has a more obvious and direct dialectical impact on that which is to be represented.

In fact, insofar as the term "representation" seems to imply something different in substance from what it represents – as the drawing of a horse is clearly not made of the same flesh as a horse, and there is nothing particularly rosy about the word "rose" – it is singularly misleading with regard to the representation of social and cultural facts which are of necessity always in and of themselves representations.

What do I mean by that? Recently I came across an anecdote regarding one of the events that shook Eastern Europe at the end of the last decade, which can serve to represent my view of the embeddedness of representation within social reality:

A young Romanian librarian described to me how, on December 21, 1989, the last famous compulsory pro-Ceausescu demonstration on Bucharest's Palace Square turned into a counter-demonstration. At first there were only ritual chants of "Ceausescu and the People," but then suddenly, next to her an inconspicuous little man began to yell, "Ceausescu the Dictator!" There was immediate pandemonium. People shrieked with fear and struggled away from the man, creating a large empty circle. Yet he went on undisturbed, and when it became clear that the

police were not budging, others, too, took up the chant, at first
hesitatingly and then ever louder. Ceausescu turned on his heels
and was never again seen in public.[1]

I don't think this story needs a close reading to reveal how the
mere articulation of a new way of representing the relation of the
ruler to the ruled actually succeeded in helping to transform that
relationship. It is obviously rare for artistic forms of representation
to have the power of direct intervention in political events in this
way, though when art engages topical subject matter it is not in-
capable of doing so: think of the effect in the nineteenth century
of such paintings as Gericault's *Raft of the Medusa* or Manet's *Ex-
ecution of Maximilian*. And when Bob Dylan sang "The Times They
Are A-Changin'," he helped change the times. But more often, art
intervenes within its own sphere. An important work of art is gen-
erally such because it has helped change the representation of ar-
tistic tasks, artistic values, artistic ambitions.

Today, in the realm of the visual arts, there is very little agree-
ment about what those tasks, those values, those ambitions should
be. On the American scene, at the moment, I see a clear tendency
toward a polarization between two kinds of art: first, an art that
intends to be topical and political in the sense of intervening in
struggles over representations of, for instance, the environment,
AIDS, race, homelessness, and so on; and second, an art that, while
not necessarily "formalist" in the sense of positing an absolute au-
tonomy or self-containment of the aesthetic sphere, can be called
"formal" because it sees that its primary means for producing
meaning is to work on the elements of artistic form. Incidentally,
the residue of utopianism that is common to both these strains in
contemporary art, despite all the seductive theories of postmodern
passivity, is not something peculiar to art since modernism or the

5

age of the avant-garde; it is perennial. The German medievalist Arno Borst has written, for instance, that "it is possible that medieval art in general . . . had always tried to produce a radical alternative to reality, something more than a purified reaction to it" – although, as I think it over, I'm not entirely sure whether the alternative to reality here corresponds to abstraction and the reaction to it corresponds to representation or whether it's the other way round.[2]

In any case, it may be that this dichotomy between a topical art and a formal one, too, is part of what my pairing of representation and abstraction might allude to: presumably the first kind of art would be an art of representation while the second would be an art of abstraction. (Here the "confessional" portion of my remarks is about to begin.) Anyone who has read much of my work as an art critic since 1984 knows that my interests have leaned heavily, although far from exclusively, toward the kind of art that is supposed to fall within the second of these categories – the one that corresponds to abstraction, to a concern with the workings of form, to the practice of painting – but I would also hope that anyone who has read me carefully might realize that I am unlikely to take such a rough-and-ready categorization at face value. What does it mean to write criticism of abstract art? For me it has certainly not meant writing about reified formal features as though they were somehow of self-evident value in and of themselves – the kind of writing you can find, for instance, if you look at the reviews Donald Judd was writing in the early 1960s, where he would say of a Barnett Newman painting something like this:

> Shining Forth (To George), done in 1961, was shown in New York this year [1964]. It's nine and a half feet high and fourteen and

a half feet long. The rectangle is unprimed cotton canvas except
for two stripes and the edge of a third. Slightly to the left of the
centre there is a vertical black stripe three inches wide. All of the
stripes run to the upper and lower edges. Slightly less than a foot
in from the left edge there is a black stripe an inch wide. This
hasn't been painted directly and evenly like the central stripe, but
has been laid between two strips of masking tape. The paint has
run under the tape some, making the stripe a little rough. A foot
in from the right edge there is another stripe an inch wide, but
this one is of reserved canvas, made by scraping black paint across
a strip of masking tape and then removing it. There isn't much
paint on either side of the white stripe; the two edges are sharp
just against the stripe and break into sharp palette knife marks
just away from it. Some of the marks have been lightly brushed.
The three stripes are fairly sharp but none are perfectly even and
straight. It's a complex painting.[3]

Such writing clearly had a polemical intention: to take abstract art
from a mythic realm into a material one. That intention was im-
portant in its time – it did manage to create a big empty circle
around the "vir heroicus sublimus" who was the Newman of the
1950s, though only temporarily – but it doesn't interest me very
much today, because I don't really believe that, as Frank Stella put
it at about the same time, what you see is what you see. I think that
not only – but especially – when you look at art you see a lot more
than what you see, and that criticism is meant to articulate this
something more. But it doesn't seem to me that it gets you very
far to say that this something more is something that is represented.
It is evident that all abstraction represents something, and that all
representation abstracts from something. It's just a little less obvi-
ous that representation only takes place *in and through* abstraction
and vice versa, although familiarity with E. H. Gombrich's dem-

onstration in *Art and Illusion* that all pictorial images arise through the use of abstract representational schemata is helpful here.

But let me go back to that fable about Romania for a minute – and it is a kind of fable, whether it's entirely true or not. I said that it was by articulating a new representation of the relation of Ceausescu to the populace that the "inconspicuous little man" helped transform that relationship. What I want to say now is that the term representation is too vague, and that this is why it has, as I said, a tendency to mislead. If I were to emphasize instead that the man was *articulating* Ceausescu's role, articulating how people actually felt about him in contrast to the inert representations they had allowed themselves to repeat, I think I would be giving a more vivid sense of how his action had to do with an active forming or formulating of the very material with which it is involved rather than some passive mirroring of things.

In this sense I would say that as a critic I have tried to talk about the way in which abstract art articulates its content – keeping in mind what Willem de Kooning said, that "content is a glimpse of something, an encounter like a flash,"[4] which means to me that you need to use some delicacy in trying to get at it, a little stealth – but that then at the right moment you just have to jump out and grab it, somewhat ruthlessly or recklessly, if it's not going to slip away. This is very different from what I once called the "allegorical lamination of meaning" onto an abstract form. The problem is that it leaves you with suggestions of meaning that may be indefensible, because it puts criticism in the position of likewise having to articulate meanings that – like a pre-1989 Romania's perception of Ceausescu as a dictator, for that matter – both are and are not there. Although it strikes me that the most significant form of abstraction there is may be typified by precisely the "large empty circle" widening around that little man by all the people withdrawing in dis-

may from the infection of his unspeakable words, unless it is rather the ulterior withdrawal, that of the "representative" of the people whose claim on representation has suddenly been put into question – since, etymologically, "abstraction" is nothing other than a drawing away from something. While I am hardly as brave as that "inconspicuous little man," and I would never want to imply that anything one could do as an art critic involves that kind of moral heroism, I do tend to think that if I haven't somehow, in writing about abstract art, allowed my argument to lead into some statement that's foolhardy or ill-founded or that might even make me feel as though people will cringe away from the page in embarrassment, then I haven't been quite honest with myself in doing my job. So I've written about Carl Ostendarp's work as equivalent to hallucinogenic drug experiences, compared the three-panel paintings of David Row to the narrative structure of "triangular desire" as explicated by Renè Girard, talked about Suzanne McClelland's "stuttering of sense in the face of its own indeterminacy" as a rebuke to the implicit Gnosticism of American conceptual art.[5] Not claims that put me at any particular physical risk, obviously, but still, all of these things are highly debatable, and none is represented "in" the work. They are all effects, articulated by me as having been articulated for me by the works in question, that emerge in the temporality of viewing them, either through the relations among parts of the works or in the relation between the work and its embodied viewer. Which is another reason why I prefer the word "articulation" to the word "representation": because representation seems to be a static relationship, whereas articulation takes place in time – since I am in accord with neither the old or new Laocoons that would have it, as Clement Greenberg wrote in one of his last published essays, that "visual art is instantaneous, or almost so, in its proper experiencing, which is of its unity above and before any-

9

thing else."[6] I completely disagree with that. When asked, "How long would you like people to look at one of your paintings," Agnes Martin replied, "Well, I'd like them to give it a minute, anyway."[7] Visual art is ultimately neither abstract nor representational just because it comes to us in time and in pieces, and what unity or structure or meaning it has must be reconstructed by us in the empty space left by another unity, another structure, another meaning, that has been withdrawn.

# "THE REAL SITUATION"

## Philip Guston and Mark Rothko at the End of the 1960s

Philip Guston once recalled a 1957 studio visit in which Mark Rothko told him, "Phil, You're the best story-teller and I'm the best organ player."[1] As a piece of comparative criticism, this remark sums up a good deal of what one might want to say about these two painters. But not quite all.* In April 1985 we were given the opportunity to see Rothko's "dark paintings" of 1969 and 1970 (at Pace) and Guston's small paintings of 1968 and 1969 (at David McKee), two nearly concurrent bodies of work which document a crisis that could hardly have been foreseen in 1957.

This conjunction opened a window onto the end of a decade in which the New York art world had changed drastically. If the 1930s was the decade in which an advanced artistic community began to form in New York, and the 1940s was the one in which that community began to fulfill itself (the Abstract Expressionist break-through), it was in the 1950s that, in the face of cultural acceptance and worldly success, this community began to seem less possible and began to fragment into a collection of Olympian individuals

*This chapter is a revised version of an essay originally published in *Arts Magazine*, December 1986.

11

whose emotional involvement with one another was no more placid for having become essentially a matter of the past rather than of the present. By the 1960s, the New York school was already in some sense historical, as the new generations of Pop artists, Minimalists, Color Field painters, and so on (most claiming inheritance of some aspect of the Abstract Expressionist legacy, but nearly all partaking of a technocratic ideology utterly alien to the practice of the Abstract Expressionists) eclipsed them in the public eye.

Writing earlier in the decade, Harold Rosenberg had noted the insufficient recognition given to movements as factors in the history of modern art, to the incalculable significance of collective energy and interchange that entered into the work of artists who took part in Cubism, Surrealism, and Abstract Expressionism. "Solitude, the unknown, inwardness are, of course, facts of artistic creation," he wrote, "but they are today cited against the art movements not to epitomize creative experiences but as character references demanded by the reigning personalist credo."[2] With the dissolution of Abstract Expressionism as a movement, the artists associated with it found themselves once more in a situation of isolation and incomprehension, though highly rewarded – a situation in which they were by now so deeply invested, thanks to their very success (artistic and worldly), that resistance itself must have seemed just another way of sustaining the myth. This is what Guston meant when in 1966 he told an interviewer that "Rothko thought too that the smoke that existed ten years ago was a false situation, that this was the *real* situation."[3]

This sense, on the part of both artists, that they had been exiled somehow to the margins of a historical process of which they had once been at the center reached a critical level by the second half of the 1960s. Undoubtedly "the usual lassitude that follows a prolonged major effort"[4] exacerbated this for Rothko, who finished his Houston Chapel murals in 1967, just as Guston's 1966 Jewish Mu-

seum exhibition did for him by marking the completion of a period. But an exasperation with the given situation had already been detectable in the work itself. The Houston murals attempt a spiritual architecture so complete and self-contained as to negate the outside world, the clamor of history, leaving space for the soul's still small voice to echo, but at the cost of moving in a direction which, pursued any farther, could well have resulted in a dissolution of aesthetic specificity. Rothko's thinking characteristically moved from the whole to its parts. The opposite was the case with Guston, and in the paintings he executed between his 1962 Guggenheim retrospective and the 1966 Jewish Museum show there is an increasing sense of the parts striving to become more concretely individualized than their relation to the whole will allow, "like actors in a play who haven't learned their parts."[5] These are Guston's densest, most recalcitrant paintings, and although they did not generate anything like the hostility that would greet his 1970 Marlborough show, they now look like his most angry and inaccessible works as well, despite the wealth of aesthetic experience they offer the viewer willing to give himself over to their demands.

In the face of their unhappiness with "the *real* situation" surrounding their work – its apparent failure to have been *received* – Rothko and Guston both found themselves desperate for a new direction. For Guston, a tactical retreat would be necessary: two years without painting (but much drawing). For Rothko, there was no such overt caesura. Nonetheless, in looking at the dark paintings of 1969 and 1970 (Fig. 1), we feel that a boundary has been crossed, that there is a distinction as absolute as it is elusive between these paintings and those Rothko had been making over the previous two decades. Of course, we can easily enumerate the overt differences: the reduction of forms to two rectangular color areas, one above the other (instead of Rothko's usual three color patches amid a

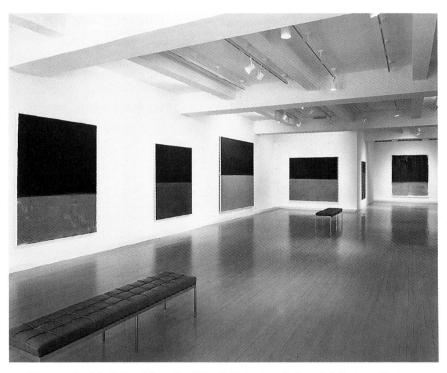

**Figure 1.** Mark Rothko, the "Dark Paintings" (1969–70), installation at the Pace Gallery, New York, 1985. (Courtesy of PaceWildenstein, New York)

surround of some fourth hue); the unpainted white border around the edges of some of the new paintings, which for some viewers would give rise to associations with photography; a new, loose brushiness in the application of paint; and above all, the extremely narrowed range of the color, formerly the glory of Rothko's art, now reduced to grays, blacks, and browns. But wherein lies the essential distinction? This list makes it sound simply as though Rothko had gone farther toward a reduction of means than he'd ever gone before. But Rothko had always been a seeker of essences, and it is not in itself surprising that this artist, always slow and

deliberate in his transformations, after twenty years would have made a move toward a further concentration of resources. That would simply have been another move down the road he was already on. But this is not, I think, what had happened.

The key to the change lies not so much in the most obvious difference, that of color, but in Rothko's handling of the surface. Max Kozloff once wrote, perceptively, that "Rothko's surfaces have a studied look that tries to conceal itself – the deadpan, as it were, rather than the dead."[6] The chromatic mists of his earlier paintings may have been painstakingly worked up, but their surfaces were intended to disappear. These were windows on the infinite, ones you had to be able to fall through forever without touching ground. By contrast, the surfaces of the late paintings look almost self-consciously slapdash. They convincingly and unsentimentally evoke the tragedy of one brilliant, bewildered, disillusioned painter's isolation, not because of their gloomy palette or their renunciation of sensuality, but because they are paintings that could only have been made by someone who once cared very much about, but can no longer induce himself to be concerned with, the effect his work might have on any viewer. "To achieve clarity," Rothko had declared long before, "is, inevitably, to be understood."[7] The Rothko of 1969 knew the opposite to be true. The organ player diffidently fingered a last few deep chords, but the church was empty.

There had never been a church of Guston, of course (although there may be one now). The elective ambience of his work might instead have been something more like the "smoker's theater" that Bertolt Brecht used to call for, "where the audience would puff away at its cigars as if watching a boxing match and would develop a more detached and critical outlook."[8] In 1963 John Russell lamented the fact that "Guston is now in a position in which every move he makes is scrutinized, dissected, and where possible held

up to ridicule. This is always an unpleasant situation, and it is especially so in the case of one who is essentially a scrupulous and introspective artist."[9] This may have been exactly what Guston needed, however. Like Brecht, but for quite different reasons, Guston had an immense need to internalize the Philistine art skepticism of the presumed popular audience. One of the reasons he gave for his eventual disenchantment with abstract art was that "too much sympathy was required from the maker as well as the all-too-willing viewer . . . It was like a family club of art lovers."[10] It seems that the condition for Guston's continued ability to paint was the conviction that the validity of his doing so remained under indictment.

So, one by one, in the small paintings of 1968 and 1969, Guston lays out his images, his exhibits for the defense and for the prosecution: a book, the back of a head, a hand, a paw, a picture, some buildings, the now-famous hooded Klansmen: ordinary things, mostly, outlined with cartoonish simplicity, in sooty color not so different from his palette in his last abstractions. A shoe (Fig. 2). Clunky, pathetic, the shoe suggests that Guston had at the back of his mind the passionate objectivity of Van Gogh, that he was hoping to find the same kind of humility within himself. That the painter in these pictures is always that dopey Klansman shows Guston suspected otherwise. These paintings, simple as they may seem, have not been nailed down on canvas in one shot. Through their layers of paint you can see that other images have been tried, found wanting, been effaced. Their traces remain, visual echoes. This is where the connection with Rothko's dark paintings becomes most perspicuous: in the peculiar simultaneity of scrupulousness and unconcern, the sense that getting the image right could no longer be compatible with caring how it looks – because it no longer seemed plausible that someone's looking at it, other than by the artist in its making, would any longer have to be taken into account, an intu-

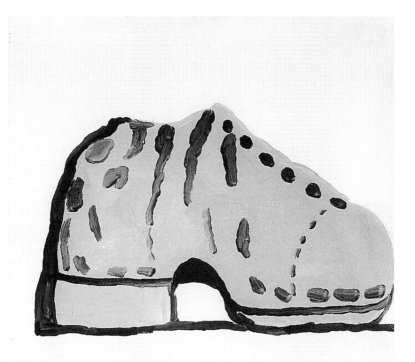

**Figure 2.** Philip Guston, *Shoe*, 1968. Acrylic on panel, 18 × 20 in. Photograph by Steven Solman. (Courtesy of McKee Gallery, New York)

ition that had been granted to Goya, among not many others, toward the end of his life.

Why is it – biographical considerations aside – that for all that they have in common, Rothko's paintings at the end of the 1960s look like the end of something while Guston's look like a beginning? It is a question of forms of resignation. Where Rothko sought to escape his ego, Guston merely sought to be objective about his. Both goals may strike us as equally unattainable. The fact remains that the former also implied an escape from history, the latter a deepening immersion in it. In both cases an earned lack of solici-

tude for the viewer seems to open up a hitherto unknown realm of truth and freedom, but in the experience of Rothko's paintings we are moved by what has been surrendered there; in that of Guston's, by what has been retrieved.

# NORMAN BLUHM AND THE ETERNAL FEMININE

### I

Auch Farb und Farb klärt sich los vom Grunde,
Wo Blum und Blatt von Zitterperle triefen –
Ein Paradies wird um mich her die Runde.

– Goethe, *Faust*, Part II, Act I

News from nowhere, or the return of the repressed?* Norman Bluhm's impressive return to visibility in the New York art world after a twelve years' absence (his last show, at the Martha Jackson gallery, was in 1974) presents a challenge to all the facile interpretations – formalist, moralist, political – that have been offered of the New York school. To be sure, there have been anticipatory tremors: in 1985, at New York University's Grey Art Gallery, the "Action/Precision" show organized by the Newport Harbor Art Museum gave us a chance to see half a dozen paintings from 1956–9, the period of Bluhm's first maturity;[1] and, at sufficient distance

*This chapter is a revised version of an essay originally published in *Arts Magazine*, Summer 1986, and a review published in *Artforum*, February 1995.

19

for it to have had a much smaller audience than it deserved, an exhibition of seven paintings from 1975–9 at the Fine Arts Center of the State University of New York at Stony Brook let us see early tokens of the aesthetic direction which has been more richly adumbrated in Bluhm's more recent work. Neither of these shows provided sufficient evidence to answer – though the latter prompted Donald Kuspit to pose – the question that must be addressed in any evaluation of Bluhm's work: "Is there anything more than superior loveliness in Bluhm '70s [and, by extension, '80s] abstract painting?"[2] The new work on view at the Washburn Gallery allows us, I think, to give a pretty secure response.

Kuspit's question concerns content before it concerns value. He implies that what he calls Bluhm's "refined, lyrical sensibility" is enabled only by a diminished capacity for risk taking (and therefore, by the implicit logic of action painting, for significant meaning), making Bluhm, along with other painters of the so-called "second generation" of Abstract Expressionists, less "heroic" than the first generation, less sublime and less strenuous. Kuspit notes that Bluhm has continued to exhibit his work regularly in Paris during his absence from the New York galleries and thereby assimilates it to that late School of Paris art which was the object of so much condescension during New York's decades of unquestioned ascendence, and which was felt, in words Kuspit quotes from Clement Greenberg, to promote "the pleasure principle with a new explicitness."[3] The artists Greenberg had in mind when he used that phrase included Picasso and Matisse, Braque and Bonnard – which makes the pleasure principle sound rather less decadent and insubstantial than Kuspit (or Greenberg) might like. But the idea is clear enough. From the strenuous to the voluptuous, from the heroic to the lyrical, from the aggressive to the seductive, and ultimately from the masculine to the feminine – this is the trajectory that Bluhm's

art, in its swerve away from the original triumphs of Abstract Expressionism, is felt to incarnate, and which we are invited to disapprove.

It is certainly true that the first generation of Abstract Expressionists were inventors of pictorial language in ways that Bluhm's generation did not hope to be; it is precisely the sense that they had been given a language, along with the injunction to invest that language with new meaning – the sense that it was incumbent upon them, as Kenneth Baker recently put it, to "justify and account almost viscerally for the . . . decision to continue painting" that fueled much of the early work of the second generation.[4] That few among them were able to sustain this sense in the long run is itself as sure a sign as any that the tasks of the second generation were less "predictable," less "settled" than Kuspit claims.

Bluhm's more recent work does not carry the same burden of desperation as his paintings of the 1950s did, any more than they communicate the very different sort of desperation that marks the work of Pollock, Kline, or de Kooning. It seems to me that Bluhm has done something extremely rare in the short history of American art. He has accepted the achievement of an older generation as having achieved classic status, has worked through many of its basic assumptions without any overt gestures of defiance, and has thereby won through to something that is not only new and distinctly his own but which profoundly revises many of its own founding assumptions – assumptions, above all, about the moral basis of artistic expression that the guardians of taste in our time continue to construe in a deeply repressive and puritanical way. "Action alone, as you are aware, gentlemen, may animate your compositions, particularly in the heroic vein, with that sublime fire which speaks to the spirit, takes possession of it, transports it and fills it with wonder and admiration."[5] No more than the comte de Caylus perceived

the action in the paintings of Watteau does Kuspit see the action in Bluhm's strangely transmuted action painting. The reason, I would suggest, is that the only actions the two critics recognize (as heroic, at least) are those inscribed within the oedipal drama of paternal repression and filial revolt.

After connecting Bluhm to the School of Paris, Kuspit goes on to directly compare him with Tiepolo, that is, with the Rococo – the period in which the consciousness of the European ruling classes became as distinctly feminized as it has ever been; the art most admired in that period was the art that was best able to "represent a world from within feminine consciousness," as Arthur Danto recently wrote regarding Boucher, "looking, as it were, outward onto a reality of softness."[6] There has undoubtedly been a renewal of interest in the art of the Rococo recently, of which the exhibitions of Watteau in Washington and of Boucher in New York are only the outward manifestations. The latter led one perceptive critic to remark on "the glorious and surprising kinship . . . between the notoriously 'frivolous' Boucher and an artist associated with the painting style most heavily burdened by postwar Modernism's laurels of angst, asceticism, and moral seriousness: Willem de Kooning."[7] Here is a topic worthy of deeper exploration. "Flesh was the reason why oil paint was invented," de Kooning once said. This realization accounts for his affinity with the extravagant sensuousness of Rococo art and helps make him not only the greatest of the Abstract Expressionists but also the one most set apart, the most difficult one for critics and historians to assimilate to a linear, "progressive" history of modern painting, conceived as powered either by either a logic internal to art or the urgings of the *Zeitgeist*.

Bluhm, as his paintings in the "Action/Precision" show clearly revealed, began as less of a de Kooningesque painter than many of his colleagues. His most obvious precursors among the New York

school were Pollock and Kline. But thanks to the carnal luxuriance he eventually learned to admit into his work, Bluhm can now be seen as the true heir to the challenge that de Kooning presents to every attempt to portray modern art as a procession of "correct" positions. With regard to the relationship between de Kooning and Bluhm, furthermore, it is not certain that the direct influence has been all in one direction; while de Kooning's work of the 1980s must surely be seen as a direct outgrowth of what he was doing in the preceding decade, it is interesting that the 1980s de Kooning bears a stronger resemblance to the 1970s Bluhm than the 1970s Bluhm does to the 1970s de Kooning.

## II

Das Unzulängliche,
Hier wird's Ereignis;
Das Unbeschreibliche,
Hier ist's getan;
Das Ewig-Weibliche
Zieht uns hinan.

– Goethe, *Faust*,
Part II, Act V

The titles of Bluhm's paintings of a couple of years ago typically referred either to landscape (*Byzantine Earth*) or to the movement of a figure through a landscape (*Dante's Promenade*). The titles of his most recent paintings are different. *Pinkerton's Lady*, *Princess Cuervo*, and *Inca Bride* (Fig. 3) all refer to female presences, often with an implication of mythic stature (although there is clearly more than a bit of humor involved as well). Paul Schimmel suggests that

23

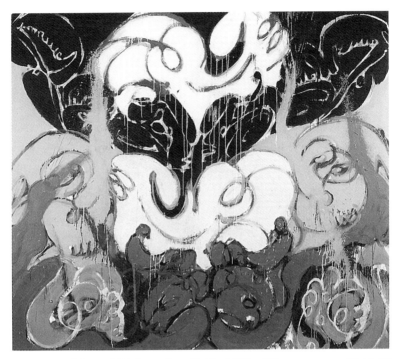

**Figure 3.** Normal Bluhm, *Inca Bride*, 1985. Oil on canvas, 72 × 84 in. Photo by Geoffrey Clements. (Courtesy of the artist)

the transition from a still-life paradigm to an abstraction based on landscape was crucial to Bluhm's development in the early 1950s:

> In the French plein-air manner, Bluhm would carry canvases and paints into the countryside around Paris to create his watercolor-like, centrally loaded, horizonless landscape. Working out of doors, Bluhm is immersed in the romance and tradition of the great landscape artists Corot, Courbet, and Monet. In the forests of Fontainebleau and van Gogh's wheatfields, Bluhm concentrates on capturing the essence of the sensation, light without articulation or definition.[8]

In the 1970s, Bluhm's integration of landscape space with imagery based on the human form – in particular, the female form – would be just as significant.

Just as, for his early landscape abstractions, direct observation of nature was a stimulus, a never-ending source of forms, and a measure against which to test the gestural productions of the hand, so Bluhm's practice of life drawing from the nude model serves as both a stimulus and a measure for his recent abstract paintings. These drawings, produced quickly but not so quickly as to constitute mere notations (perhaps ten in a two-hour session), provide probably the clearest indication of how Bluhm's artistic thinking works. He first captures the dynamic disposition of the figure – not in an anatomical sense but as a quasi-abstract network of tensions – in a few broad, decisive strokes that create a kind of ideogram of forces, somewhat reminiscent of the work of Franz Kline. The second step is to elaborate this structure of forces as a complex of sinuous, supple surfaces; these are disclosed in more delicate, insinuating marks, which relate to the underlying structure not as decoration but as incarnation. It is this desire to provide a supplement to the essential structure – a supplement never conceived of as inessential – it is this interlocking of reduction and elaboration that defines the generosity of Norman Bluhm's vision.

In Bluhm's paintings (as well as in the abstract works on paper that Washburn is also showing) the forms generated through the figure drawings have been analyzed and recombined as constituent elements in a synthetic space that still relates to the landscape paradigm that has remained the basis for most of Bluhm's work since the 1950s. This is not to say that there is any direct copying of elements from the figure studies involved. The reference is, rather, to an entire vocabulary of forms that is continually becoming both

wider and more specific. These forms of figurative origin coalesce into a landscape that not only recedes into a multilayered distance, but simultaneously emerges as though to envelop the viewer in its surging, billowing volumes. This sense of envelopment, as much as the fleshly, often breastlike or vaginal forms, accounts for the uncanny voluptuousness of these paintings. Although it is never insisted on, there is an invitation here to a kind of psychic disintegration that is as disturbing as it is enticing.

Despite the large size of these paintings, their scale is quite human, even intimate. The secret is in the way diverse units of scale are related to one another (an intuition Bluhm acquired through his architectural studies with Mies van der Rohe in the 1930s?): the juxtapositions of big, succulent expanses of gently curving color with hairy nets of thin splatter; the way color not only creates distinctions of depth but also divides the canvas into distinct, often symmetrical zones, which are then tied together by swathes of paint that cross and connect them in sweeping gestures. It is because of this unexpectedly intimate scale that, although I have heard people refer to these paintings as Baroque, I consider them rather closer to Rococo. It is characteristic of the Baroque to want to overpower the viewer; the viewer wants to seduce her (yes, her – the Rococo also believes that the psyche is feminine). Baroque is political; Rococo is erotic.

So Bluhm's recent paintings revise the Abstract Expressionism of his beginnings in two distinct ways: first, by fusing to the landscape paradigm that was the basis of Abstract Expressionist composition a system of representation based on the human body; second, by fusing its essentially masculine posture (the validation of heroic scale, athleticism of execution, etc.) with a stylistic coding that refers emphatically to the feminine (a matter of ostentatiously "pretty" color – all those pinks, yellows, lavenders – as much as the

curvilinear forms). There is, as I have mentioned, some precedent for this in the work of Willem de Kooning, but the differences are telling. De Kooning plays landscape and figure against one another, just as masculine and feminine elements in his work always seem engaged in a struggle for dominance; Bluhm makes them impossible to differentiate. One might think of de Kooning as the realist and Bluhm as the utopian.

Ultimately, for all that they unreservedly embrace the decorative, it is this utopian extremism that puts Bluhm's paintings definitively beyond the boundaries of *mere* decoration, of "superior loveliness." Their ecstatic androgyny, their objectless eroticism, their vertiginous intimation of a dissolution of boundaries between the self and its surroundings, constitute the reserve of unassimilability in Bluhm's work.

## POSTSCRIPT

One of the most curious things about the so-called second generation of Abstract Expressionists was the need so many of them felt to renounce the Abstract Expressionist legacy. One could imagine the mature work of Al Held or Alfred Leslie having been made by an artist who had never seen or heard of Jackson Pollock or Willem de Kooning. To be sure, Joan Mitchell upheld the tradition, and so has Norman Bluhm, yet Bluhm's most recent paintings would be as impossible to extrapolate from his paintings of the 1950s as Held's or Leslie's recent work would be from theirs of that time. Unlike them, however, Bluhm has renounced nothing. His art has simply become so much more inclusive, so much more historically informed, that it easily subsumes everything it has ever been within its grander, more ambitious pattern.

Luckily, the present exhibition is a selection of Bluhm's paint-

ings from 1986 – the date of his last show of new work in New York – until now, clarifying the development of his work. In earlier paintings, like *Pinkerton's Lady*, 1986, a single centralized image counterpoints an explosive dynamism to the solidity of symmetrical composition and synthesizes multiple levels of scale, from huge muscular gestures defining large yet complicated movements and areas to delicate sprays of paint that spread light among such large areas. By 1989, with works such as *Venetian Altarpiece*, Bluhm had begun to amplify these effects through repetition and an implicit multiplication of spaces within the painting. Soon this multiplication would become more emphatic through the use of internal borders to define distinct zones within the painting, borders nonetheless crossed by the energetic gestures they can barely contain, as in *The Ascent of the Spheres*, 1991, a single canvas more explicitly subdivided than the six-paneled *Venetian Altarpiece*.

Since then, Bluhm has essentially been teaching himself to place the kind of forms he was using previously within intricate patterns that recall those of the art of Tibet and India. Bluhm has long been immersed in the art of Renaissance and Baroque Italy; more recently he has spoken of having looked to Tibetan art for new ways to use numbers, pattern, to create "structural power." In doing so he has sidestepped the sometimes naively direct "orientalism" of much Pattern Painting; as conveyed by Bluhm's gritty textures and unrestrained gesturalism, these compositions recall Tibetan tankas or Italian Baroque ceilings without direct quotation, because their subject is not art history but rather the aspiration to ecstasy that the religious art of both Europe and Asia shares. With his palette steeped in sumptuous purples and lavenders, juicy reds, resonant blues, Bluhm can juxtapose subtle tonal differences with brash, jumpy contrasts without losing control of the total effect, which is complex yet astonishingly clear. Such color, rich almost to the point

of fulsomeness, is matched by a delirious way with composition: bursting with energy and beatific excess, each form claims its place like some god or angel, whether soaring in exaltation, reclining in luxury, or bowing in blissful obeisance. And if all this excess starts to feel sinister rather than joyous, don't think Bluhm hasn't noticed. Recent titles like *Kingdom of Darkness* or *Satan's Conquest*, both 1994, remind us that a heavenly host and a "Walpurgisnacht" are equivalent in their transcendence of the mundane.

# 4

# COLOR FIELD
# AND CARO
## Mannerist Modernism

By the mid 1970s, Color Field painting was self-evidently passé.*
In his classic essays on the "white cube," Brian O'Doherty hardly
needed argue his assertion that the art Clement Greenberg and
Michael Fried championed as the crescendoed triumph of Modern-
ism had become a kind of latter-day salon painting. Calling for big
walls and big collectors, it looked "like the ultimate in capitalist
art." Well, it's been so long since Color Field resembled this kind
of ultimate that it's now hard to believe it ever did. Today, it's
Minimalism that seems to have surer access to elite patronage and
to the attendant presumption of taste. In fact the tables have turned
so decidedly that the same Minimalist art that to O'Doherty seemed
pointedly to shun allegiance to "wealth and power," and indeed to
try to "redefine the relation of the artist to various establishments,"[1]
has lately (and reasonably) been subject to critical interrogation of
its "rhetoric of power."[2] Color Field painting, by contrast, has
seemed so pathetic for so long that it threatens to become inter-
esting again.

*This chapter is a revised version of an essay originally published in *Art-
forum*, September 1994.

At least since Fried's essay "Art and Objecthood" and Greenberg's "Recentness of Sculpture," both 1967, the discourse on Color Field painting has been structured as an agon with Minimalism. Donald Judd asserted that "actual space is intrinsically more powerful and specific than a flat surface";[3] in fact, the positioning of Minimalism as an "art of the real" famously inspired Fried to dismiss it as merely "literal."[4] In a celebrated counterintentional twist, Fried's anti-Minimalist polemic provided the very coordinates by which the movement was written into art history. Today, most accounts would say that Color Field painting's status as the destination toward which the mainstream of artistic development flowed (Greenberg and Fried tended to designate this painting, along with the sculpture of Anthony Caro, simply as Modernist) was long ago ceded to Minimalism. Recently, a spate of East Coast exhibitions focusing on the work of Caro, Kenneth Noland, Jules Olitski, and Larry Poons provided an opportunity to take another look at this singularly maligned movement.[5]

Reconsidered today, the work of Caro, Noland, Olitski, and Poons seems to refuse its assigned post in the battle between illusion and literalism at several crucial junctures. Noland's work is a striking case in point, where the resistance of his best early work to the optical orthodoxy is concerned. In the late 1950s and early 1960s, Noland used a motif of concentric circles on square canvases. These paintings seem to be a rationalized form of the canvases of ribboned stains made by his older friend Morris Louis. Their counterpoint of color as weight and color as recession/advance remains striking, though in a somewhat academic way. Noland's wall-length horizontal stripe paintings, such as *Via Blues*, 1967, are as centrifugal as the earlier paintings were centripetal. The approach to space and to the physicality of the viewer here is still fresh. The stripes have an almost friction-free velocity that draws the eyes away from

the center toward both ends of the painting at once – points that cannot be apprehended simultaneously because of the painting's length. And the color is so keyed up as to create a quasi-physical resistance to your advance, as though it were buffeting you back. Push on, though, and at a certain point the color becomes tranquil and accommodating – you're inside the painting now. Clearly this experience is not "purely optical"; a painting such as *Via Blues* is "theatrical," in the sense of the word that Fried used in his attack on Minimalism. No wonder Judd wanted to claim Noland for his own current: "I don't understand the link between Noland and Caro," he wrote, "since wholeness is basic to Noland's work and cubist fragmentation is basic to Caro's."[6]

Unfortunately this was not to be the direction of Noland's subsequent art. His future turns out to have been foretold by another, untitled work of 1967, a canvas in the shape of a flattened diamond, its form coinciding with the sum of its three diagonal lozengelike stripes. Strangely inert, the piece is more like some sort of wall medallion than a painting, yet it only hints at how Noland would fall off the edge of the earth, aesthetically speaking, sometime before the early 1990s, as evidenced in the naïvely slick, watered-down Frank Stella-isms of his recent Plexiglas wall reliefs. What could account for such a decline? Although the practices of these key figures have weathered their negotiations with the alternatively enabling and crippling weight of the critical legacy with varying degrees of success, in Noland's case one suspects something like a sort of phobic reaction – the need to contain and distance the quasi-Minimalist "theatricality" broached by works like *Via Blues* in order to remain within the reassuring orthodoxy of the Color Field fold.

This is not the place to reconstruct Greenberg's theory of Modernist painting after Jackson Pollock, or Fried's either. It may be said, though, that for Greenberg the success of Olitski and Noland

was dependent on their push toward both "pure" abstraction and "pure" visuality or opticality (a flat surface repressing allusion to the tactile). The work's link to what Leo Steinberg once called "design technology" has often been seen as undermining its abstractness, and it is just as hard to see it as purely optical.[7] Despite its flatness, a painting like *Via Blues* is more a tactile experience than a visual one; like music so loud you feel its vibrations in your bones, the work turns the volume of its color up to the point where it becomes physical sensation.

Olitski veers away from an experience of pure visuality in a different, more traditional, and less overt way. His color, with its interfusions and hazy indirections, allies itself with that of late-nineteenth-century Symbolism – the work of Odilon Redon, for example, who spoke of "the shudder of the colored surface by tone over tone."[8] The idea of synesthesia is central to this aesthetic; it's as though Olitski wanted to render the experience of color as some far more intimate and indefinite exchange than seeing alone affords – as flavor or scent, perhaps. His later work makes the fundamentally nonoptical nature of his interests more explicit – it is nothing if not physical. Sidney Tillim has called attention to a kitsch element in Olitski's work of the 1980s, which he ascribes to the artist's "heated and exotic" sense of color.[9] Yet in his recent paintings, such as *Beauty of Vanya* (Fig. 4), color is distinctly a secondary phenomenon. Seen in a continuum that includes the most recent work of these artists, the optical–actual (or, alternatively, merely literal) opposition seems pointedly inadequate. Color Field painting might now be better called an art of the factitious. Indeed, its stubborn attachment to illusion, even in the absence of representation, makes this art of the "virtual real" that looked like the wrong turn thirty years ago feel surprisingly relevant.

Like many other painters who became otherwise identified in

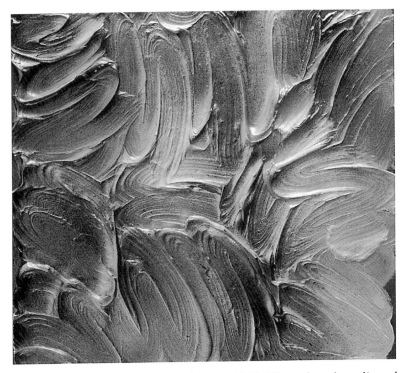

**Figure 4.** Jules Olitski, *Beauty of Vanya*, 1989. Water-based acrylic and oil-based enamel on canvas, 40½₂ × 45¼ in. (Courtesy of André Emmerich Gallery Inc., New York)

the 1960s, in the 1950s Olitski had been in the orbit of second-generation Abstract Expressionism, in an offshoot close to European "matterism," not unlike concurrent American work by Al Held and Ronald Bladen. The plastery thickness of Olitski's early work, in light of his return in the 1980s to a similar impasto (though now lustrous rather than matte), shows how much of himself Olitski sacrificed in order to produce his signature 1960s canvases, with their slowly modulating fields of stained acrylic quasi-framed along two or more edges by subtly contrasting or dissonant hues – paint-

ings of a sort in which Max Kozloff once saw "the aftermath of a physical event or contact seemingly absent from the canvas itself."[10] Such Mallarméan elusiveness, it now seems, was unnatural to an artist avid for an almost Rabelaisian physicality and copiousness, despite the complication of his studied, sweet-and-sour color. Yet if Olitski's 1960s work is subservient to an imposed notion of what good painting must look like, in this instance the Greenbergian diet was a healthy one. Though as thin and watery emotionally as it is in style, the 1960s work doesn't glut itself to exhaustion the way the recent work tends to but maintains a level of repressed energy that remains palpable today.

A generation younger than Noland and Olitski, Poons was a relative latecomer to the Color Field group. His best-known works, the dot paintings of the early to mid-1960s, occupy the same fertile zone between Minimalism and Color Field painting as some of Noland's work of this period, as well as that of Stella. It was only toward the end of the decade that Poons began pouring and pushing his paint to arrive at a facture equally distant from the manual and from the mechanical, a mode typical of Color Field. The results of this conversion, if that's what it was, were remarkable: dense rainstorms of turbid color that still overpower the efforts of many subsequent fetishists of the drip. Since then the careers of Poons and Olitski have often seemed to move in tandem, with a push and pull of influence from one artist to the other – though Poons's apparent indifference to taste has led to more eye-opening results than Olitski's infatuation with bad taste. Like Olitski, Poons today is an energetic exponent of the ultrafunky relieflike surface. His fascination with pouring has led to canvases suggesting oceanic spills of detritus. Forcing the experience of sensation to overwhelm the understanding of sensation, this work transmutes the tragic art of Abstract Expressionism, empowered by ideas of myth and heroic sacrifice,

into a disenchanted, countertranscendental immersion in the mud and debris of mundane and earthbound confusion. In a new development, Poons has taken to overlaying his broken flows of acrylic sludge with ovoid dots reminiscent of those he was using on flat surfaces three decades ago. In these paintings, the oceanic tide of surface accretion has receded somewhat, but this is still not most people's idea of salon painting, by any means. Far from nostalgia, Poons's archaeological excavation of the drip shows his rare and salutary ability to joke with his own history, not to undermine it but to filter it through the change in perspective forced by time.

If the later development of the painters associated with the term "Color Field" makes it difficult to accept the interpretation of even their early work in terms of "pure opticality," this is all the more so with Caro. His early emphasis on planar and linear elements over volume was seen as diminishing the tactility and mass of sculptural forms in favor of an appeal to the eye alone, even though that eye was navigating a three-dimensional structure rather than a two-dimensional picture plane.[11] But the claim to "pure opticality" on behalf of sculpture must always have seemed somewhat tenuous. In any case, Caro's work from the late 1980s on shows him moving as far toward mass and volume as Olitski and Poons have moved toward encrustation and density. Indeed, his work now approximates architecture and furniture to a degree that (happily) threatens its "abstractness." He has even constructed "follies," larger in scale than his other recent work, that he refers to as "sculpitecture."[12] Much of Caro's recent work seems to speak of visual fascination as a form of physical bondage or imprisonment – the huge chain links of *Marathon*, 1993, the anchor ring of *Delphi*, from the same year, the blind or labyrinthine architecture of so many works. These titles may speak of classicism, but the works themselves allude more to the orientalist fantasy made explicit in the sinister seductiveness of

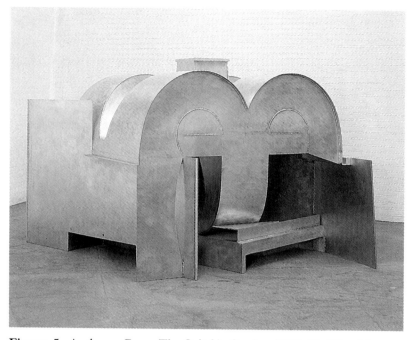

**Figure 5.** Anthony Caro, *The Caliph's Garden*, 1989–92. Naval brass. 68½ × 98 × 96 in. (Courtesy of André Emmerich Gallery Inc., New York)

*The Caliph's Garden*, 1989–92 (Fig. 5), whose "openness" is that of a cunning trap.

One can hardly fault Greenberg or Fried for the descriptive power of their writings on Noland, Olitski, and Caro in the 1960s. And compared to the work these artists have done since, their art of the time did emphasize the visual. But what once seemed the point of the work appears now as a disposable characteristic. The careers of Olitski, Caro, and Poons all demonstrate that the distillation of visual art to the "purely visual" could never have been more than a temporary expedient in a broader project. (Noland's does too, by negative example.) To decipher that project is the task

of any criticism that would seriously attend to these artists. Perhaps at this point they would be better off just conceding the mainstream. Unfettered of the responsibilities incumbent on seeming to uphold the heroic tradition, their best products reveal their eccentricity and excess more clearly. Robert Smithson was correct in categorizing the art Fried loved as a "mannerist modernism."[13] We can see how an unappeasable hunger for strong, rare, properly *unnameable* sensations – the hallmark of "decadent" art – has impelled this art from one surprising extreme to another, from the pointed and "pure" effects typical of the 1960s to the more copious, even chaotic mixtures it has sought in recent years.

It's easy to like the clarity and openness of early Caro or Poons. What it shared with Minimalism, and with a good deal more of the art of the 1960s, is the desire for an art that would be completely knowable, visible, clearly ordered – an art in which nothing remains unmastered. In significant art, this desire always revealed itself as unfulfillable. There always remains a certain uncontrollable surplus or absence, the unmasterable affect that is, perhaps, the art experience itself. Caro and Poons and to some degree Olitski have attempted to seize this surplus and magnify it. As a result, their best recent work offers the more difficult pleasures obtainable only by submission to visual confusion and psychological ambiguity. This art has come to reflect ironically on its own development, and in contrast to that of the Minimalists, its development has outstripped its origins, for both good and bad. Far more than Minimalism, it today seems theatrical, both in the special sense of the word used by Fried – more and more, it occupies the space between the arts of painting, sculpture, and architecture – and in the more vernacular sense of being flamboyant and artificial. Its profligate, sometimes grotesque concatenations of texture, color, and shape may be more salient than we think to our virtually realized fin de siècle.

# 5

# LARRY POONS
## Formalism in Ruins

Larry Poons claims not to know what "formalism" means. Perhaps he's being disingenuous. He professes to regard subject as irrelevant to the aesthetic value of an artwork, which is as good a definition as any of one kind of formalism. "What subject could be more profound than the Crucifixion?" he asks, but goes on to point out that this profundity of subject has no bearing on the fact that there are great paintings of the Crucifixion and mediocre ones. A reasonable proposition. From this point of view it might be allowed that for a long time artists were essentially formalist in their work; insofar as their subjects were relatively few, were culturally given, and were assigned by commission, the artist's essential contribution to his product lay in its formal components.

It is clear enough, however, that by the nineteenth century all that had changed, and that artists had arrived at – had been condemned to, perhaps – a quite different relation to their subject matter. Now it became incumbent on the artist to "produce" his subject, just as he had always produced its form. His task had redoubled. Even when an artist elects, under this dispensation, to produce an absence of subject (Flaubert, notoriously, spoke of writing a "novel about nothing"), this absence represents a deliberate

construction, as it were, within the field of subject matter, a stance with all the weight of intention and meaning behind it.

A perceptive fellow painter noted of Poons that "nothing conjured up by his surfaces suggests the comfort of salvation, invitation, accommodation, or even the promise of usefulness."[1] Beyond the blunt vitalism of thrown paint, gravity is the only certainty here. Poons's formalism, if thus it be called, may be nothing other than a strict adherence to the demand that whatever meaning a painting may possess should arise simply out of the activity of its making. An abstract painting can possess a clarity, an obviousness, a simple presence in time and space that make it clearly knowable and meaningful. Perhaps this might be true of Poons's dot paintings of the early 1960s. And yet the case is a little more complicated than that, insofar as it implies that the meaning put in and the meaning taken out are equivalent. The lack of socially given subjects suggests the improbability of any such congruence – it suggests that the meaning of, say, an abstract painting may be fundamentally unknowable, or in any case unverifiable.

In this debate, all of Poons's paintings since the early 1970s emphatically take both sides. "We prefer seeing . . . to everything else," explains the philosopher, because "this, most of all the senses, makes us know and brings to light many differences between things."[2] "To know is to devour with the eyes."[3] These paintings give a great deal to see, a mass of pictorial incident to devour. This glut, however, leaves the eye unappeased: there is always more than one could possibly know. The concrete physical immediacy of these paintings, almost threatening in its brooding or "sluggish" muscularity, is reminiscent of Clyfford Still or – to name one of Poons's contemporaries – of Richard Serra in his massive black oilstick drawings.[4] Yet their color does something quite different, recalling the luminous decomposition of a late Monet. But whereas Monet

used the play of color to "overexpose" and obliterate the depicted object – a grainstack, a cathedral – with Poons it is the very appearance of the painting itself as a literal agglomeration of matter that is decomposed.

The gesture of throwing paint is one of defacement. What Poons defaces with his obstinately repeated gesture is, at first, nothing other than empty canvas, the receptive neutrality of the ready-made weave. The canvas, which stain painting and other formalist modes of the 1950s and 1960s were at such pains to display and "invest," here becomes the hidden site of innumerable collisions. In a few paintings from 1975, one corner of the canvas remains untouched, as though to take measure of the torrential intensity that prevails elsewhere. "In calling the blank canvas a picture, 'though not necessarily a successful one,' " as Thierry de Duve reminds us, Clement Greenberg grudgingly "anticipated its imminent realization . . . and in so doing made its actualization futile."[5] In Poons's response, flatness undergoes bombardment; its ruins pile up to entomb it. This is the ruin that specificity of medium has contrived for itself: successful, one is tempted to say, though not necessarily a picture.

One recalls, perhaps, the downward fall of atoms through the void, out of which, said Lucretius, all matter was conglomerated, thanks to collisions contrived by random swerves from their downward courses. Yet shape already exists here, if only as the intangible ghost of itself, or as glimpsed through dense veils. Are they shapes, really, or just illusory effects of interweaving patterns of dripped paint? Eventually, "drawing," and therefore definite shape, will transpire as relieflike constructions across the surface to be inundated (Fig. 6). These lines and textures act as baffles, overflown yet evident, to the cascades of paint. They don't hold back the lumpy downpour so much as goad it on to freakier excess.

**Figure 6.** Larry Poons, *The Hanged Man*, 1995. Acrylic on canvas. 90½ × 102 in. Photo by Seth C. Jayson. (Courtesy of Salander-O'Reilly Galleries, New York)

Something unnerving is enacted here, although with breathtaking aplomb. These paintings are profoundly uncool: ponderous slabs of optically dissolving matter: they are fiercely worked up, churningly overwrought. But then they are not exactly warm and emotive either: as images, they maintain an implacable distance, even indifference. Thus the mixed emotions they have tended to arouse in their most sensitive critics. Donald Kuspit, for one, declared them "either a brilliant blunder or the realization of a bizarre beauty," implying that even as failure they would preserve a certain

42

splendor, that even triumphant they are haunted by a disturbing feeling of grotesquerie.[6] The "worked-up" quality of the surface harbors no expressionist claim (though the taste that reflexively disdains expressionist painting must reject it, thus divulging itself as "taste" in the most superficial sense). Here lies the disturbing implication that through these works we witness not simply one man's sensibility but something about the way things are.

As de Duve has argued, Clement Greenberg (and those artists who rallied to his cause) had to accede, under the pressure of the success of Minimalism and its apparent threat to aesthetic standards, to a bifurcation between "a doctrine of taste (Formalism)" and "a doctrine of specificity (Modernism)," between "tropism toward aesthetic value as such" and generic self-criticism.[7] By ceding the logic of Modernism to Donald Judd – thus to Minimalism and its successor, Conceptual Art – Greenberg (and with him color field painting) attempted to retain command of Formalist judgment. Yet I claim that Larry Poons, ordinarily considered a second-generation Color Field painter, has ruined Formalism. Having compared Poons to Richard Serra, I could push the comparison by asserting that Serra, a second-generation Minimalist, has built his success on the ruin of Minimalist Modernism, although the substantiation of such an assertion would demand another essay.

Poons, like Serra, has retained his "presentness" by pressing the arguments of Formalism and Modernism, the contention between Color Field and Minimalism, back into the past. Although evaluations based on outmoded dichotomies continue to echo in the present, they are maintained by habit more than by reason, and by reason more than by observation. Only that art which energetically registers its indifference to these systems of hierarchical opposition still deserves recognition as ambitious today. It admits of an unknown reality, in which we may discern either threat or prom-

ise, according to our circumstances and inclinations. By this criterion, Larry Poons – with these indigestible fragments that are nonetheless too massive, too replete – remains among those at the forefront.

# 6

# GESTURE REVISITED

## Mel Bochner, Howard Buchwald, Brice Marden

By pure coincidence, it was possible one Saturday in March 1987, within a few dozen yards of one another, to view three exhibitions by American abstract painters now in their mid- to late forties, whose present involvement with gestural painting would have seemed unlikely ten years ago.* This brief conjuncture of the exhibitions of Mel Bochner at Sonnabend, Howard Buchwald at Nancy Hoffman, and Brice Marden at Mary Boone gives rise to reconsideration of the wayward course of abstract painting as a self-critical enterprise, especially with regard to the place of drawing as one of its fundamental elements.

In 1974 Mel Bochner noted, "a doctrinaire Conceptualist viewpoint would say that the two relevant features of the 'ideal Conceptual work' would be that it have an exact linguistic correlative, that is, that it could be described and experienced in its description, and that it be infinitely repeatable. It must have no 'aura,' no uniqueness to it whatsoever."[1] (I would add that the distinction between a Conceptualist work and a Minimalist one would be sim-

---

*This chapter is a revised version of an essay originally published in *Artscribe International*, September–October 1987.

ply that, while the Minimalist object can also be exhaustively described, it cannot be fully experienced in its description.) If Bochner's attitude toward the position he described seems somewhat ironic, it should be remembered that by 1974 Bochner was well embarked on his sequence of wall paintings, which had begun the year before with a series whose pointedly "nondoctrinaire" title was *Non-Verbal Structures: RYB*. But this should not obscure the fact that up until 1973 most of Bochner's work had been quite doctrinaire, according to his own definition. In the 1972 *Triangular and Square*, for example, groups of small white stones were placed on the floor in sets progressing from a square of 5 × 5 stones to one of 4 × 4 stones, 3 × 3 stones, 2 × 2 stones, and finally a single stone (1 × 1) acting as a kind of hinge, beginning, at a right angle to the sequence of square sets, a progression of equilateral triangles progressively increasing in size to one of, again, 5 stones on each side. With most Minimalist/Conceptualist work this piece shared a third defining characteristic not enunciated by Bochner: arbitrariness of modular extension. There is no reason internal to the logic of the work why the sequences of squares and of triangles should cease at 5 pebbles per side rather than extending ad infinitum, no more than for a sequence of Donald Judd boxes or a line of bricks by Carl Andre. What distinguishes the Bochner from works by Judd or Andre, however, is its deliberate modesty: the lack of overt invasiveness, the primitive nature of the materials with which it expounds its thesis, and above all its diagrammatic nature, which immediately allies it with the practice of drawing.

Modesty in comparison to their immediate precursors is also typical of the early work of Howard Buchwald and Brice Marden. Taking their cue from Abstract Expressionist painting, they both conceived of the canvas as an all-over field, renouncing composition but carefully preserving the delimitation of the field as a determi-

nant structuring factor (in contrast to the arbitrariness and structural insignificance of that virtual framing in Bochner's work).

Bochner has said that he did not consider his wall paintings of the 1970s paintings: "I was thinking of them simply as an extension of drawing."[2] Whereas both Marden and Buchwald begin with an idea of drawing as essentially delimiting – drawing boundaries around some portion of space – for Bochner drawing seems more essentially a process of extension, of a gesture commanding some portion of a (potentially boundless) space. This becomes even more obvious when we look at his paintings – or rather drawings in color – in charcoal and Conté on canvas, of the early 1980s. Here color is used mainly for readability, and for a sense of velocity. The layering of linear elements produces a kind of schematic yet nebulous space, but there is no volume – or rather, as soon as volume begins to appear it collapses.

When Bochner switched to oil paint in 1983 he switched to shaped canvases as well. Once again, it was a question of using paint to draw from the inside out. Each work was painted unstretched on the studio wall, with the final shape determined by the polygonal linear structures that had arisen within it. In contrast to the relatively bodiless charcoal and Conté he had been using, which tended to generate comparatively little pictorial tension with its framing edge, the density and plasticity of oil paint would have made that tension a more crucial problem, but by literally "tailoring" the format to echo its contents, Bochner finessed the issue. The result, paradoxically, is that there is little sense of closure to these paintings; they seem rather arbitrarily excised from some larger continuum of graphic activity.

In his most recent work, Bochner has returned to the rectangle, although he uses it in eccentric ways. The newest piece in the Sonnabend show (essentially a miniretrospective) was called *Turning the*

**Figure 7.** Mel Bochner, *Turning the Corner*, 1986. Oil on sized canvas, two panels, each 96 × 70 in. Photo by Joh Abbott. (Courtesy of Sonnabend Gallery, New York)

*Corner* (Fig. 7), and it did just that, its two panels meeting at a right angle (that hinge figure again). It is a commanding environmental presence in a way Bochner's work has rarely been, but the contrast between the lucidity of its underlying structure and its heavy, almost Germanic painterliness seems unresolved.

Although he had already been painting for some time, Howard

Buchwald did not begin to come into his own until the late 1970s. His early work had affinities with that of Marden, employing geometrically delimited fields as sublimations of gesture. He then began to break the field down into tight webs of thin, flat brushstrokes. The breakthrough came by way of a challenge to the congruence of the painting-as-object and the painting-as-image: Buchwald began to build holes into his paintings, revealing the wall behind them. Circular openings neatly interrupt the surface at various angles (Buchwald's play on the Renaissance concept of "cones of sight"), and pairs of these holes were usually linked by arcs of unpainted canvas. A bit later he also began using long, straight cuts through the surface as well. All of these interruptions of the surface must be planned at the beginning of work on each painting, their framework built right into the stretcher. To draw is, in the first instance, to create an edge. The edge around the canvas is a primary instance of this. Buchwald multiplied that edge internally, increasing points of augmented compositional tension. In so doing he went in the opposite direction to the shaped canvases of a painter like Bochner (or of Frank Stella's work of the 1960s).

Buchwald's brushstroke, when it first began to emerge from the over-all field in the mid-1970s, was essentially an analytical instrument. The introduction of holes and slits into the canvas compromised its austerity. Forcing each stroke to account for its relationship to multiple – and inevitably contradictory – structural givens could not help but inject drama, and therefore expressivity, into the brushstroke. If the formal correlate of expressionism is the distortion of the picture plane, then Buchwald's willful fracturing of it (Fig. 8) would have to reintroduce a kind of expressionism through formalism's back door. This has become increasingly clear in his work over the last few years. Although the paint is still flat

**Figure 8.** Howard Buchwald, *Masquerade*, 1986. Oil on linen, 84 ×
72¼ in. Photo by Zindman/Fremont. (Courtesy of Nancy Hoffman
Gallery, New York)

and even in its application, it has become looser, more fluid, and
subject to layering that may obscure the individual mark's reada-
bility as well as the massing of strokes of one color to act within
the painting as larger-scale "events," although never exactly as

shapes or "figures" in even the broadest sense. Buchwald has also begun allowing the paint to drip, reintroducing overt reference to the sense of gravity that anchors the virtual space of the painting to the actual space of the surrounding environment, and also adding a counterpoint of random but regular vertical marks to the more controlled but irregular brushstrokes that compose the image proper. In giving himself over to the fluidity of the paint, Buchwald has revealed himself to be more of a sensualist than one might ever have suspected a few years back.

As with Buchwald, the field of color was for Brice Marden always a sublimation of gesture – or perhaps it would be more accurate to call it gesture congealed. As Carter Ratcliff nicely put it, "The Mardenesque object looks denser than the Mardenesque image."[3] The much-admired "skin" of Marden's oil-and-wax paintings always seemed to hold something back, to substitute the tension between the impulse to expression and the discipline of restraint for a more specifically pictorial tension, and yet the tension in Marden's paintings fluctuated across the surface, just as conventional pictorial tension would, in relation to the containing rectangle: held down tightly at the corners, it seemed to give toward the center. It was precisely this tension *within* the monochrome rectangle that made the line formed by the abutment of two such canvases into a significant act of drawing.

An emphasis on the quality of the surface of the painting is usually a form of overrefinement, a mannerism. Marden's moody, shrinking-violet way with color (he once remarked that "a color should turn back into itself," which is to say, shy away from the viewer),[4] although rarely less than perfectly pitched within its own terms, did little to contradict a tremulous atmospherism perhaps a shade too enamored of its own sensitivity. In the 1980s Marden modulated to a more forthright palette, but this did not disguise

the fact that his work was beginning to look a bit stale, and too responsive to the expectations it had already set up. Perhaps it was inevitable, then, that Marden's work would renew itself only through a sudden metamorphosis. While the careers of Bochner and Buchwald present the retrospective appearance of orderly development, though not in directions one would have predicted, Marden's new work looks like a break, no matter how many connections one can find to his earlier work. That such connections are largely with his works on paper rather than his paintings merely emphasizes that the break has been preparing itself for a long time. The opening up of the surface and the breaking up of the singular image evident in Marden's new paintings can only have been the result of a kind of undamming.

Marden is no longer using the oil-and-wax surface he's worked with for so long. Instead he's using well-thinned oil paint. The medium is conducive to a sense of velocity, the evidence of movement. The colors are translucent and as complex as ever, with a tendency toward whitishness, often looking like suave soapbubbles stretched taut across the webs of loose, criss-crossing gestures that are the nervous system of the image. There's nothing heroic or demonstrative about those gestures, but neither are they tight or restrained (Fig. 9). At their best they have a rigor that only reveals itself slowly: their calibration of emotion and structure compromises neither.

For Buchwald and Marden, the return of gesture has been a reinstatement of drawing from the edge of the canvas (as a precondition of painting) to the centrality of paint application itself – perhaps a shift in emphasis from painting-as-object or painting-as-image to painting-as-activity. For Bochner, on the other hand, drawing has always been diagrammatic, in the sense that it has been within the abstract infinitude of (Minimalist) seriality rather than

**Figure 9.** Brice Marden, *Untitled 3*, 1986–7. Oil on linen, 72 × 58 in. Photo by Zindman/Fremont. (Courtesy of Mary Boone Gallery, New York)

the concrete unboundedness of the (Abstract Expressionist) field, and therefore has never really been conceived within a dialectic with the painting tradition. Bochner's progressive complications of his conception have inevitably reintroduced the facticity of the painted

surface but have never been able to integrate it structurally. That Buchwald and (perhaps more fully and decisively) Marden have done so suggests the continuing importance of what used to be called "painting culture" to art's speculative reach.

# MARY HEILMANN'S CERAMICS AND PAINTINGS

## Color as Substance

In Mary Heilmann's abstract paintings, familiar sights and sensations are rendered in way that is, paradoxically, both highly mediated and spontaneously immediate.* The experience of looking at the paintings tends to involve an almost unreflectively sensuous immersion in the stubborn specificities of intense color and bold, lucid form, along with a nagging suspicion that these seemingly irreducible materialities are really roundabout commentaries, distilled from a complex train of thought, on experiences so common one had neglected even to notice them. It's something like hearing an oblique jazz solo on an ordinary show tune you can't quite identify (think of something between the elliptical elegance of Miles Davis and the mock ham-fistedness of Thelonious Monk).

Now in her fifties, Heilmann has been active as an artist since the 1960s, but like too many women artists she has had to wait for her proper recognition; only in the last few years has she been acknowledged as one of our finest painters, a natural choice for major surveys at a national level – for instance, the 1989 Whitney

---

*This chapter is a revised version of essays originally published in *American Ceramics*, Spring 1994, and *Arts Magazine*, September 1990.

Biennial – and, increasingly, international events such as "Der zer-
brochene Spiegel: Pozitionen zur Malerie" (The Broken Mirror:
Positions on Painting), organized in Vienna by Kasper König and
Hans-Ulrich Obrist. In this Heilmann has undoubtedly been aided
by the rise of an artistic ethos that no longer sees any necessary
division between the blunt, irreverent, vernacular sensibility of Pop
art and the supposedly abstruse and mandarin refinements of ab-
stract painting and Minimalism. What few of Heilmann's admirers
know – or, if aware of it, they have yet to consider its significance
– is that Heilmann's formal training as an artist was not in painting,
but rather in ceramics, and that (except for a hiatus during the
period from about 1968 to 1975) she has continued to work as a
ceramist.

Heilmann dates the beginnings of her interest in ceramics back
to 1961, when she was a student at the University of California in
Santa Barbara, studying English and American literature. Seeing an
exhibition of the Abstract Expressionist–influenced ceramic sculp-
ture of Peter Voulkos was such a powerful experience for her that
she ended up enrolling in the graduate program at Berkeley in order
to study with him. Voulkos and his way of teaching – resembling
the method of a Zen master more than of a typical art school pro-
fessor – clearly left as strong an impression on Heilmann as his
work itself, for she still harbors vivid memories of incidents like the
one in which Voulkos, wearing trademark "Beatle boots" with in-
ordinately pointy toes, constructed an elaborate ceramic tour de
force, a gigantic pot, and then, carrying it to be fired, "accidentally"
tripped over his own extravagantly shod feet so that the form was
splattered on the ground – only to be reconstructed by Voulkos in
a completely different way, as a sculptural vessel: an object lesson
in the simultaneous importance and worthlessness of technical vir-
tuosity, of "craft" in the usual sense of the word. Heilmann recalls

the ethos of the California craft world as she first knew it to be relentlessly bohemian. It was, after all, the heyday of "funk." The point of working with crafts such as ceramics rather than high-art media like painting or conventional sculpture wasn't so much the development of a technical skill of any kind as it was the cultivation of a way of life that had a conscious stake in the objects one handled every day. Objects were appreciated to the extent that they reflected a certain weight and earthiness; elegance and overrefinement were taboo, identified with the more "bourgeois" work typical of the streamlined 1950s. "The name of Gertrude and Otto Natzler was a dirty word to us then," recalls Heilmann, laughing at the intolerance of an earlier time. And yet, however sophisticated and cosmopolitan her viewpoint has become in the intervening years, that bohemian impulse – the idea that art is not part of a sealed-off realm but is on intimate terms with mundane life – is still the strong core of Heilmann's art and may be one reason for the easy continuity between her work in painting and ceramics.

Heilmann sees her work in ceramics as divisible into four broad categories: tiles, constructive sculpture, cup sculptures, and usable pottery. The tiles, generally, hang on the wall like paintings. Usually monochromatic, they eschew uniform flatness in favor of a slightly undulating surface, just as they avoid perfect rectangularity for somewhat wavy, irregular edges that recall the former malleability of their condition. The constructive sculpture, too, is essentially but not strictly planar and geometrical. In these works, two or more elements are overlapped or juxtaposed. Again, these are usually monochromatic, although there are exceptions like *Kachina*, 1985, where Heilmann has employed a simple checkerboard pattern (Fig. 10). The elements are usually of different colors, and rather than being simple rectangles they usually have more complex shapes, often incorporating a steplike configuration. The cup sculp-

**Figure 10.** Mary Heilmann, *Kachina*, 1985. Glazed ceramic, 18 × 12 in. (Courtesy of Pat Hearn Gallery, New York)

tures step out of the purely abstract realm of the constructive works: they are, as the name implies, representations of cups, but they remain planar and geometrical. Some are wall-hung, others free-standing. The category of pottery is self-explanatory: conventional

cups, saucers, plates, and so on, which Heilmann considers as primarily utilitarian rather than artistic in nature. This is not production work but something Heilmann does for her own use and that of friends, to whom she sometimes gives her pottery as gifts.

Just because Heilmann's artistic modus operandi – and not only in painting – has always been to work from the quotidian and vernacular, her functional pottery may be as good a place as any from which to start our investigation. A Heilmann cup may be a straightforward, functional object of everyday use – but then in Heilmann's way of seeing, everyday functional things are never as straightforward as they might appear. Normality is merely one way for oddity to camouflage itself. In the case of a Heilmann cup, though it may be almost generic in form, one immediately becomes aware of its slight thickness and heaviness compared to the kind of cup one would ordinarily use. The difference isn't great – not outside the realm of the ordinary so much as at its edge. It is just enough to add a certain quantum of self-consciousness to one's interaction with the object, a certain fleeting sense that one is somehow exerting the effort or acting the role of using a cup rather than simply using it. And of course there's that telltale Heilmann application of color: lush, allusive off-primaries, black, and white, in shapes and patterns too loose to be quite geometrical, too clearly ordered to be gestural. This minimal difference from the norm is already sufficient to begin to draw the cup into the orbit of "art" – but not enough to hold it there; just enough to remind us of how, much more often then we imagine, ordinary things point in that direction, and how often they partake of that sense of strangeness and opacity which art mobilizes in a more emphatic and thoroughgoing way.

This more pointed organization of the effect of estrangement

becomes visible in Heilmann's cup sculptures. Effecting a sort of *entente cordiale* between the demands of constructivist flatness (artistic high modernism), on the one hand, and perspectival orthogonal recession (conventional pictorial representation) on the other, they turn comfortable forms into angular, cartoonishly exaggerated outlines, and signifiers of sedate respite into careening vehicles of fractious energy. Like Voulkos, with his dropped and reconstructed sculpture, Heilmann's cup sculptures take her everyday pottery forms and make them go "splat," overturning expectations and reminding us that what we thought we knew too well to pay attention to can always be seen afresh. Heilmann explains that in some cases she has employed polaroids of her own pottery as "drawings" for these sculptures, using the outline created by an arbitrary camera angle to present the cup in a way it would not ordinarily be seen. As essentially pictorial representations of everyday objects, Heilmann's cup sculptures are a species of still life, a genre which tends to evoke associations with themes of the body and its needs, hospitality, domesticity, routine, and formal as well as social stability.[1] Heilmann's take on still life does not reject these associations but rather renders them strangely transitory and ungraspable. The stylized shapes, endowed with something of the dynamism of the abstract forms in suprematist painting, make it seem as though the domestic and the routine were (though remaining what they are) taking flight.

What the cup shapes in flight are on their way to becoming is, perhaps, what we see in Heilmann's purely nonobjective constructed sculpture. Here representation is turned down to degree zero, although the idea of representational space is retained through Heilmann's typical stepwise motif, which carries a certain recollection of perspectival recession. I have already mentioned the inten-

sity of color which is characteristic of Heilmann's paintings; it is with the constructive sculpture that it becomes urgent to explicate the use of color in her ceramics, which is the basis for her use of it in painting as well. Not that color is insignificant in her functional pottery or the cup sculptures, but in her more purely abstract work it comes to the forefront. The reason for the particular saliency of color in Heilmann's constructive sculpture is its coincidence with form there: each material unit equals a single color – is, in other words, a monochrome. But that may be putting it a little too simply. Looking at one of these works, a viewer has the sense that each element constitutes a single chunk of color – that here color has been made completely material, completely plastic, more a sculptural substance than a painterly supplement to a preexisting surface. And yet this color is, after all, a glaze; there is never any dissimulation of the contradictory awareness that it covers a support. So illusion and literal materiality, fantasy and sobriety, simply agree to disagree here. This kind of nonplussed acceptance of paradox is a typical effect of Heilmann's work, achieved through various means. Perhaps it took a critic who is also a painter to notice, for instance, that "all of Heilmann's paintings look as if they were wrought in a split second, though manifold washes of thin oil paint evidence the contrary."[2] Temporality and immediacy, like illusion and presence, remain coterminous yet nonidentical in Heilmann's work, as spirit and matter do in the philosophy of Spinoza.

What goes for the relation of color to form in Heilmann's constructive ceramic sculpture is all the more true of her tiles, which come as close as her work ever gets to any kind of absolute. A red tile by Heilmann seems to hang on the wall as a demonstration of redness – redness as a quality projected outward from the object, forcibly impressing itself on the perceptual and cognitive apparatus

of the person who sees it, but also reflecting itself inwardly, as it were, in the form of a complex *process* sustaining its own metastable existence in time and space, absolutely independent of any observing consciousness whatsoever. As intense as the color may be, and monochromatic as it is, Heilmann's color is full of minute and subtle variations, just like the surfaces in which it is embodied and the edges that define those surfaces. This is important, because it gives rise to the sense of process that I mentioned, the sense that a certain color is, so to speak, working itself out, developing itself in a quasi-photographic sense.

If the spectrum of Heilmann's work in ceramics as I have traced it from the pottery to the tiles represents something like a process by which the ordinary becomes more and more subsumed within the symbolic functions and self-reference that arise within it, a process attaining its farthest reach of intensity in the tiles, the tiles are also the format in which the autonomy of art gets folded back into the serviceable, because (with a suitable reduction of the physical irregularities peculiar to the wall-hung, paintinglike tiles I have been discussing) Heilmann also makes similar tiles for use in her loft as, for instance, table surfaces. What, displayed vertically on the wall, had foregrounded conditions of display and support only in order to display and support its own presence, with only small variation returns to the humble condition of serving to support and display any other object whatsoever – and not rarely Heilmann's own pottery.

In Heilmann's ceramics, function, physicality, and the generic take on increasing degrees of philosophical self-reflection without leaving behind their earthbound nature for a merely conceptual or ideal viewpoint. Here, "where abstraction and our senses meet," as one critic put it,[3] is where the ordinary is revealed as compelling

just in its ordinariness. Similarly, Heilmann's paintings evoke the emotional climate of the everyday while reconstructing it as a form of cinematic romance. "The huge, graphic, sexy movie billboards," Heilmann recalls,

> provided the scenarios for the childhood games we played at the beach near our house: *Duel in the Sun, Flash Gordon, The Thief of Baghdad, Sabu, King Solomon's Mines.* I especially remember one movie, *Slave Girl.* In the game from this movie each little girl in turn was forced to drag a huge pile of seaweed along the sand while the other little girls whipped her with strings of kelp.[4]

Like these innocent/perverse childhood pastimes, the paintings may start with something already seen and known, but the very "game" of mimesis transforms the initial data into something rich (a word that can also mean "preposterous," "laughable") something strange, and fundamentally unrecognizable.

Among Heilmann's most powerful tools for estrangement is color. Her palette is emotionally primary, not optically so. This was already the case when she exhibited a group of pink and black paintings in 1979. In *Save the Last Dance for Me*, three pink rectangles waltz across a black field, diminishing in size from left to right. The surrounding black seems to squeeze the pink shapes to some ultimate degree of tension, so that the few stray drops of pink paint scattered below them read as something like cartoon sweat. This is *echt* Heilmann: as "nonrepresentational" as can be, the painting nonetheless seems saturated with narrative. Severely reductive – just two colors arranged in basic shapes – it is also lushly seductive and flagrantly emotive, almost verging on Camp. It has the vernacular directness of Minimalism but rejects neither composition nor a discrete yet unbridled painterliness. Another of this group, *Tehachapi,*

is two canvases, both of which appear to have been covered first completely in pink, including the edges around the stretchers; the right-hand canvas was then entirely covered over with black, except for those side edges, while the left-hand canvas was painted black at its top, bottom, and right (that is, toward the center of the two-canvas composition), leaving a pink rectangle intersecting the left edge and, once again, leaving all the edges pink. At the point where the two canvases touch, where black meets black, there is just enough space for a searing streak of pink to flash through. The effect answers a question once posed by Roland Barthes:

> Is not the most erotic portion of a body where the garment gapes? . . . It is intermittence, as psychoanalysis has so rightly stated, which is erotic: the intermittence of skin flashing between two articles of clothing (trousers and sweater), between two edges (the open-necked shirt, the glove and the sleeve); it is this flash itself which seduces, or rather: the staging of an appearance-as-disappearance.[5]

Appearance-as-disappearance: we have seen this in painting before. Let's take some exemplary instances. In 1988, the Metropolitan Museum displayed Mantegna's *Descent of Christ into Limbo*. As is conventional for this scene, the entrance to Limbo is through the mouth of a cave. What is significant for us is the nature of that cave: not simply a hole, it is truly the opening into a vast and, because measureless, *irrational* space, a space greater than that of the picture itself, a sublime space – or, rather than the entry into such a space, it could be called the entry of such space into painting. If this is illusionism, it is a kind that devours itself, and it is quite another thing from the rational deployment of perspective for which Mantegna is renowned. A different form of appearance-as-disappearance is found in the late work of Velázquez. As we view

a portrait such as that of Juan de Pareja, the incredible solidity and reality of the depicted figure draws us in to view it more closely, but as we do so the image dissolves into the very matter of the medium itself. Velázquez depicts not only the flesh but also its evanescence in time. What Heilmann does is something else again. It neither overwhelms the real, as with Mantegna, nor undermines it, as with Velázquez. Heilmann treats color as an absolute reality, as substance, the way clay is a substance. Sometimes we can see it, sometimes it is eclipsed, but it is always there. Whereas the disappearances staged by the Old Masters teach resignation, Heilmann's ontological confidence sanctions desire.

Around 1983 Heilmann switched from acrylics to oils for most of her paintings. This allowed her to give the work greater weight and density. Perhaps to offset this, line has taken on greater importance within the paintings to complicate the self-evidence of color-as-substance. Some of the most successful among the paintings in recent years use an unusual shaped format based on the idea of two overlapping squares of the same size, one being halfway up and to the left of the other, so that the implied upper left-hand corner of the right-hand square is at the center of the left-hand square. In *Lifeline*, 1989 (Fig. 11), the squares are diagonally bisected into a white upper right-hand zone and a dark blue lower left-hand one. Two lines continue the top and left edges of the lower right-hand square into the upper left-hand square, thereby drawing three interior squares, each one quarter the size of the primary two. Since the diagonal between the blue and the white areas bisects one of these smaller squares exactly as it does the larger one catty-corner to it, an ambiguity is produced: Is this a single diagonal moving through two zones, or should it be seen as two diagonals, one of them the half- or double-length "picture" of the other? Although my description may seem to imply that the paint-

**Figure 11.** Mary Heilmann, *Lifeline*, 1989. Oil on canvas, 72 × 72 in. (Courtesy of Pat Hearn Gallery, New York)

ing presents an interpretive dilemma bearing solely on questions of formal designation, this play of singularity and comparison evokes questions about how identification and representation inflect our experience of time and memory. The assurance, balance, depth, and intensity of *Lifeline* are those of major art.

# 8

# PORFIRIO DIDONNA
## Vision Fulfilled

Just compare this age with the past ages; when you leave the Salon or a recently decorated church, go and rest your eyes in a museum and analyze the differences. In the former, conflict and hubbub of styles and colors, a cacophony of tones, colossal trivialities, vulgarity of gestures and attitudes, conventional dignity, clichés of every kind, and all this, staring you in the face, not only in pictures hung side by side, but even in the same picture; in short, a complete lack of unity producing a dreadful feeling of fatigue for the mind and eyes. In the latter, you find an air of reverence that makes even children take their hats off, and grips the soul . . . That is the effect, not of yellow varnish and of the filth of ages, but of a sense of unity, profound unity.[1]

The complaint of Charles Baudelaire as he reviewed the Salon of 1846 would need little updating to pass as the grumbling of a contemporary critic at some biennial now, almost one hundred fifty years later.* The ahistorical basis of a certain "postmodernist" ideology is revealed clearly enough in its attempt – whether mournful

*This chapter is a revised version of an essay originally published in *Porfirio DiDonna: Vision Fulfilled, 1984–1985* (Boston: Neilsen Gallery, 1994).

or enthusiastic – to claim as specific to contemporary culture a stridency and eclecticism that have been the norm for centuries. No more plausible, of course, would be the perennial conservative gambit by which our author here, like many others since, apportions calm and unity to the hallowed past. Unwittingly, Baudelaire himself gives the clue; not antiquity but rather that modern institution, the museum of antiquity, establishes the unity of style, retrospectively.

No, we can be assured that artistic coherence has always been the exception, a rare and heady distillate in which the contradictions of an era have been resolved into a single complex effect. As the 1980s we lived shed their veil of immediacy to reveal themselves in the light of history, claims to significance on behalf of artists who received so much esteem for their reproductions of the "cacophony of tones, colossal trivialities, vulgarity of gestures and attitudes, conventional dignity, clichés of every kind" have already begun to look threadbare. The quality of art lies elsewhere.

Porfirio DiDonna was immersed in the art of his time, and in good measure his path paralleled that followed by other painters of his generation, yet he was no follower. His path was has own. Nothing distracted him from a concentration that somehow had nothing fanatical, nothing obsessive about it. Reviewers of his work of the 1970s – meticulous paintings composed of dots and lines reiterated according to loose grids on monochrome fields – naturally mention Agnes Martin as an influence; the artist himself spoke to me of the importance of Brice Marden and of the early dot paintings of Larry Poons as touchstones for his own thinking. Yet DiDonna's grids and monochromy came from a different place, and they led to a different place, than in the work of those painters.

Aware of everything, he committed himself only to what could be measured on his own pulse. And although, by the time I knew

him – the period (1984–5) covered by this exhibition – that certainty seemed to come as naturally as breathing, DiDonna's paintings of the 1970s suggest that it was the result of a long and determined apprenticeship. For what else are those paintings if not an extended process of testing, of measurement? What else but the determined effort to ascertain – What? What is real? What can be counted on? I'm not sure, really, how to characterize it, except to maintain that whatever it was he was testing, it was something *between* himself and the painting, not something about himself alone (for which painting would be the measuring instrument) or about painting alone (for which he would serve as the measure). A mutual measuring, one might say – like solving equations with two variables. In any case, it is notable that (unlike some others of his generation) he did not seem to need to test the basic convention of painting as such – shape, support, surface, and so on – but rather the immediate components of the activity of painting, the marks that construct and body forth the individual painting as image. In other words, his quest was not for definitions ("What is a painting?") but for something more elusive: What kind of mark can I stand behind? What makes meaning? What connects?

It was only when, after his death, DiDonna's first paintings (from around 1963–4) were shown that it became clear what the starting point for this quest was. Titles tell part of the story: *Eucharist*, *Stations of the Cross*, *Crucifixion*. But DiDonna preserves this traditional Catholic iconography only through its formalization, distancing, and dissolution. What remained was, on the one hand, the attachment to painting as a vocation in a quasi-religious sense, and on the other, a sense of the painting's "iconicity" (a term I borrow from Joseph Masheck),[2] its role as the vehicle of a direct confrontation rather than a representation. The marks that transpire on the surfaces of DiDonna's paintings of the 1970s may be

schematic or abbreviated, but they are no more mechanical or sten-
ographic than they are demonstratively gestural. Their criterion
would appear to be a twofold integrity: each mark must at once
stand on its own as a carrier of energy, and take its place in the
overall pattern.

Mark making remained an important element in DiDonna's art
right up to his last paintings, but in these it has become transformed
in being subsumed within the construction of an overt image. The
marks have become more varied, more complex, and often more
ambiguous, but their role in creating space, light, and form is always
evident. The forms in these paintings are abstract, not representa-
tional like those in DiDonna's first paintings. But whereas the
Christian imagery of the early work seems to have been caught in
the act of vanishing, the imagery of the final paintings appears to
be forming itself, inventing itself into being, right before our eyes.
It's as though a new, literally human-scaled certainty were being
formed from within the very condition of objectivity and disen-
chantment that had been imposed against faith before, a new elo-
quence born of reticence.

I don't know what religious convictions, if any, possessed Por-
firio DiDonna in the later years of his short life. But I am sure that
the art of painting discloses itself with religious intensity in the
paintings he made then. It would be interesting to see how these
paintings look in a church. To me they speak raptly, as with Prous-
tian recall, of an essentially Catholic, essentially Italian culture in
which spirituality and the senses, fervent emotion and dispassionate
calculation, resignation and aspiration, self-dramatizing oratory and
self-denying conviction do not contradict. The artistic culture of
late modernism has many sources, but this is not among the dom-
inant ones, which derive rather from the Enlightenment and, in
America, its intertwining with Protestantism. By the standards of

this culture, the products of an artist like DiDonna in his later work ought to appear histrionic, sentimental, even in a sense idolatrous. If, on the contrary, his mature paintings never appear less than rigorous, if indeed (as I believe) the self-control with which they reveal their own intensity is nothing less than exemplary, this is because the success of his project was in his brave confrontation with and internalization of what is strongest in the surrounding artistic culture: his ability to make what he remembered in his bones, his Catholic heritage, reappear from within the Enlightenment tradition of Minimalism.

It would be a mistake to assert, as one critic has, that "DiDonna was clearly aligned with the mystical rather than the materialist side of 20th-century abstraction."[3] For him, eventually, this distinction would dissolve. I never heard DiDonna speak as a mystic, but rather, if anything, as a formalist. I think he would have agreed with the young Ludwig Wittgenstein that what is transcendental is what cannot be put into words, and he respected that impossibility through his silence. The only time I ever heard him moved to refer explicitly to what is called spirituality, in regard to his paintings, was in speaking of one he had dedicated to his mother. And when I see DiDonna's paintings of the 1970s I am somehow lured in the direction of such themes much less than by the work of Martin or even Marden, though perhaps more so than by that of Poons – to limit myself to names I have already mentioned. Those 1970s paintings *are* materialist, though their materialism was not an end in itself. It was a sort of sacrifice. I am reminded of something Georges Bataille once wrote about the equally oblique "formalism" of Édouard Manet, that "to break up the subject and re-establish it on a different basis is not to neglect the subject. . . . After all, the subject of Manet's pictures is . . . not so much obliterated in the interests of pure painting as transfigured by the stark purity of that

painting."[4] So it was with DiDonna. His long immersion in painting as materialism, as rationalism, as Protestantism – the greater part of his artistic career, as it turns out – was the calm working out of a determination to eliminate from his work anything merely received. It was an emptying out, an ascesis, but in a way that recalls the remark of the English novelist Sylvia Townsend Warner that to her it was the emptiness of a church that was holy. Of course, this emptiness is the most profane thing, as well as the most holy. My friend the critic and psychoanalyst Josefina Ayerza holds that, indeed, emptiness is characteristic of the work of art as such. What's the difference, she asks, between a Warhol Brillo box and the one you buy in the supermarket? It's that Warhol's is the empty one, of course. The sacred and the profane meet at this point of emptiness, or perhaps I should say this moment of emptying. It is a place or a moment that DiDonna spent a long time looking for, I believe – and it is one that gives him more in common than might be imagined with an artist like Warhol, likewise an icon maker, with a very charged and eccentric relation to Catholicism.

The tendency to abstraction has a number of sources in the history of art, and two of the most important among them are in direct contradiction. On the one hand, there is the tradition of icons – representations, or perhaps more accurately vehicles for encounter with or access to transcendent being. On the other hand, "genre," landscape, and still-life painting – pictures "without a subject," works immersed in the surfaces of everyday life. What lies between these two categories – the heroic, historical, and religious narratives that had been the mainstream of Western art from the Renaissance through the eighteenth century – could never of itself have led to abstract painting. (Note that religious imagery can go in the direction either of narrative or of icon; only the latter is a source for abstraction.) Part of what makes DiDonna's late work

special is the way it mediates these two approaches toward the abstract.

I have already said enough to indicate this work's relation to the iconic tradition. While DiDonna's work of the 1970s preserves certain formal dimensions of iconicity, at the same time its materialism and modesty partake strongly of the still-life tradition of "rhopography," as Norman Bryson (following Charles Sterling) has called it. I have spoken of DiDonna's work as abstract, and that is so, but it is not insignificant that most commentators on his last paintings have spoken of shapes in them as "vessels" or "chalices."[5] Bryson writes that "the *things* which occupy still life's attention belong to a long cultural span that goes back beyond modern Europe to antiquity and pre-antiquity. . . . The bowls, jugs, pitchers, and vases with which the modern viewer is familiar are all direct lineal descendants of the series which were *already* old in Pompeii."[6] But speaking of jugs and pitchers is not quite the same as speaking of vessels and chalices. "Chalice" is not a word we use often; it is an elevated word to denote a ceremonial object. "Vessel" is more common but far more generalized, that is, abstract; and through its generalization it gives greater scope for metaphor. For all that, however, bowls, pitchers, and the rest remain nothing other than vessels, and to the extent that we must see vessels in DiDonna's last paintings they remain, however abstractly, however metaphorically, however exaltedly, tied to the tradition of still life – but to a specifically modern devolvement of that tradition, one that commences only with Chardin. Until Chardin, as Bryson reminds us, still life was the realm of high focus, sharp and brilliant delineation, meticulous particularity, what might today be called "hyper-reality." Only with Chardin – as later with Manet – does the focus relax so that the "feminine" intimacy of tactile prehension and peripheral vision might come to the fore.

In a sense, the earliest of the paintings here (PDN 8, 1984)[7] shows the issue still undecided for DiDonna. A bit too deliberately Old Masterish in its facture, its central form is rendered in a much more volumetric way than it will be in the later pictures, and it is more clearly outlined. The shape is very much a singled-out object contained by a space. It is surrounded by feathery little brushstrokes which begin to cross over into it, a sort of tactile atmosphere, but they do not contest the figure–ground dichotomy. But in the subsequent paintings all this changes. The space becomes flatter, and the vessel figure tends to be much more interwoven or continuous with the ground. What this form is, and what it does, varies dramatically from painting to painting, but always it is a monumental form that, paradoxically, is without stasis. It is the permeable figure of a vibratory space, wavelike, resonant. Nothing about the form appears predetermined. Instead, like a river, specific interactions of flow and resistance to flow determine its course. Amazingly, for all the unmistakable hieratic transplendence of these paintings, there is no stiffness, no Sunday-best pomp or correctness about them, but rather the most natural and welcoming modesty and ease. Not that they are easygoing. Often we find a Gothic sense of upward stress, as in PDN 12, where the form rises upward from light into shadow, becoming flatter, dimmer, closer-valued, as if veiled in mist. Elsewhere, in PDN 5, the figure acts as a pillar, humbly but with an intense force of concentration supporting a weighty horizontal. In one of the rare titled paintings of this period, *Angel* – a recollection of DiDonna's 1960s – the figure leans slightly to the right, as though toward something to the right of the painting; I wonder whether the title doesn't invite us to recall the angel of the Annunciation (Fig. 12). Generally, as we follow the progressive development of DiDonna's last paintings, we see the paint thinning out, becoming sparer, gestures becoming more rarified – not for the sake

74

**Figure 12.** Porfirio DiDonna, *Angel*, 1985. Oil on linen, 33 × 17 in. Private collection. (Courtesy of Nielsen Gallery, Boston)

of reduction or to isolate a basic vocabulary or syntax, but because an ever-increasing plenitude of contents demanded more immediate transcription. There is a letting go of the inessential, as though this young man, who did not yet know of the illness that would claim

his life, were already passing into his *Alterstil*, his late style. New fullness, new emptiness.

No doubt that is giving an accident of fate more weight than a critic should. These paintings were never meant to be the last word on anything. But they are among the rare works of our time capable of communicating without embarrassment "that sense of respect" Baudelaire spoke of, the essential one that "touches us to the quick." We needn't ask whether that sense belongs to the painter or to the viewer, for it belongs to one as it belonged to the other. It is nothing other than the generosity of a proffered vessel of vision being filled, completely filled and flowing over, through time, to the human vessel prepared to receive it.

# MOIRA DRYER

## Answering Machines

## I

Moira Dryer's first solo exhibition was at the John Good Gallery in 1986, although her work had been very visible in recent group shows.* Already the work (all casein on wood) looks very sure of itself, very resolved. Around this time, Donald Kuspit distinguished between neo-Geo and "new Geo," the distinction being that in the latter "the geometry they use is discovered rather than designed." In a four-man show at Sonnabend, neo-Geo painter Peter Halley showed a large horizontal painting consisting mostly of a black rectangle and a white one of equal size. The painting seemed to fall apart, because although each half of the painting had a determinate relation to the viewer, neither had any determinate effect on – no significant relation to – the other. I couldn't help thinking of this while looking at Dryer's *The Sentence*, a two-panel painting in which the larger panel is a horizontal rectangle divided into four

*This chapter is a revised version of reviews originally published in *Arts Magazine*, December 1986 and April 1990, and *Artforum*, April 1994.

77

equal rectangles, two black and two white. Unlike Halley, who has simply filled in predetermined areas with predetermined colors, Dryer has clearly worked, unostentatiously, to get the edges of her rectangles and the paint's texture and directionality just right. It pays off, because each of those rectangles pushes against its neighbor to create the formal adhesion necessary to allow energy to circulate through the panel.

There is no predetermined look here. Each painting has been thought through on its own terms. There are all kinds of formats, and the paint application ranges from flat and uninflected to quietly lyrical, although without bravura. Particularly telling is Dryer's concern for the presentational aspect of each piece. Some hug the wall; others float off it on wooden supports, which might themselves be bare or else painted in such a way as to inflect subtly the painting's optical atmosphere. In *The Sentence*, for example, the black and white articulation is continued on the painting's sides but with the edge occurring at a different point, creating a different ratio of black to white. In *The Stripe*, one vertical panel leans away from the wall, the other toward it. There's no one ideal vantage point from which to view these paintings; they conceal and reveal different aspects through time. The same is true of the single-panel paintings: as you look toward the center of the blue rectangle which covers most of the surface of *Untitled*, it appears to create a vast distance, yet as the blue meets the edge of unpainted wood surrounding it like a frame, it seems instead to push out into the space in front of the surface. These formats may be mannerist, but they're not simply willful. The quirkiness of this work is really the result of the artist's discipline, even self-effacement (which here turns out to be something quite different from restraint). A debut this striking does not come along very often.

## II

For her third exhibition in New York (Mary Boone Gallery, 1990), Moria Dryer presented a group of paintings that was more subdued in effect than viewers familiar with her previous work might have expected. Dryer's work has always been marked by its deadpan wit, by a kind of playful perfectionism in the *framing* of its mordant arguments, suggesting the character of a visual aphorist. With two comparatively modest exceptions – *Picture Perfect II*, with its awkwardly scalloped edges, and *Old Vanity*, which sports a plaquelike steel "predella" – the paintings here eschewed the guying of pictorial formats at which Dryer is so adept. That only made it all the more obvious just how much she can do with paint. There is a plangent, emotional quality to these new works that is just as sharp, in its way, as the drier (no pun intended) effects she's mostly worked with until now. In contrast to the more obvious quirkiness of some past work, Dryer's new paintings are recklessly *comme il faut*.

This is hardly to say that Dryer has submissively bowed to the conventions. It's just that her play with them is more subtle, and in a way more disinterested. I don't think it would be correct to call Dryer a formalist, but all of her work is concerned with activities of formalization and their effects – or should I say their affects? Each element of each painting is, as it were, theatricalized, but now mostly to a rhetorically minimal degree, that is, just enough for this formalization-as-theatricalization to register as such – not so much as to make it become the meaning of the piece, just enough for it to insert a certain slippage or discrepancy into a meaning that lies elsewhere. Think of it this way: in the formalist painting of the 1960s and 1970s, the physical structure of a painting counted as a

proposition, and the way it was painted was to count as an exemplification of that proposition. In Dryer's work, on the other hand, the physical structure has become a presentational device that nonetheless may still count as a proposition, only now there is a discrepancy between the example (the way the thing is painted) and the proposition (the structure). (Readers of Paul de Man may notice an affinity here to what he called "the intentional structure of the Romantic image" in poetry.)

What I mean by citing 1970s formalism can be shown by mentally sidling an *Untitled* painting by Dryer of 1988 (Fig. 13) up to the notion of "hard-core painting" introduced by Joseph Masheck in a 1978 article now collected in his book *Historical Present*.[1] This was the idea of a "wall-like painting" that would retain composition, or at least "inflection or articulation," but not, "if possible, anything like traditional pictorial content," and in which "what is finally important is not so much that the surface be concretely hard as that it be apprehended as an intransigent plane," thus salvaging the minimalist demand for presence over illusion without sacrificing the historically endowed practice of painting. Now, Dryer's *Untitled*, which (like everything else in the exhibition) is painted directly onto a wood surface, seems to reflect some of Masheck's requirements, and it certainly goes out of its way to stress the hard, objective quality of its support by allowing the grain of the wood to show through. But the sultry bands of red and green casein she has painted onto this supposedly intransigent surface have actually soaked into it, rather than remaining on top of it, and therefore have completely invested the surface, have even (one might say) seduced it. What was intransigent at the macro level reveals itself as completely porous and receptive at the micro level, so that the wall-like surface is (without being effaced) made to give way to a

**Figure 13.** Moira Dryer, *Untitled*, 1988. Casein on wood, 46 × 48 in. Photo by Zindman/Fremont. (Courtesy of Jay Gorney Modern Art, New York)

tremulous space filled with gauzy folds of light. The painting is soft-core and hard-core all at once, and as the wavy bands of color, their edges blotting into one another, converse with the equally irregular curves of the wood grain, they seem to recall to painting that libidinal economy evoked by Masheck's appellation but strangely absent from most of the formalist work he'd applied it to a decade earlier.

81

# III

Two posthumous shows (at Jay Gorney Modern Art and in the Projects space at the Museum of Modern Art) remind us that Moira Dryer was an artist who combined pragmatic experimentalism with a deep concentration of feeling. Dryer promised to be one of the central artists of her – my – generation, thanks to her completely persuasive (because deeply intuitive) synthesis of two apparently incompatible strains within post-Abstract Expressionist painting: on the one hand the literalism of Robert Ryman's "investment" of the entirety of the painting object (edges, hardware, and so, along with the painted surface), and, on the other, the allusive, quasi-literary nature of Ross Bleckner's historicism. To do so, of course, she had to jettison central aspects of those artists' work as well: Ryman's "minimalism," his fundamentally dandyish preference for the least marked means to achieve a particular effect, or Bleckner's sanction of conventional representation with its concomitant potential for flat-out sentiment. She more than made up for it by what she added of her own: an eccentric theatricality, a whimsical fantastication of the quotidian, a piercing coloristic gravity.

Unemphatically masterful painter though she was, Dryer's work began well before the application of paint. Within the support itself, devices such as holes (*Random Fire*, 1991), grommets (*The Wall of Fear*, 1991), and scalloped edges (*Untitled*, 1992), and so forth affirm the object by attacking it. They irritate certain lovers of abstract painting the way my teenage niece's nose ring irritates her grandmother: "Why must you do that to such a pretty face?" The fact is that Dryer could never reconcile herself to the criteria of wholeness and unity, so dear to formalist aesthetics, that would cast an aura of false naturalness around the formal radiance she so resolutely pursued. For her, it seems, the ostension of artifice was the

true hinge between beauty and truth – or at least between beauty and wit.

Occasionally that wit could become scathing, as in *Random Fire*, a work produced during the Gulf War. It's a kind of diptych, whose larger part is a white and green field full of glarey hotspots and pierced by a multitude of bullet-sized holes. To the left of this, displayed on a music stand, lies the "score" for this performance, a green and white target motif. The contempt for violence expressed here takes on an even sadder undertone if you let the music stand remind you of how central metaphors of music, of talk, of sound in general always were in her work (think of titles like *Short Story*, 1987; *NBC Nightly News*, 1987; *Country and Western*, 1991). All of Dryer's best paintings possess a resonance, a vibratory amplification of some small motif, some private awareness of her own, that is projected and then internalized, as sound more easily than sight can be.

Two days after Dryer died I came across her card in my Rolodex. I had to – even while telling myself it was crazy – call her number one more time. Strangely, the answering machine in her studio was still working. I heard her voice one more time. But it's the richly timbred, strangely cool-warm voice of her paintings – answering machines too, mechanisms that uncannily respond to the questioning eye – that's still with me.

# THE RUSTLE OF
# PAINTING

Jacques Lacan, David Row,
Brenda Zlamany

## I

Having been asked to contribute to a discussion on "Lacan and
Visual Art," my first impulse was to say that the subject I can make
some contribution to is the reverse: "Visual Art and Lacan."* Un-
fortunately, I suspect mine to be a much smaller subject. "Lacan
and Visual Art" is a big subject, not just because it is very clear that
Lacan personally had an intense interest in visual art, in painting,
but because his discourse is hungry for images – even though it is
also, as Martin Jay (among others) has recently pointed out, an
intensely anti-ocularcentric one.[1] Any reader of Lacan immediately
notices that his is not an "abstract" discourse but one that forwards
itself by means of images, pictures, diagrams, and so forth. It's not
a case of there being, here, some concepts in need of images and,
there, some images in need of concepts. Art may already have more
concepts than it knows what to do with.

*This chapter is a revised version of an essay originally published in *La-
canian Ink* 9, Winter 1995.

# II

In looking over my own writings to see if and how I had cited Jacques Lacan, I noticed that there was a single case of an artist I had written about twice, in both cases citing Lacan. The artist is David Row, and so I would like to begin by discussing his work. In interpreting his three-panel paintings of 1991, in which fragments of arcs butt up against one another as elements in intensely chromatic fields, I had borrowed from the literary critic René Girard the notion of the narrative structure called "triangular desire": the desire of one character for another is always mediated by the real or imagined desire of a third.[2] "In these paintings," I wrote, "each panel appears to seek its completion, to make good its lack, by joining itself to the fragmentation of another; but (the words are Jacques Lacan's) 'what the one lacks is not what is hidden in the other,' and to the extent that a stable structure is attained, it is only because of the troubling presence of a third panel, which is also attempting to use another to complete itself in a wholly different way."[3] So in this instance my citation of Lacan is secondary, both in the sense that I cite him to clarify a notion suggested by quite another source, but also in the sense that, if I remember correctly, this particular quotation derived from my reading, not the as yet untranslated seminar which is its source, but rather from the work of Slavoj Žižek in which I found it. In a broader discussion, I might have drawn a connection between Girard's triangle and the triadic oedipal dynamic subsequent to the introjection of the paternal prohibition, what Lacan punningly called "le non du père." But that would have been to broach the distinction between the "imaginary" and the "symbolic" – not something I would undertake lightly.

85

# III

A more direct (though still parenthetical) use of Lacan occurs in my review of Row's 1994 exhibition, and it is one that also retrospectively illuminates what I had been thinking of three years previously. The more recent paintings show a marked shift in Row's work. It is clear that, as I wrote, "color, while far from an afterthought, is a recessive element in the new paintings, giving way to more broadly structural – or better, *logical* – concerns."[4] Here the arcs of the earlier work have yoked themselves together to form ovals – the numeral zero, in fact. As I pointed out, zero is what the logician Gottlob Frege called "the number which belongs to the concept 'not identical with itself.' "[5] Lacan himself writes that "what specifies the scopic field and engenders the satisfaction proper to it is the fact that, for structural reasons, the fall of the subject always remains unperceived, for it is reduced to zero."[6] Perhaps this very non–self-identity is what called for the doubling of the zero in each painting (Fig. 14). The mathematical use of the symbol zero is surely, as Brian Rotman calls it, "a self-absenting move," but for that very reason it continues to refer to a subject capable of this self-removal. Whereas Row's previous three-panel paintings, as I pointed out, "seemed to designate a dispersed and non-totalized subjectivity, his conscription of this representational abstraction – this figure which is not one – and particularly its specular doubling through the abutment of panels, seems to invoke the empty specularity of the (Lacanian) Imaginary ego yoking its fragmentary impulses into a closed, self-reflecting totality around a primordial lack."[7] I was somewhat disturbed by this apparent assumption of what, in his famous essay on the "Mirror Stage," Lacan had referred to as "a form of totality that I shall call orthopaedic . . . the armor of an alienating identity, which will mark with its

**Figure 14.** David Row, *No Data*, 1993. Oil and wax on canvas, 50 × 96 in. (Courtesy of the artist)

rigid structure the subject's entire mental development,"[8] especially since I had identified elatedly with the assumption of a fragmented, untotalized subjectivity traversed by uncontrolled flows of desire I had discovered in the 1991 paintings. Why this newly closed, totalized, rigorous, and monumental identity?

## IV

At this question, a cut – to a rather different set of ovals, and a somewhat different set of problems for painting. An abstract painting can never exactly be a diagram, but its essential problems have to do with traversals of a surface. They have to do with the lateral. A portrait is something else: it has do with problems in depth. It is a negotiation with what is in front and what is behind. Portraiture

occupies an unusual position in representational painting, neither occupied, as history and genre are, by narrative and morals, nor, like the "genres without a subject," landscape and still-life, pointing in the direction of formalism and abstraction. The portrait's burden is the specificity of the concrete encounter, something that cannot completely be situated or generalized through either narrative or formalization. Nonetheless, I am going to approach it by means of anecdote.

# V

Brenda Zlamany has been painting a number of portraits of bald men. Here we may have the right to see some near relation to Row's ciphers of closed, totalized, rigid, and monumentalized subjectivity: the male ego, in short. But the portrait is an encounter with this ego, not a mapping of it. My anecdote is this. I was in the studio, looking at these portraits. I pointed out that in all but one, the subject faces the viewer – if you will, the painter – directly. Only in one, that of Christian Leigh (significantly, a curator rather than an artist), does the subject turn away, avoiding eye contact. The painter explained that this was the first of the portraits. "I wasn't ready to paint the eyes yet. It took me a while to master the gaze." As we continued to look at the paintings, she continued to expatiate on how she saw the portraits as being portraits of the gaze – the idea that the gaze was really what these paintings are about. Then she began to tell me that the last visitor to her studio had been a Lacanian analyst, and that this person had proposed instead that the paintings' true subject was death. Well, analysts are always wrong about painting, I reminded her. They don't know how to *look*, it's not their job. Clearly, any chain of associations will always come around to death sooner or later, so you can never really be

wrong saying something is about death, and a bald head will always to some degree indicate what a poet once called "the skull beneath the skin"; nonetheless, to say these paintings were specifically and particularly about death seemed beside the point. "Do you want to hear *my* misinterpretation of your paintings?" I asked. "It's true that these are not what you say they're about – they're not about the gaze at all. As I look at them as a group, what begins to disturb me are the ears. The ears are the only parts of these paintings that, from an academic viewpoint, are doubtfully rendered. The reason is clearly not a lack of skill. The reason is that the ears are the symbolic rather than realistic portion of the portraits. The ears are where things get 'charged' beyond the capacity of 'straight' rendition to capture what is going on. These men are not looking at you so much as they are listening to you – listening to hear between the words, through your actions, to hear what you're *thinking*. They want to figure out what you want with them, what you want with their images." My continued confidence in this assertion is such that I am even willing to show Zlamany's portrait of Leonardo Drew, which is exceptional in the series because it seems uninvolved with this problem of the ear – this subject is shown as free of an anxiety that affects the others.

# VI

I was very proud of my interpretation of the portraits as being portraits of listening, not of the gaze. I also began to reflect that in fact, logically, the gaze of the one portrayed can never reach the painter – nor need she ever apprehend his gaze – because there is always an intervening apparatus; whether it is a camera or an easel and canvas makes no difference. She looks at him in order to look harder somewhere else, at the canvas on which she will paint. Some

further reading of Lacan, however, led me to realize that my interpretation was not exactly wrong but was incomplete. The gaze exists in the form of listening. In analyzing a passage from Sartre's *Being and Nothingness*, Lacan remarks that

> if you turn to Sartre's own text, you will see that, far from speaking of the emergence of this gaze as something that concerns the organ of sight, he refers to the sound of rustling leaves, suddenly heard while out hunting, to a footstep heard in a corridor. And when are these sounds heard? At the moment when he has presented himself in the action of looking through a keyhole. A gaze surprises him in the function of voyeur, disturbs him, overwhelms him, and reduces him to a feeling of shame.[9]

So one apprehends the gaze of the other by means of the ear. Doesn't this leave us with the conclusion that these paintings are about the gaze after all – but not the gaze of the sitter, the subject of the portrait. The paintings are about the gaze of the painter as marked by the ear of the sitter.

# VII

My next image is another painting by Brenda Zlamany, *Cristina #2* (Fig. 15). Here the subject is as clearly female as those of the others were clearly male, and this is just as clearly marked by the roundness of an oval – there the bald head, here the pregnant belly. And another oval as well: if the painting is hung at a normal level, our gaze is met not by the woman's eye but rather by her nipple. In fact, our impression might be that her gaze occurs through the nipple, that she looks at us with her nipple. Further contemplation of the painting reveals this as a ruse, however. The nipple is, so to speak, a fetish this woman projects as bait for our gaze, but her face

90

**Figure 15.** Brenda Zlamany, *Cristina #2*, 1994. Oil on panel. (Courtesy of the artist)

reveals the vulnerability of one who imagines that her subterfuge will be easily discovered. She is studying the viewer, as it were, from behind the nipple. And what about the ear? She is not listening, as the men were. Her ears are hidden, she has her own intervening apparatus. The earrings she wears are by far the brightest spots on

this canvas, and, like the breast, they serve the function of displacing attention from her eyes, which would otherwise have been the points of brightest light. Where the men revealed the gaze of the painter through the aggressiveness of their retaliatory listening, this woman reveals it through her propitiatory offering of certain lures. In this we see, not as it might appear, a representation of a difference between the genders, but a difference in identification between portraitist and subject. In one of his most astute passages on painting, Lacan has this to say:

> It might be thought at first that, like the actor, the painter wishes to be looked at. I do not think so. I think that there is a relation with the gaze of the spectator, but that it is more complex. The painter gives something to the person who must stand in front of his painting which, in part, at least, of the painting, might be summed up thus – *You want something to see? Well, take a look at this!* He gives something for the eye to feed on, but he invites the person to whom this picture is presented to lay down his gaze there as one lays down one's weapons. This is the pacifying, Apollonian effect of painting. Something is given not so much to the gaze as to the eye, something that involves the abandonment, the *laying down*, of the gaze.[10]

The woman who posed for this painting is posed as she is because she is doing what an artist does. The men who posed for the portraits, although for the most part they really are artists, are posed as they are because they are in competition with the artist who painted them. Perhaps she has used her art to transform them into critics – an artist's revenge on her fellow artists. (This point leads me to recall with satisfaction my prediction, when Zlamany was just beginning to venture into portraiture, that it could make her art "even more subtle, seductive, and cruel.")[11] In any case, we "lay down our gaze" on the artist's self-portrait as her own sister.

# VIII

But although it would give me great pleasure to conclude in the contemplation of that remarkable image, the questions I had about David Row's painting have continued to vex me. Seen again in the orange afterglow of that pregnant oval, Row's ovals begin to look a little different. Perhaps I was being reductive – too much like a psychoanalyst – in my understanding of Row's recent work. Yes, those enclosed ellipses display a new reserve in comparison to the earlier paintings. But looking more closely at the internal logic of the diptychs, I can see that the curved forms should rather be seen in dialogue with the grids that underlie and traverse them. In that case the zeros begin to take on an aspect that is more vulnerable, egglike, sheltering what they encircle. The jubilation I felt on seeing Row's 1991 paintings begins to sound suspiciously like that of the child recognizing its reflection in the mirror – even though what I thought I saw reflected there was a postspecular subjectivity. My misgivings about the recent diptychs might have had something to do with their refusal to project this subjectivity, their way not of denying it but of holding it in reserve, protecting it. I ended my second review of David Row by noting a "choice [that] throws us back upon a judgement of taste such as resists any formalization," and I sense that I am ending there once again.[12] What I had forgotten in my earlier interpretation of Row's recent work is that, after all, abstraction does operate in depth as well as laterally, and that if there are two "figures" inscribed on these paintings, there is also the triangulation with a third figure, namely the person who is looking. Row's earlier paintings had been structured with multiple points of access and egress, granting the viewer a pleasurable mobility, whereas the new ones implied a stereoptic fixity of viewpoint that could be uncomfortable. Yet, as a friend of mine wisely ob-

served in discussing the "pair objects" of the sculptor Roni Horn, "To experience the same thing twice puts the first under erasure and makes the second redundant. It creates a preclusion of hierarchy."[13] This doubling faces us with a choice, and in the most extreme sense possible: a choice with no criteria to fall back on. That is why these difficult, unrelenting paintings keep sending me back to the effort of concentrated receptivity – of that *listening* rather than looking which is the fated role of the critic.

# II

# Italian Interlude

# 11

# W DE PISIS

Italy's artists seem more drawn than others to attempting to change their destinies by changing their names.* Andrea de Chirico may have changed his to Alberto Savinio in order to avoid comparison with his older brother, but how did Luigi Filippo Tibertelli, born in 1896, become Filippo de Pisis? More revealing yet might be to trace the process by which de Pisis (again, like Savinio) transformed himself from a writer who dabbled in painting to a painter who also wrote. That's a process I'm in no position to reconstruct.[1] We do know that from around 1916 on the young de Pisis threw himself wholeheartedly into the cultural life not only of his native Ferrara, at that time home to the de Chirico brothers, but of Europe. In September of that year, for instance, Savinio sent a message through Tristan Tzara to de Pisis and several others, "Demandez-leur de piloter 'Dada' en Italie; ils se mettront à l'oeuvre avec beaucoup d'entrain." Indeed a longstanding correspondence did spring up between Tzara and de Pisis, a fact which is all the more fascinating since Dada left no more apparent trace in de Pisis's mature work

*This chapter is a version of an essay originally published in *Arts Magazine*, January 1988.

than did the Futurism with which he also seems to have been flirting at the time. And yet de Pisis chose these connections with the more violent and subversive manifestations of modernism in order to place the apparent intimism and even conservatism of his work within a broader context. In 1938 he would write that "the surrealists overlooked or tried to overlook an aspect of my painting which is nonetheless closely connected with their aesthetic; only the technique puts it at a distance."

If Giorgio de Chirico found it necessary to specify, in a 1926 catalogue presentation, that "Filippo de Pisis n'est pas un naïf," it is because this error, although fundamental, was also in some way invited by the work. The second, and one might say diametrically opposed criticism from which de Pisis has at times had to be defended – indeed, from which on occasion he had to defend himself – is that of facility. What gives rise to both these impressions is a certain sense of disproportion between the subject and its painterly treatment, even a kind of disjunction. The subjects tend to be as traditional, and often as neutral, as possible: landscapes and cityscapes, portraits, and above all still life. But they are painted in a manner at once emphatic and elusive, giving rise to the impression of an emotional urgency pushed beyond the technical means required to express it (naïveté), or of technique cultivated beyond any communicative necessity (facility). And yet it is precisely in the orbit of the indecision between these two contradictory forces that the fascination of de Pisis's paintings is found. Their subject is sensuality and disappointment; the object slips away at the very moment it is caressed by the gaze. De Pisis's lyricism consists in this: each brushstroke is a passage toward a form that is elsewhere. Thus, one's first impression of de Pisis's work may well be of something nebulous and evasive – and yet he shows us that only in the act of perception is the thing that evades us evoked at all. De Pisis's is

sometimes referred to as a "nervous" brushstroke. That is not exactly accurate. Rather it is his eye that is nervous, an eye which, in contrast to the unflinching gaze of a Cézanne or Matisse, is so sensible of the beauty of its object that it is forced to turn away. It is here that the brave extremism of de Pisis's sensibility finally lets us down.

Of all the Italian painters of this century, de Pisis, who for many years lived in Paris, was undoubtedly the one who felt most deeply the French tradition in painting, not just from Manet and the Impressionists through Matisse and Fauvism, but back through Delacroix into the Baroque. This too can give rise to misunderstanding if it is allowed to obscure profound differences. Loredana Parmesani perfectly encapsulates the relation of de Pisis to Impressionism: "Where the Impressionist painters were seduced by the atmosphere of light, de Pisis rereads the objects of the world in a cultural light: a flower is still an allegory, a book is still knowledge, a table is still a story." One might say that de Pisis was able to assimilate French technique, French light, to the extent that he recognized it as a way of reclaiming the Venetian tradition that culminated in Guardi, in which a profound attention to the phenomenology of seeing was never isolated from the manifestation of the sign. In this sense de Pisis the writer would always remain a "literary" painter.

A recent exhibition of de Pisis, at the Galleria Gian Ferrari in Milan, was organized specifically around a selection of works that are homages to or citations of the work of other painters. (There was also, simultaneously, a second de Pisis exhibition at Galleria Tega.) This was a brilliant idea; whereas for most artists such a show might consist mainly of curiosities, with de Pisis it takes us to the heart of his activity. De Pisis had the habit of inscribing many of these paintings with the name of the artist to whom they are dedicated. But not just the name; usually it would be preceded

**Figure 16.** Filippo de Pisis, *Natura Morta con bottiglia e conchiglia*, 1943. Oil on Masonite, 57 × 57 cm. (Courtesy of Paolo Baldacci Gallery, New York)

by the symbol W, short for "Viva!": there are paintings, not all of them at Gian Ferrari, on which we can read W MORANDI, W TINTORETTO, W KOKOSCHKA, W TOSI, W CARRÀ, W SAVINIO, among others (Fig. 16). This gesture, so often repeated, deserves attention in itself. It is capable of revealing more about what art meant for de Pisis than one might expect from so insouciant an indication. First, the simple fact that it *is* an inscription shows something about

his attitude toward the "purity" of the pictorial. Not that we can attribute this diffidence to any want of pictorial skill; on the evidence of this exhibition de Pisis was uncannily able to pay rich and explicit pictorial homage to other artists without violating the canons of his own style. And yet what can only have been an overflowing generosity of impulse impels him beyond that, to add the inscription, so it seems, out of sheer seduction by the idea of homage. De Pisis himself wrote, "My elective state of soul is poorly adapted to painting, unconfined by it. It's too ecstatic, too simplistic, it goes too far beyond these dear things with their varied and beautiful colors, rising to a sphere of colorlessness, even of bodilessness." It is precisely this tendency to slip into the incorporeal that the inscription literalizes in de Pisis's paintings. And yet before we allow ourselves to become too intoxicated with the ethereal, let's remember that the symbol W, far from any spiritualizing associations, has a distinctly proletarian flavor, being above all the mark of the urban graffitist. It is most often encountered on walls, followed by the name of a sports team or perhaps a political leader: W JUVENTUS, or once upon a time, W TOGLIATTI. So, paradoxically, this same gesture of enthusiasm desacralizes its object, rendering both it and the painting that contains it familiar and down to earth. De Pisis was no spiritualist but a materialist, though undoubtedly a Lucretian one constantly aware of the vibratory "atomic" life of things in the process of adhering and dispersing beneath the apparent solidity of appearances. I have spoken of de Pisis's manifold connections to the art of the past; more difficult though no less important to speak of is his connection to the art that came after him. For now, I will only suggest that if de Pisis has any true successor, he can be found in an American who settled in Italy the year after de Pisis's death in 1956. Cy Twombly's paint-

ings evoke the same sensuality, the same love of sparseness, the same classical culture, the same silvery light. The two artists share the same love of inscription, too: I can almost imagine Twombly writing, as de Pisis did on a remarkable still life in the Tega show, W LA BELLA PITTURA – "Long live beautiful painting."

# — 12 —

# ROTELLASCOPE

## I

"Décollage," the invention with which Mimmo Rotella's career is most readily identified, may be thought of, because of its stripping bare of hidden layers of imagery, as a kind of subjective archaeology of a determinate cultural locus.* Born in 1918 in Catanzaro (Calabria), Rotella's career as an artist really began after he settled in Rome after World War II and began painting in a style that apparently included elements of both geometrical and gestural abstraction.[1] In 1951 he found himself in Kansas City as a Fulbright Scholar, and the next year he executed a large mural for the university before his return to Rome the next summer. There, in 1953, Rotella produced his first décollages, his term for what he considers the reverse of collage, since it involves not affixing elements but tearing them away. Initially, in other words, the method was an extension of painterly gesture. Rotella found his source material in

---

*This chapter is a revised version of essays originally published in *Mimmo Rotella "Sovrapitture 1987"* (Milan: Studio Marconi, 1988), and *Flash Art International*, March–April 1988.

the ubiquitous billboard posters (often for the latest movies) that are a familiar sight on the walls of any Italian city. As new posters are issued, they are simply glued on top of the ones already in place, so innumerable layers of paper can eventually build up. Rotella simply began tearing these down from the walls of Rome, taking them to his studio, and, without knowing what the hidden layers of poster would reveal, he removed layer after layer in order to make new abstract "paintings" out of the intersection of chance and will.

Understanding Rotella's most recent work calls for a certain archaeology of our own; original as they are, his *Sovrapitture* (Overpaintings) allow many layers of his own history to show through, integrating them with a new, and for him unprecedented, use of paint (Fig. 17). Before undertaking such an excavation, however, I should say something about how I came to do so, given that Rotella and I are separated by two generations and one ocean – and given, above all, the near impossibility of seeing Rotella's work in New York. At first, for me, Rotella was a footnote to art history, one of the names that came up as part of the European wave of Pop art to which we Americans have never paid much mind. But the occasional reproduction of his work – one in Edward Lucie-Smith's *Art Now* made a particularly strong impression on me – suggested the possibility of something a bit too strong, a bit too personal to be riding anyone else's wave. My first direct experience of Rotella's work finally came through a small show of his works from the early 1960s at the short-lived Malinda Wyatt Gallery in the East Village. The pieces there were generally of small dimension, and that must be why my first impression was of an artist of delicate sensibility. I thought of Kurt Schwitters, with his luminous collages made of scraps carefully gathered from the streets and arranged so that each could reveal its own particular tone and weight in a composition that thereby redeemed it for the ephemeral eternity of the work of

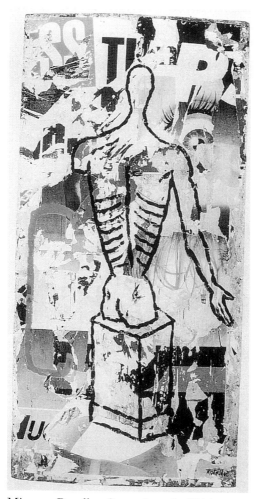

**Figure 17.** Mimmo Rotella, *Omaggio a de Chirico*, 1989. Décollage, 300 × 150 cm. (Courtesy of Marisa del Re Gallery, New York)

art; I even thought of the boxes and collages of Joseph Cornell, those little universes of melancholy and desire. Only later was I to discover that this was just half the story – and not the half that should have been most prominent. For that I had to wait until I went to Italy, where I was finally able to see more of Rotella's work,

to find more detailed information about the course of his career, and best of all, to meet this remarkable artist himself. With all the pieces in place, I began to understand that Rotella is first of all a risk-taker, a daredevil – no wonder that for the catalogue of his 1987 exhibition with Galerie Lavignes-Bastille he had himself photographed wearing a World War I aviator's getup! He is, in short, the kind of fatalist who rushes in where angels fear to tread. I had been mistaken in seeing the delicacy in Rotella's work before seeing its violence, its sweetness before its sarcasm, the resignation before the protest, the silence before the joyful noise. And yet I may not have been so wrong as all that, or not as wrong as I would have been seeing *only* the noise, the protest, the sarcasm, the violence. Rotella himself has written,

> Somehow, tearing down posters from the walls was my only revenge, my only possible protest against a society that had lost its taste for mutability and for the incredible changes that were going on. . . . If I had had Samson's strength, I would have collaged Piazza di Spagna and its soft, tender autumnal colors together with the sunset-red squares of the Janiculum.

The man's contradictions are all there.

If one thing is clear, it is that, for all the coherence and consistency of his development, Rotella's "identity" as an artist has never been more than provisional. Leonardo Sinisgalli could reasonably string together in one sentence "Burri with sponges and surgical stitchings, Fontana with holes, Nando with nails, and Rotella with wastepaper." It only made sense to see Rotella's early décollages, with what seemed to be their sovereign indifference to the imagery of the posters that were obliterated in them (Fig. 18), as sharing in Alberto Burri's and Lucio Fontana's magisterial demonstrations in the handling of materials as space, the space of paint-

**Figure 18.** Mimmo Rotella, *Dall'alto*, 1959. Lacerated posters on canvas (décollage), 93½ × 67 in. (Courtesy of Salvatore Ala Gallery, New York)

ing but no longer of the picture. Sinisgalli was not incorrect, yet Rotella's search would soon take him elsewhere, and looking back to the décollages of 1954–5 we can no longer ignore the tacit affinity with the image which is already contained there; and Rotella, as the decade went on, was destined to reawaken the image out of its sleep in the rarefaction of abstract space. Thus he allowed him-

self to be taken up by the French Nouveaux Réalistes, with whom (as before with Burri and Fontana) he seemed to have so much in common, so that in 1964 he would even move to Paris. But can we still believe that, as Pierre Restany wrote in 1961, "within the lacerated poster, there is no doubt, there is the completely sociological reality, the product of man's activity, the commerce of the world, which Rotella submits to our attention"? What strikes us today about Rotella's décollages of the 1960s is not so much the "sociology" of their materials (for that we can refer more usefully to Walker Evans's photographs of movie posters in the 1930s). What counts is the poetics by means of which those materials are chosen and transformed, the game against chance (not Rauschenberg's submission to chance) which stakes the claim to meaning on what the artist has not yet seen. What seems important is not what is "submitted to our attention," the banally Duchampian gesture of placing something in evidence, but the artist's desperate faith that what is already in evidence can be forced to reveal more than it has been meant to by the specificity of his intervention.

One of the great questions for painting has always been that of its relation to the wall that supports it: Does the painting efface the wall or reveal it, open it up or underscore its closure? Advertising posters like the ones Rotella used and still uses have a peculiar relationship to the walls on which they appear. They open the wall up, but, unlike a window, they reveal nothing of the life going on behind the wall; rather they place that life at an even greater distance, projecting the stroller's gaze into some unreachable elsewhere. The factitious "reality" which a Rauschenberg or, above all a Warhol, could accept with equanimity could never be passively accepted by Rotella; his work with lacerated posters becomes instead a kind of game, one might say an agon, in which the opponent

is none other than the indifference of that urban mass culture that so importunately solicits his desire, and in which his first move must always be to allow himself to be seduced.

Whatever I have been able to learn about what can by now be called Rotella's "classic" period of the early 1960s, the period that is already fixed in the history books, the first thing I learned about the Rotella of the 1980s is that he has not allowed himself to become a historical figure, a monument to his own past, but that he has continued to change and, what is more important, to surprise. I will pass over the phase, beginning in the mid-1960s, when Rotella became most interested in working directly with various means of mechanical reproduction. I'll skip instead directly to 1980, the year in which Rotella ended his long sojourn and moved to Milan, and in which he created his great series *Coperture*, those "geometrical abstractions" (once more recalling the tradition of Burri and Fontana) in which the artist made use of the colored sheets used to cover old billboards while waiting for new posters to be mounted. Here Rotella effected a nearly complete suppression of the image, which gave evidence of its presence, of its energy, only at the margins; but in doing so the broad areas of uninflected color were made to express all the more powerfully their own *negative* energy; their surfaces remained troubled, an effect of the unevenness with which the covering sheets had been applied, leaving them full of creases. If the *Coperture* represent Rotella's most potent censure of the image, despite their renunciation of the more obvious gestural violence of tearing, surely his most abject submission to the image must be in the series of paintings (for the first time in some thirty years – in acrylic on canvas) based on movie posters, shown in 1984. In these, like some Professor Unrat infatuated with his Blue Angel, the cinema, Rotella threw all caution to the wind – and with it every

established notion of good taste and painterly quality – to turn the cinematic image not into a precise reproduction but into a kind of graph of libidinal pulsions.

One might say, then, that the *Coperture* and the acrylic paintings represent the extreme degrees to which Rotella has so far allowed his love affair with the mass-mediated image to take him – and that these contradictory impulses were already working themselves out in the décollages of the 1950s and 1960s. In that case we could go farther and say that his latest works, the *Sovrapitture*, express a new balance of forces. In these, as with the *Coperture*, the artist begins, not with the layered posters, but with the gray sheet-metal support onto which they are commonly glued. By salvaging this support, he has allowed himself to tear and scrape back much farther than he was able to when working solely with the paper; at times there is more gray metal than colored paper in the final result, and naturally this means that there can be fewer legible words or images left from the posters. Even where he has not reduced the paper to scraps, Rotella has retained broad areas of solid color much more often than he has retained recognizable images. But images there are; the artist has painted them in. What he has painted are, most often, "artless" scrawls copied from the graffiti he has seen on walls along with the posters he uses. Their positioning seems suggested by the shapes and textures Rotella has allowed to remain on the paper-and-metal surface, but in oblique ways. We all know about Leonardo's recommendation that the painter let his eye wander freely over a wall in order that the random patterns stained on it might suggest new and dramatic forms; perhaps one needs to have spent some time in Milan to come to see the *Last Supper* as simply a fresco that wants to return to the state of those poor patches of color and texture which, for all we know, may have aided its creator in discovering its form. In any case, it is this sense of simultaneous emer-

gence and dissolution, the sense of things wanting both to find their forms and to lose them, that one feels on viewing Rotella's newest works. This is so, I might add, more because of his painting than because of the ground on which he has painted, suggestively scabrous as the latter might be. And in his painted signs and images Rotella should not be thought of as reproducing or imitating his sources, but as using them, almost indifferently, as pretexts for achieving what I can only call a strident intimacy he could not get any other way. Even when we know what the images mean, even when it was clear enough why Rotella might have chosen just those ones – as in the mourning figure, the skull, and the inscription that gives *Biopsia* its title – they remain mysterious without seeming arbitrary. They've been fated into place.

For some thirty-five years Rotella has remained true to the tradition of formal innovation in criticizing and overturning the postulates on which previous work was based. At the same time he has played out the antiformalist intuition that art is nothing other than the record of an individual's confrontation with his own history and condition, whether or not the results seem of any use according to some notion of the progress of art. Rotella's greatest strength may be his uncanny ability to become less refined all the time. His new works go deeper than ever into the unspoken. I can't tell you whether they're beautiful or ugly, but only that they are haunted by death and completely open to life. I won't call them a fulfillment, because that might imply that something had come to an end.

## II

The particular currency of Mimmo Rotella's work is as an example of a career carried out in its entirety as a confrontation with the notion of the work of art in the age of mechanical reproduction, a

confrontation initiated long before Walter Benjamin's title ever became part of the critical *koiné* – and therefore long before it became an occasion for academic exercises rather than an existential threat to be answered with a desperate imaginative thrust. Perhaps that is why Rotella's return to painting after thirty years makes perfect sense; for him, I imagine, the brush is less a device that allows for distancing and a refinement of the hand's movement than one that allows for a more complete physical engagement, a kind of sword to be used in his duel against the images that have bedeviled him for so long. If an artist is obstinately set on painting, postmodernist orthodoxy enjoins him at least to have the good manners to paint within quotation marks; Rotella shows his independence by painting *in italics*.

In his interview with Giorgio Verzotti, Rotella himself outlines the development of his work; I needn't rehearse that history here. But I would like to speculate on the significance of what has been both the territory and the material of that history. Perhaps it is not merely a coincidence that in Vittorio de Sica's *Ladri di Biciclette*, the film that most powerfully represents Rome in the immediate postwar era (and we know that Rotella lived that reality), the job which promises to change the father's fortunes is precisely that of pasting up advertising posters. The poster itself can be seen as representing the flow of new images into a city slowly and painfully attempting to reconstruct itself, the first sign of that pervasive though never total "Americanization" of the economic and cultural life of Italy that would eventually culminate in the economic boom of the early 1960s, an era whose most typical artistic expression may be precisely the décollages of Mimmo Rotella. But in his first décollages, those of the mid-1950s, which were still in the area of the *informale*, it was just this sense of the excavation and reconstruction of a ruined urban reality that was at stake. The posters were

reduced to mere raw material, a kind of visual rubbish, and it was out of this debris that an image might be reconstructed, an image both purely abstract and fundamentally pictorial, and therefore the prospective image of a merely virtual space, a space for the future.

In the décollages from the end of the 1950s through the early 1960s the poster surface presents itself under a double identity: as a repository of the signs and traces of quotidian reality in all its aspects, but also as the simulacrum which veils and displaces that reality. Rotella, tearing his way through that surface to reveal, not depth, but a plurality of surfaces, unleashes the phantasmagoric images of a society whose foundations are rendered insecure by the very speed with which its superstructure is being constructed. The sense of archival density, a surplus of information awaiting retrieval, is further intensified in the *Coperture* or *Blanks*, of 1980, whose apparent neutrality reveals itself as the state of tension between the explosive pressure of the "contained" or repressed images to break out and the implosive energy holding space clear for the expected inscription of new information.

It is precisely this inscription that takes place in Rotella's most recent work. The painted images, however, are not in the first instance an expression of personal sensibility, but may be considered (paradoxically, given the fact that they are an addition to the "found" surface of the décollaged posters on which Rotella paints) a further excavation into hidden layers of the collective image repertoire, since they are selected from graffiti the artist has actually seen on the street. Rotella orchestrates an encounter between these two registers, one socially produced to impinge on individual desires, the other individually produced but reflecting collective anxieties, and shows that they cannot be integrated, only held in conflict. Perceptually, this results in a gap between sensation and sense, between creation and the allegorization of creation, a gap in

which a kind of combustion of meaning can take place. Thus, if the *Coperture* represent a moment of fragile equilibrium in Rotella's work, the recent paintings on fragmented posters on sheet metal constitute a decisive break in that equilibrium, a moment of open contradiction out of which a new but unpredictable situation is liable to emerge. It is usually said that the idea of the avant-garde necessarily implies a belief in progress. I would argue instead that avant-garde art is that which measures itself against the historical particularity of its present rather than against the values represented by the ennobled and ennobling art of the past. In this sense, Rotella remains part of the perennial avant-garde.

# 13

# MICHELANGELO PISTOLETTO

## Mirrors to Monuments

The key image for the interpretation of the work of Michelangelo Pistoletto has always been that of the mirror.* At this stage in his career, however, we should be able to see that for the artist the mirror has always served more as a means than an end. As in Cocteau's *Orphée*, where mirrors are the means of passage from the realm of the living to that of the dead, the mirror has been less a window for Pistoletto than a door, and it has been the means of passage between, among other things, the world of painting and that of sculpture. We rarely remember that Pistoletto began as a painter, influenced above all, as he himself has said, by the works of Francis Bacon – though his first important commentator, Luigi Carluccio, cited Dubuffet as a source as well – and that his first use of the mirror was not as part of a work of art but as a tool in the process of art making. Like any traditional painter, he used a mirror in order to take himself as the subject of his work – in order, that is to make self-portraits.

So Pistoletto began his career as a painter; and as a painter his

*This chapter is a revised version of an essay originally published in *Sculpture*, July–August 1992.

subject was psychological. "The first reflective painting I made was one that was painted black, on which I'd laid half an inch of varnish. I realized that on this very shiny black surface I could depict my face by using the reflection in the painting itself. From then on I stopped looking in a mirror, because I could see myself directly in the painting and reproduce myself there."[1] It was not long, however, before Pistoletto began using actual metal mirrors to paint on – something Brunelleschi is said to have done in the fifteenth century – and then, giving up altogether the subjectivity implicit in the act of painting, began transferring photographic images to his mirrors (Fig. 19). These mirror pictures produce a peculiar effect, one that has not been much remarked in the criticism but which has a certain bearing on the question of these works' relation to sculpture on the one hand and painting on the other. A conventional topos in the *paragone* of the two mediums has been the fact that sculpture enables its viewer to move about the figure and see it from all sides, whereas painting can only depict a figure from a single viewpoint; we only see one side of it. To circumvent this limitation, painters would depict mirrors in order to provide a second view of the figure. Of course in Pistoletto's mirrors, we see the depicted figures from only one side, just as in painting; but when we see ourselves in the mirror, we appear to be on the other side of the represented figures, and we see ourselves moving around them as we move before the mirror. In the resultant mingling of the real world and the fictive one, we are given an image of ourselves as engaged in a specifically sculptural mode of perception, though this is through pictorial means. The mirror is the threshold, here, between mutable and frozen realities, that is, between life and art, reality and fiction. In terms of Pistoletto's development (but in striking contrast to any conventional iconology of the mirror, which is always taken to suggest narcissism and self-regard), it is the means of passage between

**Figure 19.** Michelangelo Pistoletto, *Untitled (Mirror Painting)*, 1962–87. Mixed media, 98½ × 49¼ × 1 in. (Courtesy of Jay Gorney Modern Art, New York; photograph © 1989 by Ken Schles)

the psychological and the social. We can also cite the interpretation of an art historical precedent of which Pistoletto was probably unaware:

> An actual framed XVIIth-century Dutch or German mirror is in the Museum of Fine Arts in Boston. At the bottom of the mirror, there is a painted *Vanitas* still life – a composition with books

**117**

and a skull, symbols of transience. Anyone looking into the mirror could see his own reflection, accompanied, as it were, by the symbols of *Vanitas*. But his own reflection was itself fleeting and disappeared when he moved out of range of the mirror. In which case what remained then, paradoxically enough, is the *Vanitas* painted on the glass, as if to show that the symbols of the ephemeral are lasting, while reality is transitory and devoid of any imperishable existence.[2]

The next major additions to Pistoletto's repertoire, the *oggetti in meno*, the "minus objects" of 1965–6, are more difficult to interpret, in many ways, than the mirrors. It is possible to see them as simply taking up the thematic of the Duchampian readymade (and more particularly the assisted readymade). They are "minus objects" in the sense of everyday things that have been subtracted from everyday reality, promoted to the special status of art objects. But I suspect this would be a simplification. Pistoletto has never seemed very interested in or impressed by the power of art as an institution; his interests are far more theatrical than didactic. He would rather animate a situation than illustrate or demonstrate a thesis. Although his works as a group can be considered to constitute a set of "logical operations on a set of cultural terms," as academically respectable postmodern work in an Anglo-American cultural setting is supposed to, this may be precisely in order to be as "eclectic" as possible, that is, in order to define as many distinct positions to dramatically enact as possible.[3] And although these works clearly take Pistoletto farther into the sculptural mode than the mirrors did, it should be remembered that he would later emphasize that "I used the term 'object' and not 'sculpture' for them. It would be wrong to think of them as sculptures, because for me they are paintings."[4]

If they are "paintings," they are metaphysical ones in the tra-

dition of de Chirico, creating fields of empty, abstracted space around themselves like the abandoned piazzas of *Ariadne* (1913; Metropolitan Museum of Art) or *The Enigma of a Day* (1914; Museum of Modern Art). Of course, the artist exaggerates to make a point by referring to painting in this context; it might have been less potentially misleading to speak of "pictures" (picture is to painting as object is to sculpture). As Germano Celant writes of the artist's procedure with the minus objects, "He insists on removing the figures from his imaginary world, or cutting them away from himself as they pass through."[5] In doing so he makes room for the viewer, whose path or gaze is not directed by any of the rhetoric of sculpture but must wander without fixed bearings through this alien terrain of the ordinary, of what Pistoletto correctly refers to as "objects."

Up until now, in speaking of Pistoletto's art in the early and mid-1960s, I have been considering work that precedes the appellation "Arte Povera" which has become attached to it. When Celant published the 1967 manifesto that gave currency to the term, an adaptation of Jerzy Grotowsky's call for a "poor theater," it was illustrated with a number of works whose appearance and titles were equally mute and "formal," among them Giovanni Anselmo's *Struttura*, Alighiero Boetti's *Oggetto*, Emilio Prini's *Perimetro* – and Pistoletto's *Oggetti in Meno*.[6] These are not really the kind of works that would be primarily associated with the term "Arte Povera," nor are they the sort of works that these artists would primarily be concerned with over the next few years. Celant's article calling for an art "committed to contingency, to events, to the non-historical, to the present . . . , to an anthropological viewpoint, to the 'real' man (Marx), and to the hope (in fact now the certainty) of being able to shake entirely free of every visual discourse that presents itself as univocal and consistent," like any really powerful example

of the genre of the manifesto, was more about what the work of these artists implied than what it was, more about the kind of work they were moving *toward* than what they had actually done.

In the case of Pistoletto, the work that perhaps best exemplifies his relation to Arte Povera is his familiar *Venus of Rags* (1967). The work consists of a plaster reproduction of a classical figure, nude but holding her shed garment in her left hand, turned away from the viewer with a face hidden in a pile of real and very colorful rags. For an illustration of the kind of dichotomies on which Celant's text depends, one could hardly do better. The hard, frozen, and idealized statue of Venus, a reproduction pretending to the aura of art and historicity on the one hand; the soft, formless, and quotidian pile of rags, indistinguishable yet marked by difference and individualized by use on the other – the real stuff of history-in-the-present. This is what Marco Meneguzzo has called "the opposition between a world of representation and the universe of existence – which constituted the basic aporia upon which this generation of young artists had grown up."[7] We cannot dismiss the associations with the Marxist category of the *lumpenproletariat*, literally the "rag proletariat," what we now call the "underclass," but even closer to the surface is the opposition here between an ideal of femininity as the cause and object of desire and the realities of sweatshop labor behind the production of the rags and household labor involving their use. But beware: although a reading of Celant might lead us to assume that this opposition is being deployed by Pistoletto for polemical ends, nothing in the work itself allows us to go so far. We can only say that the artist is incorporating both of these supposedly incompatible realities in his work without pretending to synthesize them, that his decidedly impure and contingent art still intends to incorporate everything that had already been claimed by idealism and tradition, by aesthetics and historicism. We should also

**120**

note that Pistoletto lays claim to the realm of sculpture by invoking the conventional form of statuary such as supposedly had been revoked by modernism on the same grounds that painting had relinquished the form of the picture.[8]

So Pistoletto, both precursor and protagonist of Arte Povera, shows his deep ambivalence toward its very notion precisely in formulating its emblematic work. Augusta Monferini has also remarked that "after having been the soul, even in fact the strategist of Arte Povera, Pistoletto was the only one among the artists in the group not to remain imprisoned in a determinate poetics; 'director' of Arte Povera, he was within it even as he nonetheless remained outside it."[9] In fact one might say that at this point his work split off into two distinct directions, each of them tending to elude some aspects of the Povera rubric even while confirming others. On the one hand there was his plunge into the realm of happenings, "actions," and theater, taking up and intensifying the promiscuous mixing of realities implied by the mirrors, what Celant called "a focalization of gestures that add nothing to our refinements of perception, that don't contrapose themselves as art to life, that don't lead to the fracture and creation of two different planes of the ego and the world, and that live instead as self-sufficient social gestures, or as formative, compositive, and antisystematic liberations, intent upon the identification of the world and the human individual."[10] This occupied Pistoletto from 1967 through 1970 and again from 1976 to 1981. On the other hand, his work of the 1970s also showed a tendency toward a new and more analytical use of the mirror. In these works the mirror is no longer the support for a photographic image but instead a self-sufficient object which can be either split or fragmented or else combined with others into three-dimensional structures. To quote a phrase Pistoletto gave as a title to several works around 1975–6, as well as to his 1988 retrospective in New

**121**

York at P.S. 1, this was the period of *The Division and Multiplication of the Mirror*. This work, as Monferini says, "energetically reaffirms the plastic and structural vocation of Pistoletto's art as a spatially 'organizational' element in dialectical confrontation with the 'shapeless' disintegration or dissemination of his own Arte Povera."[11] In these works Pistoletto reaches toward a new sculptural exuberance in his use of mirrors, insofar as for the first time he uses them as an almost neutral material to be "carved" or employed as material for construction. Here the reflective capacity of the mirror seems directed primarily toward itself. Pistoletto has said that he intended "to tell the story of a true god resuming His place . . . In this story, the god, by dividing Himself, creates not one but two sons, as two parts of the same mirror, each with the same ability to mirror."[12] The mirror has withdrawn from the life it was originally supposed to reflect, becoming a self-engendered profusion of views of itself even as it also takes its place in the world as a freestanding object or, if still attached to the wall, as a spatially avid object, spreading itself across an expanse of some 15 feet, as in *Drawing of the Mirror*, 1979, or imposing itself through the use of heavy antique frames, as in *The Shape of the Mirror*, 1975–8.

Although he has taken part in numerous retrospective projects and has continued his work with image-bearing mirrors and various kinds of object-oriented work, since the early 1980s Pistoletto has been primarily involved with a most untraditional approach to the question of sculpture in its traditional sense. In many ways this portion of Pistoletto's career still remains to be digested by an art world fixated on his work of the 1960s. "We know very well what sculpture is," as Rosalind Krauss provocatively asserted, after two decades in which, "sculpture" having become a term that could be applied to almost anything, we had begun to think that we could never know just what sculpture is.[13] For Pistoletto, at least, Krauss's

statement was undeniable. He knew what sculpture was – essentially, statuary in the old-fashioned sense, the vertical figure, the monument – because he had already used it, appropriated it, in the *Venus of Rags*. By 1981, however, he was ready to *make* sculpture, rather than just use it. A first step toward understanding Pistoletto's sculpture in the 1980s may depend on our ability to see its continuities with the first two decades of his work, even though a more profound understanding of it could well turn out to confirm the deep differences that in fact seem to be most striking on first view. (Contrast is also a continuity.)

What that first view is likely give us is a sense of heaviness, obscurity, obtuseness. The sculptures are often of very large dimensions, and yet they seem somehow fragmentary, incomplete. Although some are carved in marble, they are more often made of materials that are soft, like canvas, or both soft and "nasty," like Styrofoam. Mostly it is hard to tell just what they're made of, and in fact the artist insists on referring to their constituents as "anonymous materials." The forms are either more or less geometrical, though never hard edged and always clearly showing the signs of hand as opposed to machine work – or else more or less representational of the human figure; but the emphasis would be on the "more or less" rather than on the geometrical or the representational. I'd take a cue from the materials and likewise call them "anonymous forms."

These are objects that swallow space: "Idiotic thicknesses of a crushed and dribbled art, as arduous as childbirth."[14] Sculptures that, beginning from zero, need to feed voraciously on as much of their environment as possible. Now we can begin to see the connections, for instance, to Pistoletto's first mirrors. Those, the end of painting for him, avidly sucked in all of the life and movement and imagery surrounding them, but always in order to send it back,

**123**

in order to almost disappear. These works, the beginnings of sculpture, are to the mirrors as black holes are to stars; they retain what they take in, hoard it, fatten on it. They are also the inversion of the creation myth surrounding the "divided and multiplied" mirrors of the 1970s:

> The spirit of ancient art went out towards the moon, and now the spirit of my sculpture is returning from the moon. It's a change of direction. Thus the sacrality of the past takes form again in my sculpture as an inverse projection . . . There exists a soul common to the giant sculptures of Easter Island, to medieval wood carvings, and to Michelangelo's marbles, and this is what I want to rediscover in sculpture today. This term "sculpture" is now concentrated on the question soul or nonsoul, plenitude or void, god or nongod. Against monotheism I counterpose a center in every fragment, I occupy the spatial and environmental void of the art of the 1960s with the consistency of a full form.[15]

Against the myth he had propounded earlier of a god creating a world out of itself to populate with fragments of itself, the new myth is of a creation through anonymous fragments cohering into a renewed body, a new monumentality. And more than any contemporary artist I can think of, Pistoletto has actually succeeded in creating something like a monument. I am referring to his *Dietrofronte* (Aboutface), 1981–4, which stands in Florence near the Porta Romana. Its placement is significant, because this monument does not mark a central point but a liminal one, a threshold. You pass it (usually while riding in an automobile) before entering one of the gates to the old city. It marks the point where the periphery meets the center, and, as the name implies, it looks both ways. Consisting of two "anonymous" figures, one horizontally perched on the head of the other, it assumes both verticality and horizontality, both stasis

and flight. It takes its place in the city of Michelangelo with complete humility and unquestionable dignity.

With the failure of Auguste Rodin's monumental projects, Rosalind Krauss has claimed, "one crosses the threshold of the logic of the monument, entering the space of what could be called its negative condition – a kind of sitelessness, or homelessness, an absolute loss of place. Which is to say one enters modernism."[16] If that is so, then I would go on to say that with *Dietrofronte* we have crossed a new threshold, the negation of the negation – not "back" into premodernism, as if that were possible, but into something different which it would be unfortunate to call postmodernism. The art of the 1960s and 1970s – what Krauss would call postmodernism – tended to "reflect" life by negating or at least blurring the distinctions between art and life, multiplying the positions an object could take in the conceptual logic in which terms like "art" and "life" participate. In a work such as *Dietrofronte* we can see a new monumentality taking shape, in which life can rediscover itself precisely through its difference from a sculpture that holds itself apart, that effaces its ability to show the social body its own image in order to allow society to find that image in each of its members. And in fact the best commentary that I can think of for this work would not be in the words of a critic or aesthetician but in the words of a social philosopher, Albrecht Wellmer:

> What shows itself in the work of art can only be recognized as something showing itself on the basis of a familiarity with it which did not before have the character of perceptual evidence. It is as if a mirror had the capacity to show the "true" face of human beings: we should only be able to know that it was their *true* face on the basis of a familiarity with them which only assumed the form of an unveiled sensual presence when the image of them appeared in the mirror. We can only recognize the "es-

sence" which appears in the apparition if we already *know* it as something which does not appear.[17]

Pistoletto's sculpture "shows" the social precisely through this refusal to make it "appear."

# THE ABSTRACTION EPIDEMIC

## A Conversation with Demetrio Paparoni

**Barry Schwabsky:** Before we can begin a real dialogue we need a common language, and that's what I feel is still lacking.* Of course, I'm not just referring to the fact that you speak Italian and I speak English, but to the cultural baggage these languages carry with them, the habits of mind and the modes of rhetoric inculcated by diverse cultures. Let's be honest. To the pragmatically oriented American ear, most Italian criticism sounds woefully disengaged from the formal and material specificities of particular artworks, having betrayed them for a pseudophilosophical or pseudopoetic generalization. We might both love a painting by Jonathan Lasker or Domenico Bianchi, but do we speak of them in similar terms – and if not, are we seeing the same paintings?

**Demetrio Paparoni:** If our dialogue concerned philosophical or anthropological themes, I'm sure we would discover that we both perceive a common cultural horizon – the salient points of which are the philosophy of language, hermeneutics, structuralism, functionalism, and so on. But because we are speaking of art we are compelled to recognize that, in Europe at the beginning of the

*This conversation was conducted in 1992.

127

century, the avant-gardes effected a break with the past, and that artistic inquiry consequently turned in different directions in different countries. The French favored an inquiry directed toward a radicalization of Impressionist language – an inquiry that, through Cubism, radically developed the notion of the objectivity of painting. In Germany, Expressionism emphasized the subjective dimension; and in Italy, Futurism and Metaphysical Painting led all avant-garde necessities back to the idea of lost directions, linked in the former case to a sort of mythology of industrial civilization and of progress, and in the latter to an estranging reinterpretation of classical Italian art. Notwithstanding this apparent contrast, Futurism and Metaphysical Painting are united by the fact that both represent a moment of passage from the speed of a solid body to the lightness of the soul. Now, if we want to create a parallel between the new forms of abstraction as they appear in New York or Rome, we must consider the evident fact that, although we share a common cultural horizon and certain mental patterns, we decode artistic language differently. Which means that the same memories act differently in different situations. So, when approaching the most recent American art, one must bear in mind that the break with tradition in the United States was first manifested after World War II – principally by Pollock and de Kooning – even though European artists such as Duchamp had been active in America, and had introduced Dada ideas, as early as 1915. It follows that the difference between the works of Jonathan Lasker and Domenico Bianchi, to cite your example, is very small and very great at the same time. Both artists move in the same direction. They have a common metaphysical mold and a common memory of the colors of billboards. But this heritage is transformed into a pronounced metaphysical memory in Bianchi's work, whereas it becomes a highly original Pop vision of reality in Lasker's. In this sense the manner in which the relationship with reality changes is emblematic.

**BS:** That's a long way around to the rather shopworn equation of Europe with metaphysics and America with Pop – the old Beuys–Warhol dichotomy. And while the notion may be flattering to European self-regard, this distinction between subjectivity and objectivity seems chimerical when applied to art. Pollock saw his art in completely subjective terms, even though its influence on the American art of the 1950s and 1960s was certainly in terms of its "objective" formal qualities. Are we really capable, with hindsight, of saying which aspect was more significant, or are we led to admit that these are simply two aspects of the same phenomenon? Are the arbitrary color of Fauve painting or the distortions of form in German Expressionism really the result of an unbridled subjectivity, or rather of new approaches to the manipulation of artistic materials, that is, a new objectivization of color and form? Is the social objectivity of a Warhol silkscreen greater than that of a Pistoletto mirror? Is Ad Reinhardt a materialist or a mystic? What about Robert Ryman? This dichotomy seems to me to be precisely one of those untenable generalizations that take us farther away, in my view, from a concrete engagement with the work of art.

**DP:** I believe the art of this century, taken as a whole, expresses a certain unity, and that many questions have been settled too hastily, as though having identified them were sufficient in itself. We can see vast differences between what happened yesterday and what is happening today precisely because we seem to view contemporaneity through a magnifying glass – with a deformed lens. I don't want to talk about the old Beuys–Warhol dichotomy, because these two artists are myths, and we approach them in an excessively ritualistic way. I don't believe the distinction between subjectivity and objectivity favors one viewpoint over the other. I agree that both may be aspects of the same phenomenon. Nevertheless there's a give-and-take that allows one to prevail over the other at times.

**129**

Certainly Reinhardt is more mystical than materialist – it could hardly be otherwise, as he moved wonderfully along a line already marked out by Malevich. The difference between a Warhol silkscreen and a Pistoletto mirror exists, though, and is immense. Warhol's objectivity is taken on by the consumer processes of publicity and advertising. The objectivity of Pistoletto is not taken on by any particular social system, not even an extended one. For Pistoletto the image is total. He begins with the human image and aspires to reveal its fundamental phenomenology; thus, objectively, space becomes time. Warhol, in contrast, repeats his figures endlessly on a vast, flat sea – a sort of absolute present, that of the system of dissemination. Moreover, Pistoletto's figures are subtly melancholic – regardless of the intentions of the artist himself, whose early works are (not coincidentally) influenced by those of Francis Bacon. This melancholy is not be found in Warhol.

But going back to my remarks on the relationship between abstraction and reality – let's take another example, Peter Halley. There is much more Hopper in his work than may appear at first glance. A 1930 painting by Hopper, *Early Sunday Morning*, represents the facade of a building with ten windows arranged in symmetrical rows over a ground-floor row of shop windows, which are also rigorously geometrical. The sky above and the street below, too, are geometrically ordered. In this painting – which has a great deal in common also with the work of Stephen Ellis – one can already see the idea, dear to Halley, of a geometrical structure representing the compulsory dimension of contemporary society. Though in Halley the spirit of Walt Disney, with his colors and cartoons, also appears. Now, if one looks at a reproduction of the Hopper painting, one wonders how such an image was able to inspire even a fragment of a cartoon. Hence the cultural mold of Lasker, like that of Halley or of other artists such as David Reed

or Lydia Dona, is in my opinion of Pop derivation – notwithstanding Reed's references to the history of art and Dona's to French semiotics of the 1960s and 1970s. Now let's consider a European artist, Sean Scully, who is Irish. In his work the sense of metaphor is more subjective than objective, as it is in that of the English artist Fiona Rae. This difference between objectivity and subjectivity seems to be one of the great points of disagreement between European and American art. I realize that to speak of cultural differentiation in an era of electronic telecommunications may seem out of place, but I sense these two different attitudes. They are clearly manifested in art criticism, too, which as you point out tends to be more philosophical and poetic in Europe than it is in America. Personally, I am always irked when I read the description of a particular work in a text: I prefer a general analysis of the concepts that are concealed or revealed in the entire oeuvre of an artist or group of artists.

**BS:** On the contrary, "concepts" in art are generally less interesting than the forms they enable the artist to achieve and the viewer to perceive. Anyone who can't feel that truth can never be touched by art would be best advised to seek out another field of endeavor. And then the citation of formal characteristics of particular works is the only guarantee, if not of rigor, at least of a certain critical probity – like the citation of sources in historical writing. But to go back to Lasker and Bianchi, I'd say that both are concerned with, among other things, the use of a kind of glyphic figure that is halfway between drawing and writing, a kind of originary inscription that does not represent anything but the potentiality of representation itself. The difference is that Bianchi isolates this figure in a luminous space, literally sealed off in wax, as a cipher of pure fascination (Fig. 20), whereas for Lasker it resides on the surface, where it becomes available for a kind of systematic inquiry.

**Figure 20.** Domenico Bianchi, *Untitled*, 1988. Oil and wax on wood, 93⅞ × 78 in. Private collection. (Courtesy of Sperone Westwater, New York)

This is not necessarily to promote Lasker's "concept" over Bianchi's. Lasker is one of the best painters of his generation, and in New York a very influential one, but his influence may not be entirely positive. His example has led painters without his restraint and criticality into too much self-conscious stylishness, a puzzlelike cleverness at odds with true artistic ambition. But most of Lasker's

work possesses real emotional resonance, though, unlike Bianchi, he prefers not to present that resonance directly but to "tell it slant," in Emily Dickinson's phrase. David Reed is another influential abstract painter of this generation, and yet only David Row has been able to draw something usable from Reed's very idiosyncratic colorism without being seduced by the rather limiting "photographic" surface effects Reed has developed to forward his coloristic agenda.

This question of influence leads me to an important point. In New York there was never a "death of painting." There has always been a viable tradition of painting here, while it seems that in Italy Arte Povera really swept away everything in its path. I can't think of a single significant painter in Italy younger than Carla Accardi, until you get to the generation of Clemente and Cucchi and then Bianchi and Dessi – with the exception of a very few eccentrics, "primitives" even, whose roots are in any case conceptual or Povera, such as Aldo Mondino or Salvo. Whereas in New York the generation born in the late 1930s and 1940s includes figures as diverse as Mary Heilmann, Brice Marden, Elizabeth Murray, Thomas Nozkowski, Larry Poons, Susan Rothenberg, Joan Snyder, Jerry Zeniuk, as well as Lasker and Reed . . . a multiplicity that attests to the considerable energy with which each succeeding age cohort has entered the terrain of painting. And while everyone seems obsessed with looking for the next "young artist," many of the most promising abstract painters seem not to begin to come into their own until they reach their late thirties or forties, because it's a discipline that takes time to develop. These days we probably should be looking to people like Tod Wizon, who've been nursing their very idiosyncratic art in relative isolation, or someone like Norman Bluhm, who is doing some of the greatest and most complex painting of our time, at over seventy years of age, and pretty

much ignored in his own country. It's amazing to me that the recent works of Bluhm or Wizon or Zeniuk have been seen in Europe and not in the United States. I have the impression of an effort afoot to canonize certain artists as the "official" abstract painters of the moment, and while these painters, including some we have mentioned, may be worthy ones, the selection strikes me as premature.

It's also important to remember that while we are often told that with the ascension first of Johns and Rauschenberg and then in their wake of Pop, abstraction lost its importance. But if that were so, why have some of the most important works by the same artists been essentially abstract? I'm thinking of Johns's *Between the Clock and the Bed*, Warhol's piss paintings and shadow paintings, Lichtenstein's *Mirrors* and *Entablatures* and his de Kooning-esque works of the early 1980s. So in contrast to the Americans, the Italians, as I've said before in writing about Bianchi, are painting "after" Arte Povera, rather than painting after painting. This accounts for a difference in their attitude to materials, for instance, which seems more essentialist, less structural than ours. American critics and artists cannot quite take seriously this essentialism amounting at times to a sort of mystification, even when we admire its results. On the other hand the young Italians' formal unselfconsciousness sometimes betrays them into jejune solutions but also allows a freer approach, less reliance on formula than the Americans. Do you agree?

**DP:** I absolutely agree when you say that concepts are less interesting than forms. Not by chance, we both admire the same artists. And we have always agreed on the fact that abstract painting is as alive today as ever, even if there are important differences. This is clear, for instance, in the painters you have called "neo–Color Field," who consider the possibility of using processes and materials as image. But this also shows how everything mixes to-

gether in the twentieth century. The distance between certain works of Schwitters and Arp from the 1920s, others by Kounellis from the early 1960s, and others still by Carl Ostendarp today, can be small. And if we look at Kounellis's most recent works, the circle seems to draw even tighter. Clearly I'm simplifying matters, and quite a few distinctions need to be made; but the idea seems convincing as a whole. I think it's fantastic. As is the fact that, notwithstanding the cultural and linguistic differences that separate us, you and I feel the same way about Lasker, Bianchi, Reed, Dona, and Row. Nonetheless the risk exists of falling into facile nationalisms and provocative attitudes with the goal of demonstrating the superiority of one over the other. That's not what we need.

**BS:** Of course I agree. Still, what about my idea of a "break" in the Italian painting tradition?

**DP:** I think you're right to a great extent, but I suspect it would be more interesting for you to discuss the matter with the critics of the generation before mine rather than with me; for I've fought for years to make it understood in Italy that abstract painting is as alive as ever. And even today it isn't easy. Yes, a middle generation between artists such as Burri, Vedova, Turcato, or Accardi – who are still hard at work, by the way – and the young painters of the trans-avant-garde seems to be lacking. But at the same time Italy is the country which, more than any other, regenerated the idea of painting in the early 1980s. It must not be forgotten that painting was considered a minor phenomenon almost everywhere at the time, and that the art scene seemed to be under the universal and absolute dominion of minimalist and conceptualist art or of Arte Povera. In Europe and America alike. If the Italians realized the necessity of bringing painting back onto the field before others did, it was because Italian criticism was more acutely aware of the importance of analyzing the idea of painting rather than individual works. Today,

I think, the same attitude is necessary in order to understand the abstract artists in whom you and I, with a curious and significant accord, share an interest. If there is a form of art that rejects every kind of formula, it is nongeometrical abstraction – although it is sufficient to look to the work of Halley or Bleckner to see that geometrical abstraction does not have to mean repetitive formulas.

The 1960s represent one of the most fervid periods of American art. Arthur Danto – to cite just one example – told me that, in his opinion, there was a global subversion of values in the 1960s. Danto rightly wonders how it has been possible that objects blown up or reproduced in those years – like comic books or T-shirts, detergent boxes or improbable toothbrushes – could have been considered art. This same question, it seems, is being asked by many of today's abstract artists. As I was saying earlier, I see a Pop matrix in the works of Lasker, who uses colors and surfaces that sometimes seem silk-screened, as in certain examples of Pop art. Furthermore, think of the use that is still made today of comic books. Halley, in some of his prints, tries to achieve the dot pattern of four-color process printing as it is manifested in comics printed just after World War II. And even in his paintings, sometimes, Halley goes after a color he has already seen in a comic book. Another example might be the work of Steve Di Benedetto, who I think expands on the work of Rosenquist with ingenious insight, linking it to the exploits of today's computer technology. Lastly, consider the work of Carl Ostendarp: his early foam monochromes are about gravity, and are like objects suspended in space. But before long they became images of the liquidity of painting – not so much an analysis of the painterly "process" as an insight into the procedure of structuring the work. Ostendarp's gooey "spots" are nothing other than reworkings of details from Ninja Turtles comics. Now, what does all this mean? I recently spoke about this with Halley, who told me that he pre-

ferred to think of the objectual nature of his paintings as a reference to minimalist rather than Pop concerns. But he did not rule out my interpretation tending to place Pop influences in the foreground. So everything mingles and blends.

Now a lot of young artists are working along these lines in New York; but the same can be said of Rome, where there is an entire generation – Bianchi, Gianni Dessi, Marco Tirelli, Nunzio, Pietro Fortuna, to mention just a few – that has moved in the direction of a nongeometrical abstraction for the last ten years. Then there are Pizzicannella and Bruno Ceccobelli, who have an attitude very close to that of Bleckner, doing work that is both figurative and abstract – and abstract painting can have figurative implications. Finally there are younger artists, such as the Milanese Stefano Peroli or Chiara Dynys, or Luigi Carboni from Pesaro. Curiously, most of these artists are convinced that if they were Americans doing the same work, they would be considered more important – in the sense that the American art system promotes and protects its artists far better than the Italian system does. And they might be right.

**BS:** Here we part company. I see the work of most of the Romans you've mentioned – Bianchi is a partial exception – as being very far from that of the New Yorkers. I always have the feeling that the great problem for Italian painters in general and those in Rome particularly is that they always seem to be trying to make something as beautiful as the worn and ancient walls with which they're surrounded, and they can never quite do it. But there's so often this "look" to the work which seems to have to do with a simulation of age. I'm very suspicious of that. The Milanese artists you mentioned may be closer to an American sensibility. As to the Italian art system, I'd agree that it presents certain dangers to young artists that are not present in the United States. The lack of cen-

tralization, and the paucity of ambitious collectors, means that an artist can best survive by having a large number of exhibitions at galleries all across Italy – as long as the works are inexpensive and rather similar. It's a recipe for overproduction and self-pastiche.

But just to get away from this U.S./Italy axis, let's not forget that we can't talk for long about contemporary painting in general or abstraction in particular without speaking of what has been done in Germany over the last thirty years – the names of Richter, Polke, Kiefer, and Baselitz are only the tip of the iceberg. Gotthard Graubner is a figure from an older generation whose work has been unfairly overlooked internationally, and now there are young painters like Karsten Wittke who have a lot to add to this discussion.

But in a way, the longer the discussion goes on, the less certainty I have about what it is we're really talking about. Is Jessica Stockholder an abstract painter? Yes, if your criterion is her use of paint as such, but her deployment of everyday objects, however decontextualized, always returns us to referentiality. Today it makes little sense to separate abstraction from representational work, painting from other art forms, except as a purely defensive measure, a simple claim for the validity of this work when we are surrounded by aggressive claims for the exclusive significance of topical subject matter or for certain media that supposedly carry an immediate connotation of avant-gardeness. The recent outbreak of group shows of abstract painting in New York – which you too have participated in – served to call attention to the impossibility of nominating this work in terms of any common project or meaning. Is it "metaphysical," "conceptual," "stubborn," "aesthetic," "feminine," or what? To call attention to abstraction should be nothing more than to reassert what ought to be obvious, the incidence of *form* in the elicitation and dispersal of meaning.

**DP:** I've said over and over again that art is a beneficial illness.

When form *falls ill* and is able to get well while remaining true to the traces of its own illness, then art has been regenerated. Hippocrates, in his book *On Epidemics*, did not consider illness as separable from the ill person with his symptoms and his character, his constitution and his imbalances of humors. I wonder if, where art is concerned, he was right – that is, if art is generated by art or if it is the expression of the social environment.

 **BS:** Isn't the point that the two are inextricably entangled?

# III

# . . . and Inscription

# 15

# THOMAS CHIMES
## Concerning the Surface

A little reflection reminds us of how misleading the distinction we often make between trained artists and self-taught "visionaries" or "outsiders" can be.* To think of an artist like Alfred Jensen, with his eccentric painting diagrams based on an idiosyncratic understanding of the Mayan calendar, is to realize the permeability of the barrier we tend to place between what is publicly accessible and what is irreducibly arcane; in a different way, the fanatical concentration of an artist such as Myron Stout, with his abstract invocations of primal myth, recalls the fierce necessity of abstention from apparent consensus. It may well be that to make more than ephemerally significant art today requires – even (or especially) of the academically educated artist – a self-imposed autodidacticism, at the very least a healthy inoculation of information (however fantastic or unverifiable) tangential to the obvious and acknowledged sources of public discourse. There exists a need for sources that are, in the etymological sense of the word, *occult* – that is, hidden, concealed. So we learn from artists like Stout or Jensen, Bruce Conner

*This chapter is a revised version of an essay originally published in *Art in America*, January 1995.

or Jess, and among the artists taking that risk today I would name the Philadelphian Thomas Chimes.

To place Chimes in Philadelphia already communicates a pathos of propinquity and distance with regard to our sense of New York as America's art capital. It would perhaps be more apt to recall the presence in that city of a venerable and continuing tradition of realist painting, on the one hand, and of the Arensberg Collection, with its great hoard of Duchampiana, on the other. (It may not be irrelevant to note that in Philadelphia, Chimes and I have been able to lunch in a restaurant housed in the former dwelling of Madame Blavatsky.) Born in 1921 of Greek parentage, Chimes lived and studied in New York through much of the 1940s and early 1950s, one of the innumerable young artists to breathe the atmosphere of Abstract Expressionism, right down to the obligatory hostile encounter with Jackson Pollock at the Cedar. (Chimes still cites Pollock as an influence, though not for his innovation of the all-over surface so much as his involvement with Jungian psychology.) Chimes returned permanently to his hometown in 1953, though his public career as an abstract painter began later in the 1950s with exhibitions at New York's Avant Garde Gallery, leading to his work's inclusion in collections such as those of the Museum of Modern Art in New York, the Ringling Museum, and the Philadelphia Museum of Art.

By the mid-1960s, however, Chimes had temporarily abandoned painting in favor of making boxlike, wall-mounted objects constructed primarily of metal over a wood core. Their surfaces inscribed with cut-out shapes and cryptic emblems, with inset images and useless hardware, they seem picture machines of unidentifiable function. These boxes, with their easy synthesis of Surrealism, Minimalism, and Pop and their witty allusiveness, reflect perhaps too easily the manner of their time. They are period pieces.

But in the early 1970s Chimes married the "objectness" of his metal boxes to an extreme and willfully anachronistic manner that, in retrospect, looks far more interesting. Between 1973 and 1978 Chimes executed a series of forty-eight small portraits of figures of nineteenth- and early twentieth-century culture – Guillaume Apollinaire, André Breton, Edgar Allen Poe, Marcel Proust, Arthur Rimbaud, Robert Louis Stevenson, for example. Each was based on a period photograph (never a painting) and painted in nocturnal shades of depressive brown that echo the wide, heavy wooden frames that enclose them (as well as citing the wood panel supports).

It's clear enough that these portraits document an interest in nineteenth-century Symbolist aesthetics, its sources, and its early twentieth-century offspring such as Surrealism. But a few figures seem anomalous: what is Lord Kelvin, the British physicist and mathematician, for instance, doing among the *poetes maudits*? – until one realizes that there is a more specific unifying thread to the group: each figure has some connection, direct or merely speculative, to an individual who reappears in this series in several different guises: the scandalous, enigmatic, and finally pitiful creator of Père Ubu and Faustroll, Alfred Jarry. (Lord Kelvin, for instance, is a sort of guiding spirit behind Jarry's posthumous mock-scientific masterpiece, *Exploits and Opinions of Doctor Faustroll, Pataphysician*.)

But why Jarry? Certainly he is a pivotal figure in the transition between Symbolism and modernism, thanks to his cross-circuiting of art and life, which "pushed systematic absurdity into the realm of hallucination, of violated consciousness," as Roger Shattuck put it.[1] Yet Jarry's influence, though pervasive in modern art, is more easily traced through the careers of provocateurs and theatrical quasicharlatans from Duchamp and Marinetti through Yves Klein to James Lee Byars, Gino de Dominicis, or even Mike Kelley – not a soberly contemplative, reclusive painter like Chimes, who (and

this is his virtue) purifies this tradition for once of everything pu-
erilely transgressive, domesticating it, as it were. Jarry's quest was
always for a metaphysical, even cosmological truth, and the depth
of his revolt is a measure of the desperation of that quest. Chimes's
portraits represent a search for origins, an invention of artistic com-
munity, but they are hardly idealized and more than nostalgic.
Rather they are haunted, mournful, like the "sad, accurate faces of
artists" they convey.[2] As Chimes emphasizes, *hylē*, the ancient
Greek word for matter, in mundane usage simply meant *wood*.
These images, boxed in by oversized wooden frames, are those of
spirits unhappily imprisoned in and distorted by matter.

In an interview conducted in 1977 – that is, as the series of
portraits was beginning to wind down – Chimes cited the British
psychologist Havelock Ellis's comment on the religious conversion
of J. K. Huysmans, the French Decadent writer whose *A Rebours*
so influenced Oscar Wilde, among others (both Huysmans and
Wilde are among Chimes's portrait subjects). Ellis wrote of the
conversion experience, according to Chimes, that "it occurs espe-
cially in those who have undergone long and torturing disquietude,
coming at last as the spontaneous resolution of all their doubts, the
eruption of a soothing flood of peace, the silent explosion of inner
light."[3] Chimes's dark portraits are surely evocations of that "long
and torturing disquietude," clearly not just the private condition of
a few individuals but a driving force in late nineteenth-century Eu-
ropean culture; his paintings suggest that, far from having found its
resolution in the unholy release that was World War I, this con-
dition still resonates today.

What crises these works may have been charting in Chimes's
own artistic development is hard to say, but there followed a period
of several years of silence between the end of the portrait series and
the initiation, around 1983, of the current phase of Chimes's work

– a reemergence with a difference that can indeed appear as a sort of conversion, a "silent explosion of inner light." But the doubts whose "spontaneous resolution" is contained in Chimes's paintings of the past decade are just those manifested as such in the dark portraits of the 1970s. Thus, paradoxically, these doubts have been maintained and sustained, over more than a decade, in the very medium of their resolution.

The current phase of Chimes's work began in 1983 with a group of nearly pure-white landscapes, images essentially faded to nebulous fields of atmosphere inhabited at the center by a shadowy horizon line from which a nipplelike dome rises up. According to Jane Livingston, the source of this image is the view of Philadelphia Memorial Hall from the artist's childhood home at Thirty-First Street and Girard Avenue;[4] the image is the euphoric resolution of a tension between the overwhelming nearness of the maternal breast and the elusiveness of a distant prospect, between origin and goal. Sometimes there is a barely legible inscription at the bottom, and the edge of the canvas (later in the decade Chimes would return to painting on wood panel) is invariably but discreetly painted black, giving a hint (though an implacable one) of the boundedness of this area of illumination.

The Jarry connection remains important, as in the painting whose inscription (and title) reads, "And behold the body of Faustroll's wallpaper was unrolled by the saliva and by the teeth of the water." The body is the landscape, and the landscape is the lacteous light in which it is bathed. The basis of all of Chimes's subsequent work is contained here, awaiting its patient unfolding (or "unrolling") and articulation. New elements will enter, and aspects of the earlier work will recur, transposed into a new key. First among these is photo-derived portraiture, with Jarry and the constellation around him returning, their lineaments now shadowy, incorporeal apparitions from within a benevolent white light. Where there was

shabbiness, there is now grace; where there was neurotic dispro-
portion, there now reigns equanimity.

By the end of the 1980s, Jarry's profile will be practically the
only image left in Chimes's repertoire, as we see, for example, in
*Ruler of the World*, 1989 (Fig. 21). Just as often there is no imagery
left at all, just white-to-gray fields of half-buried inscriptions, as
often in Greek as in English, constellationlike sets of points dis-
posing letters by means of Fibonacci spirals or other formulas, and
the recurrent geometrical figure of the perfect circle, sometimes
appearing as the merest halo of light (it can even appear to be an
effect of the ambient illumination rather than part of the painting),
sometimes as a slight elevation of the painting's surface, the lowest
of low relief. In some of the most recent paintings, segments of the
outline of Jarry's profile are overlapped to form ribbonlike abstract
forms in relief that, with a crazy sort of near idolatry, suggest the
generation of cosmic patterns from the outline of a single face. In
*The Alchemist* (1994), which uses this technique of monochrome
relief, braided strands of profile segments, flanked with triangles
and circles, lead toward the central image of Jarry's complete pro-
file. Inside Jarry's head is a Chinese box arrangement of squares,
circles, and pentagons. Just below, tiny letters spell out the title.

To some, these paintings may seem trapped between hermeti-
cism and didacticism, private reverie and the insistent reiteration of
a preconceived message. Taking such a narrow point of view would
be to assume that the opacity endemic to these paintings exists only
for the viewer, contingently, that opacity is not part of the artist's
method and message. It would also be to mistake their obsessive
but ambiguous connection to what Frances A. Yates called "the art
of memory," the part of rhetoric (often closely allied with the aura
of magic, divination, and cosmological speculation) concerned with
the creation of fanciful imagery and "memory theaters" for the

**Figure 21.** Thomas Chimes, *Ruler of the World*, 1989. Oil on wood, 30 × 24 in. Photo by Eric Mitchell, Saint Peters, PA. (Courtesy of the artist and Locks Gallery, Philadelphia)

memorization and coordination of otherwise dauntingly intricate and wide-ranging bodies of information and reference.[5]

Chimes's paintings are theaters of both memory and forgetting and, far from being didactic, ought to be called autodidactic, as I realized only while viewing them in the company of the artist. It was fascinating to see how he would, less to me than to himself, "read off" the elements in them, pointing to some barely legible lines of text as he concentrated on half reading, half recalling the words he had secreted there. This process seemed surprisingly similar to how any viewer might try to work out the contents of the painting. Fewer of the constituent bits of information may be accessible to most of us than to the artist himself, but the elementary process of drawing connections – and seeing in them a Platonic sense of recollection, anamnesis – is what is most at stake in this work.

The specifics of what Chimes thinks about Jarry, for instance his connection with the mythological figure of Hermes and with Goethe's Mephistopheles, are fascinating and could generate endless commentary, but to concentrate on them would be to lose sight of the paintings as such. What counts is essentially Jarry's polymorphous identity. When asked, for instance, why his subjects (aside from the French novelist Rachilde) have been exclusively male, Chimes replied, "The representation is either masculine or feminine or both . . . I paint a portrait of Alfred Jarry, but at the same time a woman appears."[6] Indeed, sometimes Chimes gives Jarry a distinctly androgynous air.

Entering a roomful of Chimes's recent paintings (as was possible recently at the Institute of Contemporary Art in Philadelphia)[7], what one seems to see is simply, at first, a collection of mostly small grayish-white monochromes. Aside from their varying proportions – proportion itself being among the subjects of Chimes's meditations – the immediate differentiating quality among the paintings is their degree and quality of grayness. That already signifies a good deal. Chimes uses just two pigments in his work, titanium white and Mars black, each painting consisting of twenty of more layers of glaze applied in horizontal strokes. Images and inscriptions are revised, emphasized, or covered over from layer to layer, sometimes becoming completely buried or transformed into effects of texture reminiscent of scarification. The purer and more pristine their whiteness, the more intensely they seem to glow with inner light, the more the paintings come forward to claim the space between themselves and the viewer. The grayer the paintings, on the other hand, the more they appear soiled, sooty, "touched by hands," the more their light hovers back, diffused and absorptive, reflecting a sort of inwardness back into the work.

If we linger on the surface of the paintings – as the title of a

1989 work, *Concerning the Surface*, seems to explicitly urge – it becomes clearer that the degree of whiteness or grayness is a function of Chimes's working method. As layers of information accumulate on a particular painting – that is, layers of paint – it tends to become grayer. The result, however, is that information in these paintings does not correspond to intelligibility but to obscurity. Only the pure white light, more suggested than presented, is given as wholly intelligible. In their refinement of surface and their dialectic of emptiness and density, abstraction and image, the paintings Chimes has made over the last decade are somewhat reminiscent of those of Vija Celmins.

But in the process orientation that the paintings discreetly reveal, there is an even closer but more unexpected relation to the work of the Polish conceptual painter Roman Opalka, whose ongoing sequence of counting works is based on a gradual increase in the ratio of black to white in the paint he uses. In both cases, the work's deep subject turns out to be something purely quantitative yet endlessly metaphorical, the ratio of admixture of black to white, information to illumination, spleen to ideal, disappearance to revelation, death to life. To give this recognition greater precision – to provide commentary, so to speak, rather than interpretation – would require a lengthy self-education in hermetic philosophy and mythology as well as the history of modern art and literature, and would open the risk, common to all appeals to arcane learning, of leading to a cul de sac. What is needed is not so much a process of reproducing the knowledge Chimes himself has gathered in the course of his work as of matching it in passionate commitment. Only a few viewers have done as much. In this sense, as well as in a more worldly one, Chimes remains to be discovered.

# CY TWOMBLY

## Et in Arcadia ego?

A peculiarly defensive aura haunts the presentation of Cy Twombly's 1994 retrospective at the Museum of Modern Art.[1] It takes the form of a pretense that Twombly's stature in the pantheon of contemporary art has gone unrecognized, his contribution overlooked – as if he were not, justly, among the most famous and well-rewarded painters in the world.* At the very beginning of his catalogue essay, Kirk Varnedoe complains that, in contrast to his friends and fellow Southerners Jasper Johns and Robert Rauschenberg, Twombly "has suffered from the fact that, unlike theirs, his work tells little in reproduction and provides no convenient entrance into Pop Art."[2] If only all artists could suffer so! Johns and Rauschenberg, it might be advanced in contradiction, are honored as part of a glorious past. Rightly or wrongly, it is their work of the 1950s and early 1960s that continues to exert a magnetic attraction on today's artists, whereas Twombly, whose work can be said to be the constant production of "glorious past–ness" as a present phenomenon, has only grown in influence as his career has

---

*This chapter is a revised version of an essay originally published in *Art Press*, December 1994.

progressed. This prestige can easily be verified by noting the number of Twombly's fellow painters in attendance whenever one visits the retrospective or the concurrent exhibition of his single vast *Untitled Painting* (subsequently given the subtitle *On Wings of Idleness*; Fig. 22) at the Gagosian Gallery.

For all that, the initial critical reception – and anticipation – of the retrospective has had about it a distinct air of sour grapes, a need to deflate what seems to be considered a somewhat puffed-up or at least misconstrued reputation. Remember that this reputation was made "out of town." Skeptical New York does not look on that without ambivalence: a name made in Europe may, for that very reason, shine with romantic effulgence, but there always lurks a suspicion at heart of smoke and mirrors. This sourly grudging note was sounded by Michael Kimmelman in the *New York Times* as well as by two critics as different as Peter Schjeldahl and Rosalind Krauss in *Artforum*. Krauss's performance was perhaps most telling, if only for the way it framed as a denunciation of a dominant interpretation of Twombly what in fact amounts to a censure of a principal strain in the work. Seeing none of the hymns to culture that "others," in a view she finds "sick-making," discern there, but only the desecrations of a bored and idle schoolboy; insisting, with Roland Barthes as her witness, that within Twombly's work there abides no "analogy (mimesis, representation, likeness)," only operations of a performative or nominative nature, Krauss condemns the "semiological overkill" that is in fact suspiciously rife in writing on Twombly's work. Yet Krauss indulges in some rhetorical slippage of her own when she claims that "to rewrite *Mars* as *M/ars* is to make a deflationary, scatological, schoolroom joke: 'Mars = m . . . arse' "[3] – apparently referring to *Mars and the Artist*, 1975, although the scission of the word there is much less clear-cut than her typographical transcription might suggest. In

**Figure 22.** Cy Twombly, *Untitled (On Wings of Idleness)*, 1994. Oil and acrylic paint, oil and wax crayon, and graphite on canvas, 157 × 624 in. (Cy Twombly Gallery, Houston. Gift of the Artist)

this case it would be more appropriate to take the artist at his word, or rather at his letter: to find the "ars" that is the Latin for "art" concealed within the name of the god of war. There's no denying the secondary connotation Krauss claims to find here. She discerns the aggression in Twombly's art where I see him revealing the art within warfare, but in any case Twombly paints Mars and the artist as secret sharers. But in any case, it would be for the same reason that one cannot deny the pictorial connotations she would rule out of court when other commentators indulge in them: because Twombly's art encourages the semiotic drift that both verbal and pictorial associations and analogies favor. Such reverie is the very means by which the paintings work, and it is the effect they provoke in turn. To this Twomblyesque drift, a will to discipline such as Krauss displays must prove fundamentally alien. Varnedoe is shrewd in realizing that the generally negative reaction to Twombly's early exhibitions in New York had to do with the way his revision of Abstract Expressionism must have seemed to violate it by "accepting [its] freedoms while disrespecting what had appeared to be the attendant responsibilities."[4] It is instructive

to see how his failure to uphold the banners of rigor and progress still rankles.

Twombly's beginnings were brilliant, as we see in such works as *Tiznit*, 1953. His teacher Robert Motherwell's perception, in introducing his protégé's first gallery exhibition, that "at a remarkably early age, Twombly has come upon the grain of present day painting's willingness" seems more than prescient;[5] it is positively oracular, the sphinxlike pronouncement of an entangling destiny, since Twombly's every effort to go against the grain of his facility in a mode valued in his time, to become crude, artless, "obtuse," has only served to plunge him closer to the heart of a certain contemporary sense of refined style – to endear him to an involutedly snobbish/reverse-snobbish regard for aristocratic insouciance, discernable even in Krauss's hero (and mine!), Roland Barthes.

But it was also Barthes who, in his celebrated essay for the catalogue of Twombly's 1979 retrospective at the Whitney Museum – an account as narrow as it is magnificent – gives us the clue as to Twombly's importance for so much of the art we have seen since then, and not only for painting.[6] It does not come from the "nominalist," linguistic side of Twombly that fascinates Krauss. When Barthes speaks of Twombly's "habits," such as scratching, clotting, or smearing; when he speaks of these gestures as ones of "dirtying," of a "sensation" in preference to a rhetoric, of an inimitable "clumsiness"; in speaking of all these things Barthes alludes to an attitude toward the evidence of the body which was original to Twombly and which has become urgent to younger artists. Not only the painting of Cora Cohen or Suzanne McClelland, but also the sculpture of Curtis Mitchell, the installations of Karen Kilimnik, the floor spills of Lauren Szold all engage in distinct ways with Twombly's bad habits: his clumsiness, dirtying, and smearing in

pursuit of material sensation. Like Twombly, these artists seek through what Wallace Stevens called "waste and welter" a place where subjectivity once again becomes objective and impersonal, not by being rationalized, but by descending to the level of the distractedly somatic. But Twombly also reminds us – and perhaps this is what we cannot forgive him – that this impulse, for all its pretenses to transgression, is also intimately allied with an idea of luxury, in both its most utopian and most obnoxious senses.

Abstract Expressionism, as Fairfield Porter long ago pointed out, was inseparable from the idea of labor.[7] It has been Twombly's genius in art – as it has been his good fortune in life – to have known how to cut that link entirely. Like Marcel Duchamp before him, Twombly has been able to embody the artist-as-dilettante. One of the most remarkable things about this retrospective is the way it blithely skips over great swaths of chronology at a time. If the years 1962–6 are almost entirely unrepresented; if the decade 1972–81 turn up only some drawings and small sculptures, and then again the same for 1984–92 (what a contrast, for instance, to the years of earnest woodshedding that segregated the masterpieces in the Guggenheim's recent retrospective of Roy Lichtenstein), that is because this artist has never been moved by economics or careerism to press his inspiration, to force his muse.

From the artist's point of view, his mythographic musings must seem the veriest realism; for the rest of us, they form images of a life in which the passions may exercise themselves more absolutely – with less stimulus but with less restraint. The pastoral mode that dominates Twombly's work, at least after the "blackboard" paintings of 1966–71, used to be one in which the privileged could imagine the simpler lives of the humble, the clear music of their oaten pipes. For us, idleness is the ultimate Arcadian fantasy, evoking the

dissonant strains of an emotional orchestra grown restless and twittery.

"In Illyria there are no seasons," concluded John Hawkes, another American pastoralist, Twombly's contemporary.[8] One might agree, seeing how Twombly ends this retrospective – as Jasper Johns did his big 1988 exhibition of "Work since 1974" at the Philadelphia Museum of Art – with a suite of the *Four Seasons* (1993–4). In contrast to Johns's allegorical approach, with its complex and self-reflexive iconography, Twombly remains loyal to his aesthetic of sensation. And yet one can only conclude that Twombly is as far from evoking the full range of sensations implied by this theme as Johns was. For Twombly, it would appear, there is really just one season, and that is summer, which in the painting of that name appears here in all its radiant intensity, its blinding heat. *Autumn*, *Spring*, *Winter* . . . these are merely lesser degrees of summer, its approaches and withdrawals. After all, Twombly is, as Varnedoe tells us, a "summer painter,"[9] a man for whom the work of art is a vacation from mere living.

This undoubtedly accounts for why the more than 50-foot long *Untitled Painting* on which Twombly has worked intermittently for fifteen years should be nothing less than, as the most prominent of its many inscriptions proclaims, "an anatomy of melancholy." To plumb its depths would in the end be to show how and why it falls apart, to analyze its failure – a breakdown that reveals itself most glaringly in an extreme compositional imbalance. The painting pulls so strongly to its right that you can watch viewers being pulled insensibly rightward, almost without seeing the whole left side of the painting, like cargo on a dangerously listing boat. It's easy enough to see that the painting does this, but to explain why it does might begin to answer, through antithesis, the one question none

of Twombly's commentators have seriously addressed, though it is the really pressing one for his work: Wherein lies the visual unity, so strongly sensible, of Twombly's best paintings, and therefore the calm within the fury, the *ars* within *Mars*? What, in fact, makes this welter of smudges and scribbles something more than a glorified notebook page, but rather a veritable work? The artist's failure to find it in his *Untitled Painting* should incite us to define it ourselves.

# BRUCE CONNER'S INKBLOT DRAWINGS

## Documents for a Secret Tradition

Warning: the documentary status of anything one writes about Bruce Conner remains indeterminate.* He may be more accurately described as a creature of legend or myth than as a denizen of reality. For one thing, Conner seems to be one of those genuine rarities, an artist who, while far from being an "outsider," is also working at a noticeable distance from the Western (that is, European) pictorial tradition. It really seems unlikely that if Conner "had stayed in New York . . . undergraduate art history texts would now speak of Johns, Rauschenberg, and Conner," as one writer has claimed[1] – simply because the precipitate of Conner's artistic activity is not easily soluble in any narrative of modern art history that begins with the assumptions that allowed for the quick and easy canonization of Johns and Rauschenberg. While Conner certainly shared and even exceeded their affinities with the petulant anti-art gestures of Dada, he was far less able or willing to package his refusals in ways transcribable through a concept of formal evolution from Cézanne through Cubism to Abstract Expressionism, as artic-

*This chapter is a revised version of an essay originally published in *Print Collector's Newsletter*, November–December 1993.

ulate critical supporters did for the New Yorkers. Conner's sources would appear to be far more scattered, barely the stuff of a credible narrative construct. "Naïve" junk constructions, magical diagrams, Tantric mandalas, and other equally suspect stimuli seem more apposite than the monuments of mainstream modernism, but Conner's most important sources may not even be visual so much as textual. And the effect of his own peyote visions must be incalculable; it is hardly insignificant that the modernist Conner most resembles is another traveler through the doors of altered perception, Henri Michaux.

My own sense of Conner's legendary stature, as well as of his tangential situation with regard to art history, may also be ascribed to the fact that long before I became aware of his work as a draftsman, collagist, assemblagist, and occasional painter, photographer, or print-maker, Conner was already known to me as a filmmaker, one of the heroic generation of American independents that also included pioneers like Stan Brakhage. And his influence in that realm continues. "When I look at MTV, it seems they must all have been students of Conner," as Dennis Hopper remarked in the catalogue for Conner's 1990 exhibition at the Michael Kohn Gallery in Los Angeles. Hopper must have been thinking of Conner's way of mounting a subliminal siege on the optic nerve – a way of working that underlies the aesthetics of, say, Nam June Paik just as much as of the jump-cutting creators of the more interesting music videos.

As important as Conner's contribution to the thinking of the relatively new medium of film (and, by extension, video) may be, his uniqueness – I might even say his essential strangeness – emerges even more clearly against the background of the immemorial art of drawing, which is really the only "traditional" art Conner has ever consistently practiced, perhaps because it is rela-

tively undefined, private, and vernacular in comparison with painting or with carved or modeled sculpture. Conner's position with regard to the mainstream of artistic tradition is one that is unlikely to have sprouted in any other than American soil. By contrast, perhaps only a European could write with such confidence, as Thierry de Duve once did in an important essay on Robert Ryman, "There can be no artist who has learned the history of art from books alone, who has not received the shock of perception from the work of others . . . From the works, and not from their reproduction, that goes without saying."[2] I could not help thinking of de Duve's pronouncement when reading about a boy growing up in Wichita, Kansas, in the 1930s and 1940s, one who, according to Rebecca Solnit, "remembers reading Robert Motherwell's *The Dada Painters and Poets* soon after it appeared in 1951, and he conceived a passion for the work of Motherwell, Baziotes, and the other biomorphic painters after reading an illustrated magazine article about them."[3] A hunger for art that precedes any firsthand experience of it, and which for that reason may never be fully satisfied with any actual example of it, can probably be imagined much more easily by an American critic than by a European one. What a critic like de Duve would hardly imagine is just how far "outside" most of America can still be – and how in such a situation, one's sense of tradition would most naturally tend to be that the true tradition must be a secret or *hermetic* one.

As a parallel to my imagining of Conner's Kansas, I think of passages in Ron Padgett's recently published memoir of Ted Berrigan, in which the poet, just a few years younger than Conner, evokes the disconnected existence of the rare "beatniks" of Tulsa, Oklahoma, in the late 1950s: "many of these people considered themselves special, as indeed they were, in the context of Tulsa; but they tended to be scornful, elitist, atheist, and angst-ridden"[4] –

where I read the word "atheist" in the sense of the proverbial "village atheist," the sterile mocker of common verities. Bruce Conner is clearly not the village atheist, but he is by all accounts a prickly, eccentric personality, "a man apart," as Thomas H. Garver put it in introducing Conner's 1975 drawing retrospective at San Francisco's DeYoung Museum. Conner's way of placing himself at odds with institutions and conventions, particularly those of the art world, has become part of his legend. At least the exhibition Garver organized actually took place; two subsequent museum presentations of Conner's work had to be canceled, according to Solnit, "partly at Conner's request."[5] (According to one rumor I've heard, the reason was that the artist demanded a cut of the gate.) Artists of my generation would undoubtedly find such recalcitrance incomprehensible, or regard it as merely strategic. Certainly by comparison with the contentiousness necessary to stymie the organization of a retrospective, Conner's sometime refusal to sign his works, or such pranks as having himself listed as deceased in reference books, may seem minor irritants. But what all these things have in common is their projection of an extreme anxiety over the notion of identity and its artistic correlate, authorship.

A more subtle instance of Conner's recalcitrance would be his indifference, at least during some phases of his career, to the physical survival of his work. Speaking of his early years in San Francisco, he told Garver "that it was unnecessary to make work of permanent materials because it was ideas as well as forms that were at issue and that there was no buying public for the sculpture"; and then there was the episode later on in which he simply tossed the only copy of his film *Leader* (its visual track did indeed consist of nothing but film leader) into the audience, whence it disappeared. Just as contrary is Conner's disinclination to organize his production around a given medium – or rather his tendency to abandon a

162

medium when it seems that he is becoming identified with it. It wasn't long after the Museum of Modern Art opened its 1961 landmark exhibition "The Art of Assemblage" (Conner had given one of its curators, William Seitz, some tips about artists to include from the Bay Area) that Conner more or less abandoned the practice of assemblage – except, of course, in the sense that his films too were based more on a sculptural sense of assemblage than on a classically cinematic approach to montage. By 1973 he'd stopped making films as well.

Still, if one could locate a constant in Conner's work, it would have to be his drawings – all the more so in that insistence, patience, and obsession are among their essential traits, even taken singly, as the November 1992 exhibition at Curt Marcus Gallery of nearly fifty such works, or the somewhat smaller show in September 1993 at Gallery Paule Anglim, could not fail to demonstrate. Many of the drawings have been executed with felt-tip markers. Conner exploits this everyday medium's properties of absorbability and "spread" – the way a small mark tends to be slightly expanded by the paper's porousness – as well as its associations with ordinary, absent-minded doodling to create drawings of great density yet bizarre detachment. These drawings often suggest maps or overhead views of landscape, as though repetitive, hypnotic activity inducing forgetfulness of self would evoke a sense of that self's place in nature, or perhaps an identification with nature. (In 1964 Conner actually executed a "drawing" with acrylic paint on a globe, emphasizing his equation of work and world.) Sometimes the paper becomes so blackened that only a few points of original whiteness remain, shining through like stars.

Interestingly, Conner's drawings generally show no trace of anything like a collage or assemblage "sensibility." The one exception that could be taken to this observation is that many of the

more recent drawings employ a highly elaborated inkblot technique (Fig. 23), and that, with its multiple foldings, this involves a kind of physical manipulation of the work's support that might be located somewhere between the "violence" of collage, with its cutting and tearing and arbitrary joining, and the respect accorded the paper on which a traditional drawing is made. It would be more accurate, however, to say that Conner's folding represents an altogether distinct attitude, a third way.

In a sense, Conner's inkblot drawings turn his assemblages inside out. The assemblages conjured a dark, Freudian symbology, rife with overt evocations of neurotic sexuality, random violence, inbred religion, and a morbid desire for dissolution of consciousness – the whole Gothic stew that's been central to American culture's artistic self-diagnosis from Edgar Allen Poe on. However much they may have rebelled against Greenbergian formalist dictates in every other way, New York artists who emerged in the 1950s, such as Johns and Rauschenberg, inherited Greenberg's allergy to the "literary" in art, where the word implied psychological subject matter of the kind forwarded by the Surrealists. (A form of this would eventually resurface in Johns's work, it can be argued.) The work of the important Bay Area artists of the time, however – I am thinking particularly of Wallace Berman and Jess (Collins) as well as of the Conner of the assemblages – was always radically literary. Some of Conner's work may testify in favor of the New York–oriented antiliterary bias – to my eye, for instance, his collages from old engravings look too much like Max Ernst, and therefore too conventional, too quaintly antique-y in their Surrealism[6] – but this should not conceal the fact that Conner's best drawings, though without the literary "look" that mars many of the collages, are deeply imbued with literary – that is, psychological – substance.

The very form of the inkblots continues to imply something of

**Figure 23.** Bruce Conner, *Inkblot Drawing (Dec. 30, 1991)*, 1991. Pen and ink on paper, 23⅛ × 29 in. (Courtesy of Smith Andersen Gallery, Palo Alto, CA)

the psychological content that was openly presented by the assemblages, but in a much more insinuated and indirect manner. By appropriating Hermann Rorschach's well-known analytical technique, they take up a theme that is almost a cliché of the 1950s tendency to reduce social alienation to personal neurosis. But the essential property of the Rorschach inkblots – and the same is true of Conner's adaptations – is that they present suggestive but non-

representational images possessing no conventional or preassigned meanings, not in order to obviate signification, but to place the onus of interpretive responsibility entirely on the viewer. Obviously, the critic who discusses Conner's inkblot drawings must also accept that any account he gives of what the blots resemble may point back to his own obsessions or neuroses rather than to any content actually residing in the works. So it is with full consciousness of the risk involved that I suggest that these numerous flat figures, which share bilateral symmetry with biological forms, often appear like nothing so much as hordes of insects, or at least as analogous to the somewhat repulsive multiplicity associated with the millions of species of living insects. It may not be irrelevant that, when explaining the nature of his anxiety about being subjected to the analytical and classifying gaze of the institutions around art, Conner employed a simile with a certain redolence of Franz Kafka about it: "I began to get a feeling that I was a kind of odd insect to be pinned up on the wall and observed."[7] And being pinned to the wall is no atypical fate for a drawing, either.

Repeating the inkblotting process hundreds of times in sometimes intricately gridded patterns of bilaterally symmetrical figures on small sheets (the dimensions of those exhibited at Curt Marcus were generally in the range between 10 and 30 inches), Conner creates all-over fields capable of seducing the viewer into a prolonged, almost trancelike contemplation of the rhythmic pulsing of their infinitely varied yet always similar details. This patterning seems to point to two interpretations at once. On the one hand, it conveys the notion of someone psychologically testing himself over and over, hundreds of times per drawing, adding up to thousands upon thousands of times in the course of an ongoing body of work: a self-obsessional neurosis, the archive of an ego narcissistically intoxicated with its own obscure tracings yet equally anxious about

how they will appear to others. At the same time the drawings also give the sense of a radical opening to the impersonal, an astonished return to the continual reappearance of an originary writing which is not given by human intention or convention (these glyphic figures take shape under cover of the darkness in the action of folding the paper) but by the fatality or accident embedded in events, like the signs employed in divination.

Looking at these remarkable pages is to be struck by the uncanny sensation that one could be viewing the hieratic instruments of some unknown religion or culture, but one which employs an alphabet of literally infinite compass, and which must therefore remain eternally unmasterable – the illegible scrolls of an incomprehensible Law. Conner's interest in occult and esoteric traditions is well known – he told Greil Marcus that his fascination with them dated back to his days in Wichita[8] – but I have never seen any discussion indicating whether or not he is familiar with their Jewish sources in the Kabbalah – literally, "tradition," but implicitly, an esoteric tradition handed down through the reinterpretation of canonical texts. Still, it is hard to imagine that anyone who was close to Wallace Berman, an artist obsessed with the power of the Hebrew letter, even (or especially) when employed in a strictly nonsensical manner, can have been totally untouched by such information. If Conner has inquired into the Kabbalah, even cursorily, he will have encountered the views of its greatest scholarly exegete, Gershom Scholem, who found in Franz Kafka "the most perfect and unsurpassed expression . . . of the Kabbalistic world-feeling in a modern spirit."[9] In Scholem's almost nihilistic interpretation, kabbalistic commentary reflects the situation in which one is faced with the existence of Law in the absence of any comprehension of its meaning. Scholem gave this explanation to his friend, the critic Walter Benjamin:

You ask what I mean by the "nothingness of revelation"? I understand by it a state in which revelation appears to be without meaning, in which it still asserts itself, in which it has *validity* but *no significance*. A state in which the wealth of meaning is lost and what is in the process of appearing (for revelation is such a process) still does not disappear, even though it is reduced to the zero point of its own content, so to speak.[10]

It is something like this sense of primal inscription that marks Conner's drawings, particularly the inkblots – an inscription that is primal but also perhaps residual, since its intensity of repetition and variation (with a concomitant hypnotic narrowing of vision) also implies that Conner could just as well continue his patient blotting even if the whole world were vanishing around him. Two of the drawings at Anglim, dated January 12, 1993, and March 27, 1993, have been matted, but the mats are covered with photocopied reproductions of the drawings themselves, as though the drawings were threatening to colonize their surroundings, taking over the gap between the space of art and that of life. In these drawings the world reduces itself to innumerable points of vision, and a potentially endless concatenation of insignificant marks expands to imply the vision of a cosmos. This endless cycle can be as terrifying as it can be exhilarating, an absurd sequence whose deferral of significance at once parodies and excludes the incessant and indifferent round of profane activity. Meaning is not canceled but held in suspense. The work's absolute latency underwrites its potential availability for use in any further reconstruction of the secret tradition.

# 18

# REVERSE CONTINUITY

## The Prints of Mel Bochner

The earliest piece included in a recent survey of Mel Bochner's printed work[1] was not exactly a print, although it exists in two versions and was certainly made by printing.* One version is a set of four ordinary index cards, on the first of which is rubber stamped the statement "LANGUAGE IS NOT TRANSPARENT." On the second card it is stamped twice, and on the third, four times, producing a still-readable blur, while on the fourth card the statement has been stamped sixteen times – enough to have become quite illegible.

This work, from 1969, is on the face of it completely congruent with the ethos of conceptual art to which it evidently belongs. Still, it displays Bochner's distance from contemporaries like Joseph Kosuth or Sol LeWitt as much as it portends certain aspects of the otherwise unpredictable turns Bochner's career has taken since then. Works such as Kosuth's *Definitions* or LeWitt's instruction pieces are essentially tautological in intention – for instance, everything about the result of an early LeWitt work's realization is already given in the instructions for its making; "the execution," as

*This chapter is a revised version of an essay originally published in *Print Collector's Newsletter*, July–August 1994.

he put it, "is a perfunctory affair."[2] In *Language Is Not Transparent*, by contrast, Bochner uses the fundamental sign of tautology, namely, repetition, to create a situation that reveals the opposite of tautology, that is, contradiction. In fact, the assertion that language is not transparent is already contradictory insofar as it seems to state its case transparently. It is only in the last card in the sequence, where the statement no longer exists because it has become inde-cipherable, where it has obliterated itself through an insistence of gesture, that the statement becomes true.

Such paradoxes have been a driving force in Bochner's ever-widening exploration of the nature of systems of representation. This much might have been clear enough twenty years ago. What would not have been imaginable then was that the sequence mapped out by *Language is Not Transparent* can also be seen as one from using the rubber stamp as a deliberately prosaic and mediated sur-rogate for the work of the artist's hand, in the first card, to a use of the same surrogate that begins to reinstate the unpredictability, the materiality, and the ambiguity which are the domain of personal gesture, that is, of expression or expressiveness, by the final card. This is the aspect that has come to the fore in Bochner's work as a painter since the early 1980s.

In Bochner's first formal print projects, dating from 1973–4 and published by Parasol Press, his contrarian effort to make "work in which conception and perception cut across each other"[3] continued apace. These aquatints, like *Triangle & Square*, 1973, or *Rules of Inference*, 1974, but especially the remarkable *Q.E.D.* portfolio of etchings with aquatint, 1974, are not related to the wall paintings Bochner was beginning to do in 1973 but reflect his earlier work in sculpture. This is not to say that they merely repeat what had already been done. It is true that the prints serve to document works that had previously taken the form of ephemeral installations, and

Bochner himself has said, "I began thinking of my print as a map from one of my sculptures . . . like pages from a manual, a diagram of how you would lay out a particular structure,"[4] calling attention to the connection between these prints and certain utilitarian, "non-creative" forms of printed imagery. At the same time, however, these prints typically force concept and percept to "cut across each other" even more sharply than in the original installations, effectively bringing a new element, a heightened degree of tension, into the work.

The four *Q.E.D.* prints are striking in that, on the one hand, they appear to take the form of "information" about four of Bochner's sculptural works of 1972 (*Meditation on the Theorem of Pythagoras*, *Five and Fifth*, *Principle of Detachment*, and *The Ten*) while at the same time embodying perceptual experiences which could only occur in this graphic form. In a sense they call on the viewer to exercise simultaneously competencies and presuppositions associated with artistic positions that can, broadly speaking, be characterized as "conceptualist" and "formalist" – positions that were then, as they remain today, generally considered antithetical. Each print carries two images of the same sculpture, which was originally realized as an arrangement of pebbles on the floor. On the left side of the sheet, it is represented numerically, printed in black on white: a conceptual diagram to be *read*. On the right side, the same sculpture is represented as an array of white dots (with a certain degree of optical "ping" *à la* Larry Poons) on a dark-gray ground, or rather a luminous faded black: a visual pattern to be "beheld," as Michael Fried would put it. But there is, literally, a twist to this doubling of representations: the paired images are flipped, that is, they mirror each other across both their vertical and horizontal axes. The result is that as the viewer almost unconsciously attempts to "match" or overlay the two evidently identical patterns, he is stymied; the over-

**171**

lay can only be accomplished by an imaginary turning of the body to look at one of the two images as though from the other side. In this way, time, memory, and the physical embodiment of the viewer are evoked as underlying the intellectual process of imaginatively re-creating the sculptures and the information they represent.

The *Q.E.D.* portfolio both culminates the first phase of Bochner's career as a printmaker and vividly foreshadows the turn his work was taking in 1973, bringing percept into the foreground, using concept more as a tacit substructure. The new work continued the mathematical interest Bochner had already evidenced, but took it in the direction of an investigation of geometrical forms – specifically, of the interaction of three primary shapes, the triangle, the square, and the recalcitrant pentagon, which cannot be integrated without remainder into a grid nor supply the basis for a regularly repeating pattern. Bochner conducted this investigation by means of a series of wall paintings executed between 1973 and 1981. As Elaine A. King has remarked, "the wall in these works was not meant to be viewed as a container holding the floating paintings but instead as the spatial plane where figure and ground came together."[5] For this reason, as Bochner says, there was a hiatus in his print-making activity: "Because of the framing problem. The issue of the margin in a print, the border of paper that pictorializes the image. So I stopped doing prints because there was no way to integrate print-making into what I was thinking about."[6] Bochner actually did make a few prints during this period, but they look back to the earlier work – in the case of the red and black screenprint *Range* (Simca Print Artists, 1979), to a series of drawings rather than sculpture.

Bochner's print-making activity recommenced in earnest only in 1988, that is, eight years after he began working on canvas. Actually, Bochner's wall paintings, with their delicately pellucid, fres-

colike color recalling the Trecento as seen post-Matisse – but which he has considered more "an extension of drawing"[7] – might be thought of as the beginning of a Long March toward an ever more encompassing critical engagement with the conventions of Western easel painting: from the wall to shaped canvases to rectangular canvases, from casein to Conté and charcoal to oil, with all the differences in approach to basic issues of space, light, and form that those differences in media might imply.

Only toward the end of the 1980s did Bochner's paintings really begin to resolve these issues, in my opinion.[8] It was precisely at this time, once he had "made peace with the rectangle,"[9] that he also began a second phase of intense involvement with print making – after a number of unsatisfactory attempts that were not editioned – with two series, both entitled *Four Quartets*, the first being black-and-white aquatints (1988, Parasol Press), the second, color lithographs (1990, Diane Villani Editions). Here we can see how Bochner synthesized such issues as shaped support versus the rectangle, diagram versus drawing, literalness versus depiction, structure and system versus accident and spontaneity, in ways that maintained complexity and tension without sacrificing formal resolution. Each *Quartet*, as the name implies, consists of four sheets. The sheets are rectangular but are always arranged in such a way as to frame a square void at the center of the configuration. The two sets employ the same four ways of configuring the four sheets, though in a different sequence: all four sheets may be used horizontally; all four may be vertical; and there are two ways of arranging the sheets with two of them horizontal and two vertical. Only one of the latter subordinates the rectangular sheets to a square format overall; the other three all result in complex, twelve-sided shapes that clearly maintain the sense of four separate rectangles united by an underlying circular flow.

In the aquatint *Third Quartet,* for instance, blocklike cubic forms reverse-drawn in white on a black ground tumble in two streams toward and away from the lower left-hand and upper right-hand corners of the central square void. There is the sense that this square is exerting a force of attraction on the depicted cubes, but at the same time that there is no possibility of contact. Since the square is the geometrical basis of the cube, our sense of the relationship between them is quite insistent, but we are also led to reflect that, on the one hand, the square formed by the four edges of paper is "real" in a way the drawn cubes could never be, while at the same time it is merely an absence, a window onto the literal, nonaesthetic realm outside the print, and which the four sheets could be said to frame.

While the 1988 *Quartets* deploy their cubes in a nebulous space given further definition only by the traces of other cubes that have been wiped out in the artist's attempt to bring the placement and weight of the cubes to an intuitive rightness, by 1990 Bochner was ready to introduce, in his lithographic *Third* and *Fourth Quartets,* the controlling and rationalizing structure of the grid. But, as though not yet ready to allow the grid its full power, he employs it in ways that moderate its effect. Rather than allowing it to echo the rectilinearity of the paper and reassert its literal flatness, he curves the grid or sets it at an oblique angle. (Bochner would deploy the grid even more whimsically in the playful *Floating World* portfolio of five ukiyo-e woodcuts, published by Editions Ilene Kurtz in 1990.) In the later series of *Quartets,* the internal scale of the compositions has changed. Whereas before the sides of the depicted cubes were always larger than the central square, in the color series, after the *First Quartet* (which in this remains closer to its predecessors) the cubes are smaller, and they are more numerous as well. The result is that the emphasis is less on the weight of individual

forms and more on the overall sense of movement governing their appearance. Another change is that the cubes now intersect with the outer (but still not the inner) edges of the sheets, so that there is a much greater sense that the image we see, rather than being self-contained, is a cut from a larger continuum. All of which is to say that, while still using a very simple vocabulary, the second series of *Quartets* deals with a far more complex set of pictorial problems, even aside from the addition of color. Even in that realm, Bochner seems determined to squeeze the greatest effect out of the least means. Each sheet of the *Four Quartets* uses a single color plus black and white, although within each *Quartet*, every sheet uses a different color. The results are surprisingly rich and nuanced, giving the impression that a much wider range of color is present than is actually the case. Just as the grid functions as a highly flexible intermediary between the ideal, absent square at the center and the pivoting, mobile cubes, so color here acts as the variable intermediary between white and black.

Bochner's most recent print is a return to black and white. *Untitled (Vanishing Point)* (etching with aquatint, Parasol Press, 1993; Fig. 24), shows his use of the grid within the quartet format becoming at once more classical and more contradictory. No longer does it take the form of a single element uniting the four sheets, as with the color *Third* and *Fourth Quartets*. Instead, within each sheet, it appears as a manifestation of receding perspective, like the floor in a Renaissance painting – or at least that is the reading one gets from the lower left-hand sheet, which is vertical. The lower right-hand sheet uses the same substructure, but turned 90 degrees; the upper right-hand sheet turns it 90 degrees again, so that this sheet appears to turn the perspective of the lower right-hand one on its head, and the same is true of the relation between the upper left-hand and lower right-hand sheets. (The arrays of cubes that fill the

**Figure 24.** Mel Bochner, *Untitled (Vanishing Point)*, 1993. Etching, aquatint, 27½ × 27½ in., edition of 30. Photo by D. James Dee. (Courtesy of Betsy Senior Gallery, New York)

space defined by these grids are unique from sheet to sheet.) Just as in the *Q.E.D.* prints, the viewer must compose this print in her head by imagining looking at each sheet from different positions and then synthesizing the results of this with what is actually seen by looking at the four sheets as a complex whole. The subtitle clearly refers to the vanishing points implied by the perspectivized grids; each of the vanishing points would be located behind one of

the adjoining sheets. Yet there remains the strong sense of a different kind of vanishing point, the absent center which still appears to govern the movements of the rotating cubes. Although the square hole still reminds us of the literalness of the surface behind the print, *Untitled (Vanishing Point)* generates an almost uncanny sensation that the activity we see on its surface somehow continues *behind* the work itself.

Bochner's work has undergone unusually radical shifts in the twenty years that separate *Q.E.D.* from *Untitled (Vanishing Point)*. One might even expect that few of the viewers who esteemed his work of 1966–73 would countenance his production of recent years, and vice versa. But as we have seen, the underlying concerns remain remarkably consistent. The difference might be called one of language. But as Bochner himself has shown, no language can be at once consistent and transparent. To overlay past and present requires a mental turn of at least 90 degrees.

In a 1967 notebook entry, Bochner observed that "the usage of conflicting conceptual and visual orders reverses, in often irritating ways, the continuity of time."[10] A clairvoyant observation, insofar as *Untitled (Vanishing Point)*, while a logical outgrowth of Bochner's work in painting and print making over the last several years, in its deployment of perspective also represents the return of a "symbolic form" Bochner was concerned with in a series of photographic works dating back to 1967. If the conceptual order of Bochner's early work seems at variance with the visual order of his recent work, this should alert us to the contradictory visual dimension of his conceptualist work, the contradictory conceptual dimension of his pictorial work, and the chiasmatic connections that can cut across and reverse the temporal dimension of our interpretations (whether thematized as reading or as perception) of individual works or of an entire career. A certain view of conceptual art would

have it that the tradition of painting was superseded (or at least subsumed), and thus rendered anachronistic. But as Erwin Panofsky once stated, as it happens, in his suggestive early work on perspective,

> When work on certain artistic problems has advanced so far that further work in the same direction, proceeding from the same premises, appears unlikely to bear new fruit, the result is often a great recoil, or perhaps better, a reversal of direction. Such reversals . . . create the possibility of erecting a new edifice out of the rubble of the old; they do this precisely by abandoning what has already been achieved, that is, by turning back to apparently more "primitive" modes of representation. These reversals lay the groundwork for a creative reengagement with older problems, precisely by establishing a distance from those problems.[11]

Just as Bochner's "poor" arrangements of stones may appear "primitive" in relation to the great tradition of painting – to be literally the "rubble" or ruins of some more ancient system – his essays in painting, a veritable recommencement, may seem outmoded in light of the conceptual rigor of his early sculpture. But a change in perspective makes the reverse true as well. In contrast to the models of linear development or of stubborn insistence as expressions of artistic seriousness, Bochner's artistic development proposes continuity through reversal, detachment for the sake of reengagement, as a form of coherent complexity.

---

# 19

# RUBBLE

## Representing Mel Bochner's
## Early Work

PÈRE UBU. – Cornegidouille! nous n'aurons point tout
démoli si nous ne démolissons même les ruines! Or je n'y
vois d'autre moyen que d'en équilibrer de beaux édifices
bien ordonnés.

– Alfred Jarry, *Ubu enchaîné*

The early work of Mel Bochner – by which one would mean his
production from about 1966 to 1973, the years when his work could
be attached to such labels as "minimal," "conceptual," "systemic,"
and "serial" – has taken on renewed currency.* Not only has the
Yale University Art Gallery recently organized a major exhibition
of this work,[1] but we are starting to see it represented in context
with new work by much younger artists – or perhaps it would be
better to say that young artists want their work represented in con-
text or relation or filiation with that of Bochner: last year, for in-
stance, some of Bochner's measurement pieces of 1969–71 were

*This chapter is a revised version of an essay originally published [in
French] in *Exposé: Revue d'esthetique et d'art contemporian* 2, Spring 1995.
Special thanks to Mel Bochner for making a number of unpublished texts
available to me, and to Anna Blume for iconographical advice.

shown together with recent drawings by Dennis Balk and paintings by Nicholas Rule. As significant as such museum and gallery manifestations may be the phenomenon of a young painter like Matthew Antezzo, who in one of his paintings has depicted the photograph and caption published in an old art magazine of another of Bochner's measurement pieces. The painting memorializes an artwork, one which no longer exists (at least not in the form shown), as it was installed on the wall of a studio Bochner no longer works in, between two windows. Antezzo's painting hangs in Bochner's current studio, between two windows, the reembodied shadow of something vanished, yet still somehow operative in the world of art.

I write from a situation not dissimilar to Antezzo's painting. My sense of Bochner's early work can only be an archaeological reconstruction from shards of information: texts, grainy photographs, and recent reconstructions. But this is a situation that the work foresees, and that the artist has articulated: "To re-present can be defined as a shift in referential frames of the viewer from the space of events to the space of statements or vice-versa . . . A good deal of what we are 'seeing' we are, in this sense, actually imagining."[2]

The work of a few young artists points me back to Bochner's early work, but nothing takes me farther away from it than its contemporary critical accounts, on which I must nevertheless rely. These are not inaccurate, as far as they go, but, on the contrary, the best of those accounts are so true to the spirit of their moment that they remain half buried in that time, visible but irrecoverable. In the most comprehensive early discussion of Bochner's work, for instance, Robert Pincus-Witten presents it as from the beginning "clearly articulated and related to the strongest manifestations then open to American art."[3] Pincus-Witten's argument is convincing, but its correctness, in a way, is exactly what is wrong with it. Already

in 1973, looking back on work from just a year before, Bochner was moved to admit that "what is most meaningful to me, now, is not its strength, but its concurrent vulnerability."[4] All the more today, what has become notable about this work is an untimeliness that was then, it seems, almost invisible, an untimeliness not detached from certain manifestations of weakness, insufficiency, ruin.

Yet Pincus-Witten's argument is convincing because it accounts for so much in Bochner's early art – and in his early writings about art, too. Texts such as his important review of the "Primary Structures" exhibition at the Jewish Museum are deeply imbued with the assertive tone of blunt certainty that Donald Judd had derived from the lapidary style of Clement Greenberg. Yet the text Pincus-Witten presents as the apex of Bochner's critical perspicacity – a review of Frank Stella's 1966 exhibition at the Leo Castelli Gallery – is more than just the triumphant coup of the ephebe who has seen through the weakness of his elder in order to demolish him. Bochner observes of early Stella that "his *completeness* was his insistency." The problem, then, was one of development. "By trying to do something with Stella, he appears to have joined his imitators and variationists."[5] This was a timely warning. The artists known as Minimalists would seem to have heeded it by accepting the idea of completion and spending the remainder of their careers reiterating the logic of their assumed positions. Bochner took his own warning in an antithetical sense. After 1966, his work would no longer aspire to wholeness, completion, or certainty. Despite appearances, it would not be what Pincus-Witten (picking up the term Bochner himself had extended to artists he admired, such as Carl Andre, Dan Flavin, and Sol LeWitt) calls "solipsistic." Nor would the future course of Bochner's art be determined either by the model of continuity through organic growth which an artist like Stella seemed to have shattered. One of the culminating manifes-

tations of this phase of Bochner's work is called *Continuous/Dis/Continuous* (1972), and, as the title implies, he had embraced by then a model of coherence in and through discontinuity and fragmentation, a contingent and provisional coherence that cannot be demonstrated or perceived but can only ever be deduced retroactively – a model that I have elsewhere called "reverse continuity." Bochner works today primarily as a painter – something that could hardly have been projected from his activity of the late 1960s and early 1970s – but as we will see, he nonetheless works "after" the Bochner of this period, though hardly as an "imitator and variationist."

If I have found it necessary to begin with remarks on the critical accounting of Bochner's work, this is because the question of representation is crucial to it, and especially during the period 1966–73. Here it is not simply a question of a work that represents something, but rather of representations of the work. Perhaps I can make my point more forcefully by speaking of translation rather than simply of representation – thereby emphasizing the linguistic moment in the (not purely mimetic) process I mean to invoke. Likewise, one may speak of works that circulate ideas and materials but that themselves resist easy circulation. Bochner's early installations are not exactly performances of already existing scripts. Though it might be thought that the diagrams that precede other forms of embodiment of these works are scripts in this sense, it is more accurate to say that they too are merely embodiments of the works produced on spaces defined by sheets of paper and with materials such as pencil or pen, rather than on a floor using more substantial materials (though still not *very* substantial ones, in relation to what the history of sculpture might have led one to expect) such as pebbles, acorns, coins, or the like – for the most part, light and unimposing objects whose "sameness" is not defined by geometrical

uniformity. It would probably be more precise to speak not so much of diagrams as of *plans*, in the architectural sense, views of ground planes as opposed to elevations. (As with Andre, whose work was an important precedent for Bochner's, height tends to be a "negligible dimension," in Bochner's phrase, for his floor-based work.)[6] In any case, as with any act of translation, there is some reference to an original text, but this is not to be identified with the plan, which is, so to speak, the reminder of a text that exists elsewhere, though not solely, as idealism would have it, in the concept.

Thus, this work conceives itself neither as inhering in its objective instantiation, nor as a "concept" whose realization is a matter of indifference. As Bochner himself recently put it, speaking in the present tense of his early work, "What interests me is the way ideas break down. I try to locate that edge where the idea slips out of focus."[7] Somehow, there is an area of interference between the notion and "its" representation, or translation, or reconstruction.

Bochner's measurement pieces, for example, use ordinary materials such as might be found at any construction site – pencils, masking tape, and 36- by 48-inch sheets of brown paper, a standard size for American building materials – to translate the rooms in which they occur in such a way that the ease and familiarity with which we deal with these spaces is disrupted. The reason for this has nothing to do with any sort of "unveiling," as certain works that would appear under the slogan of "institutional critique" might assert. It is simply that the measurement pieces display the rooms they inhabit under the condition of being temporary and contingent. The gesture is one that suggests dismantling or rebuilding. It is one that does not articulate the space so much as it disarticulates it (though it becomes difficult to maintain this distinction here). It may not be irrelevant that the initiation of this series of works, toward the end of 1968, can be located in the attempt to circumvent

a moment of blockage such as every artist has known, a crisis of nonmeaning:

> The first measurement "piece" I did was because I was unable to put anything *on* the paper. Nothing at that moment seemed meaningful enough to note. I had two sheets of paper on the wall which I was just looking at. Suddenly I saw the space between them. I saw that it was as much the subject as the paper. I measured that distance and drew it on the wall . . . When I took down the sheets of paper I had the measurement alone. It puzzled me. It still puzzles me. What does it mean to have 25 inches drawn on the wall?[8]

The gesture of measurement takes its force – which is that of a question – from its existence as a fragment, or better yet as a remnant or remainder, the alienated trace of a purportedly "purposive-rational" action which instead puts the question to purpose, to reason.

In works that followed the measurement pieces, the materials used to realize a particular sculpture inaugurate specific kinds of interferences between conception and representation. Looking back on his early work, Bochner has speculated that "by juxtaposing the numbers with the stones *A Theory of Sculpture* forces a confrontation between matter ('raw' material) and mind (categories of thought)."[9] One could go farther to point out how the use of acorns or nuts forced a confrontation with nature (going beyond simple "matter" to include the organic), and the use of coins, a confrontation with the economic and social. Of course, that's easy enough to say. The confrontation may not sound very interesting at this level of generality. The examination of a particular instance may give a more vivid sense of the complexity with which the juxtapositions operate.

The work *Four, Four, Four, Four* was installed in the deconsecrated Romanesque Church of San Nicolò in Spoleto in 1972, in a

chapel containing a ruined fresco, possibly of the sixteenth century, of *The Giving of the Keys to Saint Peter* (Fig. 25A,B).[10] Among the most attractive aspects of such churches, for Bochner, was their syncretism, the way they tend to incorporate found pieces of earlier architecture, particularly fragments of the Roman ruins on whose sites they were frequently constructed. "I always wanted to find some way to incorporate that idea into my work . . . the idea that it would be the stone that had already been manipulated or changed or altered or, even better, carved," the artist recalls.[11] He found some fragments of this kind, which had been dug up in an excavation and left lying in a courtyard. *Four, Four, Four, Four* – a work already existing in the form of a plan or diagram in Bochner's notebook – was chosen for the site because its cruciform configuration seemed appropriate for use in a church. The piece consists of four lines radiating at 90 degrees from a common center, each line made up of four stones and one or more plus signs, with zero at the center, the pluses and zero having been marked with chalk on the floor.[12] In each radiating arm, the number 4 is configured differently: as $4 + 0$, as $2 + 2 + 0$, as $3 + 1 + 0$, as $1 + 1 + 1 + 1 + 0$.

One might begin the consideration of this meditation on fourness with its central sign, the zero. This zero is the "rock" on which the Spoleto *Four, Four, Four, Four* is built and is contemporary to this context, having been introduced to Europe during the later Middle Ages, notably by Fibonacci in his *Liber abaci* of 1202, a date which in Umbria still often corresponds to the Romanesque.[13] On the one hand, it is clearly used here for a strictly formal reason: without it, there could only be three rather than four plus signs in each line. In order to repeat the operation "plus" four times with four instances of the substantive element "one (stone)," in one instance the operation must be carried out with zero. Each element

**185**

**Figure 25.** Mel Bochner, *Four, Four, Four, Four*, 1972. (*Above:* With fresco in background. *Below:* Close-up.) Fragments of ancient Roman carved stone and chalk drawn on floor, installation at Chiesa di San Nicolò (deconsecrated), Spoleto. (Courtesy of the artist)

in this work is repeated four times, or four times four times, but the zero only occurs once. But from a different point of view, that's not quite correct. The zero connects with each of the four lines, but it connects differently with each one, since for each line its up, down, left, and right axes shift. Although the chalk trace is one and the same, in its relation with the four lines it constructs four different zeros – or perhaps I should write, "different" zeros. Although the questionable difference produced by the quotation marks may only defer momentarily the problem of how to understand the nature of this difference-within-the-same, that momentary deferral may be all we can grasp of this difference. Zero here fulfills, in an unexpected way, Gottlob Frege's definition of it as "the number which belongs to the concept 'not identical with itself.' "[14] And as a visual sign, its functionally perfect symmetry – its appearance as a circle – allows it to operate in pure apposition to all the other signs in the work.

The zero, the marked absence at the center of the four arms of *Four, Four, Four, Four*, can be seen as premonitory of the hole at the center of Bochner's recent paintings, which array four painted canvases (like the arms of *Four, Four, Four, Four*, they can be read as demanding to be viewed from positions at 90-degree angles from one another) in such a way as to frame a square hole revealing the wall behind the painting. That these paintings are all based on investigations of perspectival grids may remind us that the plus signs in *Four, Four, Four, Four* are not only signs for an arithmetical operation, as is clear in the work's plan, and crosses, as the work's installation in a church suggests – appropriately for a church that has been deconsecrated, the sign of the cross exists here as the barest reference, a mere indication of the history of the place, without any spiritual import. What the paintings may help us recall is that the plus signs are also generative units for a potential Cartesian

grid – the form of things that "are equal, separate, and unrelated," and therefore not sacred but "autonomous and indifferent"[15] as well as of perspectival representation. (Bochner had already called attention to the methodological interest of perspective in "The Serial Attitude," published in *Artforum* in December 1967, and had used it extensively in his photographic works of 1966–7.) We are reminded of the slip between the sacred and the profane, between myth and enlightenment.

The plus sign here functions to indicate the (suspended) sacred function and significance of the space in which the work occurs, and the use of the stone fragments from the site gives this deictic element to the work greater breadth and specificity. As Bochner recalls, "I liked the aptness of building the sculpture out of the stones that had built the church[,] in the chapel showing Jesus presenting the church to St. Peter with the statement, 'On this rock I build my church.' "[16] The fresco articulates a myth of succession, and so in a different way does the archaeological allusiveness of Bochner's installation, which seems to enact the handing over of artistic meaning from the realm of the sacred to one that is completely disenchanted, rational, and historical. To say this might make the work sound triumphal in tone – a celebration of progress. That would not be correct, though its affect is not mournful either. This is art made of rubble, but that rubble is seen to be at a perfect point of equilibrium between ending and beginning, relic and raw material, destruction and creation.

It would be vain to claim the Spoleto installation of *Four, Four, Four, Four* as "typical" of Bochner's early work. What I have called its deictic element – though this is indeed common to Bochner's early work, and in a different way to his recent work in painting as well, for instance in its framing of the wall on which it hangs, as I have mentioned – is so prominent that the work hardly exists except

in response to specific conditions. It's not a question of so-called site-specificity, either, since it is often through the circulation of highly generalized elements into diverse sites and situations that these works operate. In 1991, Bochner re-created works from his *Theory of Sculpture* series at the Milan art gallery Studio Casoli, which is housed in the space that was once the studio of Lucio Fontana. In the building's basement Bochner found a box containing fragments of highly colored glass, discards from the Murano glassworks, which had belonged to the great Italian painter and sculptor and used these as the "tokens" through which the work was embodied. Bochner spoke of this insinuation of color into these otherwise rather severe works (not its application onto them) as disclosing "the 'emotional' dimension that is missing."[17] Here the emotion was clearly one of reverence for an esteemed precursor. Yet when Bochner subsequently showed the same works at the Sonnabend Gallery in New York, the sensation produced by the colored glass was very different, exposing itself to the possibility – not unknown to Fontana, though very distant indeed from Bochner's early understanding of his own work – of seductiveness as its own reward, a possibility recognized by the anonymous critic in the *New Yorker* who wrote (not entirely unfavorably, I think) of Bochner having "tarted up" his old work.[18]

Bochner's work has always been articulated as a critical encounter with the notions of painting and sculpture; in titles like *Theory of Sculpture* and *Theory of Painting*, the word "theory" seems to indicate an intention to "critique" in a more or less Kantian sense. But it would be equally productive to emphasize this work's engagement with architecture. As we have often been told, architecture was once the mother of arts, painting and sculpture in happy dependence on it. From this point of view, the history of European art at least since the Renaissance can only be told as a chronicle of

dilapidation. Although in a 1969 interview Bochner wanted to discount an architectural reading of his work, his explanation for this stance finally affirms his work's identification of architecture as the site of its contention: "One of the reasons that the means I use are so ephemeral, so 'thin,' is to undermine the domination of architecture, to force it to surrender its transparency."[19] Bochner's "sculpture" presents itself as a counterarchitecture, an architecture of the unbuilt – allowing this word its inherent ambiguity: not (yet) built, the usual usage, but also negatively built, built backward from completion to incompleteness, even, we might say, deconstructed. Yet this "unbuilt" is not, as it might appear, in a state of equilibrium. It is not the "entropy" that so fascinated Bochner's friend (and collaborator on the text "The Domain of the Great Bear"),[20] Robert Smithson. It is the raw material of the already worked. "We take our thoughts from the accumulated rubble of our mental state, and shape them into forms suitable for discourse."[21] It is a genuinely pataphysical insight: to destroy architecture is to create a ruin, but to destroy the ruin, it must be incorporated into a new architecture.

# 20

# ROSS BLECKNER
Memories of Light

Light, space, image, meaning – these are the virtual properties of painting which are the concerns of Bleckner's work.* He explores these utterly traditional themes forthrightly but always remains willing to put each of them into question, either through negation (absence of light, of space, of image, of meaning) or through excess (too much light, too much space, too much image, too much meaning).

It is perhaps the road of excess that is more uncommon, at least against the background of the modernist penchant for reduction. What do I mean by too much light? Think of certain stripe paintings, for instance, where the clash of colors produces the sensation of being too bright to look at directly, so that the viewer's eyes must be averted. Too much space? Not only has Bleckner painted interiors that readmit the kind of deep space which was supposed to have been banished from modern painting, but he has layered this space in such a way as to reduplicate and multiply space as in a play of mirrors. Too much image? See how, in some of Bleckner's

*This chapter is a revised version of an essay originally published in *Art in America*, November 1995.

191

newest paintings, such as *Family Plot*, 1995, which are also painted in a looser, more unfinished style than we might expect, imagery crowds the surface. Too much meaning? Content is literally spelled out – no longer just a "glimpse," as Willem de Kooning once called it (and as it so often is in Bleckner's work), it materializes as a word, a text, an inscription across or within the surface of the painting.

But if all these tactics of excess are present in Bleckner's work, how can I simultaneously speak of the absence of the very same elements? In other paintings I find an obscuring darkness (too little light), a relentless frontality (too little space), absolute abstraction (too little image), deliberately elusive content (too little meaning). For these reasons, and despite the fact that Bleckner has worked at a fairly limited number of stylistic devices and recurrent images since his first mature work in 1981, it would be impossible to describe a "typical" Bleckner painting, an ideal type that stands in for the character of the rest.

Nonetheless, there are certain features that have become particularly associated with Bleckner's work, if only because they are relatively rarer in that of other artists – or were so until Bleckner's influence became pervasive. Among these, for instance, is the use of a glossy, varnished surface that recalls both Old Master painting and photography – the two bêtes noires of modernism. The "slick" surface (and notice how the purely descriptive term attracts moral overtones, of which Bleckner's detractors have availed themselves) at first glance appears to be a polemically antimodernist device, since artistic modernism came into being precisely in opposition to the "licked" surface of the output of the nineteenth-century academies. Duplicitously disavowing the materiality of its construction, the highly finished surface meant to fuse the traces of the artist's hand into a seamless and inarguable unity that would be considered synonymous with the real: such a painting should appear to be all

image, without remainder. But Bleckner's use of this technique is quite different, and it is of a piece with his use of a more conventionally modernist roughness elsewhere, precisely because both are used in contradictory ways.

Bleckner's shiny surface, like that of academic painting, renders the painting transparent to the image – but in the derogatory sense of the word "image," as mere appearance. The things we see represented here show themselves as ghostly demarcations, as reflections of light off surfaces without substance, forms without body. I am thinking particularly of some of Bleckner's urns and vases, which are depicted as it were in the act of absconding, leaving only their too-bright radiance behind, as in *Hospital Room*, 1985. By disengaging the gleam from its virtual support, Bleckner characterizes pictorial representation as projection rather than observation, as the product of longing rather than certainty.

But it is important to remember that, even if Bleckner's work has been notable for this revaluation of the possibilities for the glossy surface, its use has by no means been a constant with him. Thomas Crow's essay for the catalogue to the Guggenheim's recent exhibition of Bleckner's work perpetrates a misunderstanding by pretending that it has. The immediate result is that, in order to verify the "disturbance" caused by Bleckner's supposed break with the canonical modernist sense of surface, Crow rebukes a fellow critic for having "dismissed balance from the start" in favor of "free association" when in fact that viewer was correct in noticing the dry, tacky paint texture of Bleckner's 1983 dark landscapes such as *Delaware* and *God Won't Come* – paintings that partake precisely of the "matte, woven, porous" surface that Crow seems to believe Bleckner has utterly repudiated.[1] Crow's assumption of consistency obscures the elasticity of Bleckner's manifold approaches to a critical engagement with modernism, exaggerating them into the kind

of out-and-out break that would "save" Bleckner for postmodern-ism.

Bleckner's stripes may be considered images of abstraction, in the manner of 1980s simulationism, but this cannot prevent them from being, nonetheless, abstract. A stripe, even if it represents or allegorizes itself as "stripe," nonetheless always remains literally a stripe. The stripes are never held at the distance of representation, even when (as in *Infatuation*, 1986–7, one of his least successful efforts) Bleckner superimposed the image of a bow to see whether that would transmute the stripes into the mere image of wrapping paper. As he must have been hoping, it did not; the stripes maintain themselves as literal marks of certain colors on a canvas. Nonethe-less there seems to be some problem in Bleckner's stripe paintings as to the location of the stripes. It's as though they refuse to stay on the canvas, although they cannot possibly be anywhere else.

A painting in the mode of classical representation presents something absent as though it were really there, but Bleckner's rep-resentation tends to present something absent as no longer there. By contrast, an abstract painting claims to display things that are literally present – certain colors, certain shapes, certain markings; but in Bleckner's stripe paintings these things can escape their an-chorage to the canvas and propel themselves outward toward the viewer. The glare of the clashing colors, or simply of the strobo-scopic or (as Stephen Melville put it) "shuttering" effect of the rapid intermittency of brightness and darkness as the eye scans through the crowded stripes, approximates a tangible pressure on the viewer's body.[2] The disembodied, subjective effect impresses itself as more vivid, more intense, more physical than the merely literal marks on the canvas. The real is de-realized by its own effect.

Bleckner subjects both classical representation and modernist abstraction to similar stresses. Their opposing claims to represent

reality are made to undermine themselves. But to what end? Not as an intellectual exercise, it seems. More like a melancholic's game of reassuring himself of the hollowness of things. Everywhere, Bleckner's paintings remind us of their memorializing aspiration. Yet they leave us in doubt as to the possibility of fulfilling this memorializing desire, even of truly comprehending it. *Remember Me*, 1987 (Fig. 26), is a red, white, and black painting whose stiffly upright stripes are counterpointed by the support's fancifully scalloped contours. In this context the stripes can no longer be seen as upholding a pictorial "logic" – the re-marking of the framing edge, for instance – but as projecting a subjective stance, one which is no more or less arbitrary in its claims than the capricious curves that simultaneously contain and interrupt the stripes. Within the surface of the painting, its title appears as an embedded inscription in simple upper-case block letters: REMEMBER ME. This plea, or command, appearing as it does beneath the skin of the painted surface, and revealed by the play of ambient light across the painting's surface, would appear to be proposed as the "unconscious" message of the stripes. But does Bleckner want us to see the putatively contentless abstraction of the stripes as a cover-up? Is he implying that the abstractionist's pose of objectivity always masks some naked emotional need? Or that abstraction, rather, is the proper *expression* of this need?

Furthermore, we may wonder what subject is designated by the pronoun "me." Is it the artist speaking *in propria persona*, or rather the painting itself, in a trope of personification? Or, as in Poussin's *Arcadian Shepherds*, could Death be the speaker?[3] It would be going too far to affirm that, yet the context of Bleckner's *oeuvre* makes it hard to exclude this reading. The painting itself can never show us how to decide. Someone or something must be remembered, and the plea for memory is either inadvertently betrayed or intention-

**Figure 26.** Ross Bleckner, *Remember Me*, 1987. Oil on canvas, 110¼ × 86 in. Photo by Zidnman/Fremont. (Courtesy of Mary Boone Gallery, New York)

ally communicated by abstract painting. Does painting remind us to remember that there is something to remember, or to remember that there is something to forget? In either case, the injunction to remember can no more be completely fulfilled than the will to forget. The very idea of a subtext, by having been literalized, has been thrown into question.

Representation, abstraction, inscription – none of these is proposed by Bleckner's work as worthy of faith, but neither can any of them be discarded. Each answers, however inadequately, to some human need. If the paintings in the *Architecture of the Sky* and *Invisible Heaven* series submit modernist frontality and all-overness to a system of perspectival recession, that's because presence and transcendence are needs whose apparent opposition can hardly be adjudicated. And if one of Bleckner's recurrent images is a two-handed urn or trophy – an emblem in *Memoriam*, 1985, it has become a pattern in *Memorial I*, 1994 – this is not only because it corresponds to the notion of a vessel but also because it represents something that can be grasped. And for every painting that highlights its own elusiveness, Bleckner has painted one that gives its viewer a handle. This fact is not unrelated to the real difficulties posed by his work's reception – not, as Crow would have it, problems to do with its early reception, but the resistance Bleckner's work faces today.

At any given time there seem to be a handful of artists who are able to do no wrong. Their work is usually either of unusual breadth or of unusual ambiguity, and somehow it has been positioned in such a way that many camps within the art world feel called upon to claim it as their own. For a good portion of the 1980s, Ross Bleckner was one of those fortunate artists. He had been an early supporter of the *enfants terribles* of the first years of the decade, Julian Schnabel and David Salle, and his own cause was soon taken up by one of those of mid-decade, Peter Halley, whose essay on Bleckner's work preceded his own emergence as a notable painter.[4] Whether you were counting on a return to representation and expression, to a disabused contemplation of the simulacrum, to the continuation of modernist abstraction and self-reflection, or to an opening to topical content such as the AIDS crisis, you could find something in Bleckner to support your position.

The problem, of course, is that the very ambivalence within Bleckner's work that once allowed it to be all things to all people now makes it fall between all stools. But there has been a peculiarly vituperative cast to the reaction against Bleckner. Apparently the issue according to which his art lives or dies is that of sentimentality. But that's a curious issue. Although Michael Kimmelman accuses Bleckner of "exploiting" the AIDS issue,[5] this painter, who has, to my knowledge, made just one painting alluding *specifically* to the crisis (*8,122+ as of January 1986*, 1986, not on view at the Guggenheim) could as easily have been accused of evading it. As usual, Bleckner's excess is inseparable from his restraint. We all know that artistic modernism is dead set against sentimentality. That stance is part of the fatal dichotomy, set out in 1939 by Clement Greenberg, between "avant-garde" and "kitsch." It would take another quarter century for an intellectually respectable apologia for the role of kitsch to be mounted. But even in Susan Sontag's "Notes on 'Camp,' " sentimentality was kept at bay, since the Camp subsumption of kitsch still called for the triumph of "pure artifice," for what is "wholly aesthetic," over meaning.[6] But although it might be tempting to see work by an outspokenly gay artist which courts sentimentality as being imbued with a Camp sensibility, this would be wrong in Bleckner's case. What grates in Bleckner's work is its earnestness. The paradox in Bleckner's work may be in its attempt to reconcile the irreconcilable, what Sontag called "the two pioneering forces of modern sensibility. . . . Jewish moral seriousness and homosexual aestheticism and irony."[7]

Too modernist, too postmodernist, too earnest, too ironic, too middlebrow, too refined, Bleckner goes against the grain of the moment. That's not an uninteresting place to be. The Guggenheim retrospective does not make the best possible case for this artist, not because the show is too big – though it's inclusive enough to

remind us forcefully that, like any contemporary painter whose work reclaims aspects of premodernist technique, Bleckner is essentially self-taught, with an autodidact's capacity to handle similar problems brilliantly in one instance, lamely in another. More damaging is poor organization. Beginning as a chronological survey but veering off into near randomness partway through, the exhibition fails to delineate clearly the artist's development or to offer a synoptic view of any consistent project. But the evidence is all there, a body of work that is more, or in any case other, than the sum of its contentious parts.

———————— **21** ————————

# L. C. ARMSTRONG
## Written on the Skin

"It's a remarkable piece of apparatus," one wants to say, just as the officer said to the explorer at the beginning of Kafka's story "In the Penal Colony."* Like Kafka's horrific torture mechanism, which slowly killed by inflicting on the flesh of the condemned prisoner an absurdly embellished script of wounds, the judgment that had been passed upon him, L. C. Armstrong's *Dream Machine*, 1992 (Fig. 27) is a bed whose use could only be for the execution of a *sentence* – in both senses of the word: language as punishment. In Armstrong's work, the bare foam mattress on a folding hospital bed bristles menacingly with some four thousand sharpened pencils. What dreams are to be inscribed upon the body of the one condemned to lie there?

In any case, it is clear that language and its mechanics of inscription, as Armstrong understands them, are not be considered primarily as a form of mental activity, but rather as something investing the body as a whole. Indeed, Armstrong, an emerging but already mature New York artist with a way of making almost sub-

*This chapter is a revised version of an essay originally published in *Art Press*, July–August 1994.

**Figure 27.** L. C. Armstrong, *Dream Machine*, 1992. Mobile bed, pencils, 192 × 100 × 62 cm. (Courtesy of Bravin Post Lee Gallery, New York)

liminally "hot" sculpture and painting out of cool, severe, industrial materials, is one of a number of artists at work today for whom language is central, but precisely where it lacks the transparency of a legible text. The distinction between notational writing and representational imagery appears to be very ancient as well as deep-seated: the anthropologist Alexander Marshack distinguished the appearance of both on markings made in French caves twenty-eight thousand years ago, and the neurologist Norman Geschwind showed in the 1970s that reception of language on the one hand and of images on the other is localized in completely different parts of the brain.[1] Imagistic thinking and linguistic thinking can never

**201**

quite coincide, but each would be incomplete or lacking in depth
without being intertwined with the other. Even the most austere
and abstract language, with the possible exception of formal logic,
includes some implicit or explicit level of imagery, and all visual
imagery is dependent on some kind of linguistic coding if it is to
be recognized. When Armstrong replicates a text on the surface of
one of her paintings with a bomb fuse, which she then ignites to
leave rows of illegible burn marks – she has done this with poems,
though she won't say which, and with an obituary from a newspa-
per, though she won't say whose – do we receive the result visually
or linguistically? Here writing is just this pure image of itself, not
as denotative transparency but as something whose content is seared
so deeply into memory as to be practically invisible. Writing trans-
lates into vision, but vision in turn translates into touch.

This double relay – language to sight, sight to touch – is also
the subject of a recent series of works which take the form of square
monochrome paintings, each encased in an intensely reflective sur-
face of resin, as Armstrong's paintings usually are. In this case, how-
ever, the resin surfaces are beaded to create braille texts spelling
the names of the specific shades that make up the color of the
painting; for instance a "green" painting bears the words "aqua,"
"bottle-green," "chromium oxide," "cobalt green," "duck green,"
"emerald green," "thalo green," "shamrock green," "terre verte,"
and "turquoise." Braille, of course, is the most obvious instance in
which writing becomes tactile rather than visual. But for the sighted
viewer of these paintings, who must, moreover, respect the tacit
injunction not to touch the work of art (and a finger's imprint would
show up patently on these lucent surfaces) and who probably knows
no braille, the beaded lettering paradoxically represents a purely
visual sign for the possible tactility of language. So it's a triple relay:

writing to vision, vision to touch, touch back to the visual impression of touch.

Language, according to Armstrong's work, is always inscribed within the body. It's retained, a matter of memory. One can imagine Armstrong recognizing her own project in a certain Nietzschean theme: "If something is to stay in the memory it must be burned in: only that which never ceases to *hurt* stays in the memory . . . Pain is the most powerful aid to mnemonics." (*On the Genealogy of Morals*, 3).[2] In fact, the stylistic coolness typical of Armstrong's work begins to look all the more uncanny when one realizes that her imagery is a veritable catalogue of violence, pain, and disaster. At its most remote this violence may be present only through the sense of its bureaucratization or medicalization, as in the hospital bed of *Dream Machine*, or in a number of works that use the device of the clipboard, sometimes oneirically distorted to extreme length or multiplied numerically as if to reach toward a "bad infinity," always gripping "pages" of weirdly fleshlike latex which has been repetitively lined as though with a mute or completely neutral notation. But more often this sense of pain and violence is presented with an all too discomforting literalness, as in paintings scorched by bomb fuses or pierced by bullet holes haloed by powder burns, or in bronze sculptures – *Road Scribbles*, as Armstrong calls them with grim humor – that immortalize the strips of tread that sometimes peel off car tires in accidents. The violence implicit in Armstrong's work is not always so lethal, however; sometimes it may be nothing more than the pleasurably playful threat implied by the knotted and tightly stretched nylon stockings that are another recurrent motif.

Armstrong's is not a narrative art, but only because it remembers stories that are too painful or too private to tell. It remembers them, not in the sense that an involuntary memory wells up into

consciousness, but rather as a memorization that has willfully burned its message into consciousness and sealed it off where nothing can touch it. Armstrong once remarked that she has always wanted her art to go more in the direction of music but that it always ends up tending more toward language, which I take to mean that her art is not symbolist but rather allegorical. In an essay entitled "Sign and Symbol in Hegel's *Aesthetics*," the literary critic and theorist Paul de Man tried to make sense of Hegel's famous and enigmatic remark that "art is a thing of the past." De Man observed that

> to the extent that the paradigm for art is thought rather than perception, the sign rather than the symbol, writing rather than painting or music, it will be memorization rather than recollection. As such, it belongs to a past which, in Proust's words, could never be recaptured, *retrouvé*. Art is "of the past" in a radical sense, in that, like memorization, it leaves the interiorization of experience forever behind[3]

– forever behind resin, one wants to amend the text, because the very thing that separates us from the immediacy of experience is what preserves it as a sign, as a warning, as a promise.

# RAINER GANAHL
## Windows on the Word

It is useful to distinguish between boundaries and limits, a distinction ably expounded, under Hegelian inspiration, by the Slovenian sociologist Slavoj Žižek in his recent book *For they know not what they do*:*

> *boundary* is the external limitation of an object, its qualitative confines which confer upon it its identity . . . whereas *limit* results from a "reflection-into-itself" of the boundary: it emerges when the determinatedness which defines the identity of an object is reflected into this object itself and assumes the shape of its own unattainable limit, of what the object can never fully become, of what it can only approach into (bad) infinity – in other words, limit is what the object *ought to* (although it never actually *can*) become.[1]

Žižek gives as an example the definition of national identity. To identify oneself as an Englishman, in contradistinction to the French or Germans, is an experience of boundaries; but to wonder what is "really" English about the English, to attempt to reflect this

*This chapter is a revised version of an essay originally published in *Art Press*, April 1993.

identity internally to the concept of Englishness, is to discover that "every empirical Englishman contains something 'non-English' – Englishness thus becomes an 'internal limit,' an unattainable point which prevents empirical Englishmen from achieving identity with themselves."[2] For us, a more salient example of this process may be the way, according to Žižek, it defines

> the break between traditional and modern art. The traditional work of art presents a well-rounded organic Whole upon which harmony is bestowed by means of the boundary separating it from the Outside; whereas modernism, so to speak, internalizes this external boundary which thereby starts to function as a limit, the internal impediment to its identity: the work of art can no longer attain its organic roundedness, "fully become itself"; it bears an indelible mark of failure and the Ought [*Sollen*] – and thereby its inherent ethical character.[3]

There is something suspiciously obvious about Žižek's historicization of the distinction he's making here, although Žižek himself also provides the means by which we can resolve the difficulty; further thought obliges us, if we take what he says seriously, to locate the origin of artistic modernism in precisely that "traditional" art with which it was supposed to represent a break: certainly we would find this modernism in the Romantic cult of the fragment and the ruin, but even before that in the Renaissance itself, in Michelangelo's notorious inability to complete his projects, for example, or in Leonardo's many abandonments, the Duchampian way his few extant works are swamped by an impenetrable mass of "mirrorical" notations. We are used to Jean-François Lyotard's contention (in *The Postmodern Condition: A Report on Knowledge*) that artistic modernism was already postmodern; we must equally recognize that this postmodern modernism was already Ro-

206

mantic, and before that already classical – therefore to recognize art in its historicity is precisely to abandon these rough-and-ready periodizations. To rejoin Žižek:

> but we have . . . lost something with such a disposition into "phases": we have actually lost what is crucial, the encounter with the Real . . . The paradox is thus that historicity differs from historicism by the way it presupposes some traumatic kernel which endures as "the same," non-historical; and so various historical epochs are conceived as failed attempts to capture this kernel.[4]

The "kernel" can, of course, be identified with what Žižek will also call the "limit," that is, this inward-reflection of the boundary, but also with what Jacques Derrida, in *La Verité en peinture*, referred to as the "parergon," that is, whatever is neither inside nor outside the work (Derrida's great example is the frame). In the case of Western painting from the Renaissance on (at least), there are a number of salient instances of such internalized limits: among them not only the frame (the physical boundary between the painting and its setting), but also the viewer (or as Michael Fried would say, the beholder), for instance, or the referent. The train of art historical periods from the Renaissance through Mannerism, the Baroque, Classicism, and Romanticism on to Impressionism and Modernism could be traced as a sequence of flawed solutions, not simply to the problems posed by these parerga, but above all to the flawed solutions of the preceding phases. Likewise, conceptual art as it arose in the late 1960s (by projecting its origins back to the work of Marcel Duchamp some five decades earlier) found its traumatic kernel in precisely what it always claimed to have superseded, that is to say, in painting itself.

More recently we have seen, among other things, the appearance of a neo-Conceptualism that sought to allay the anxieties

caused by what was problematic in conceptual art through a rein-
vestment in the notion of the object, and also that of a "conceptual
painting" – what could by analogy with neo-conceptualism be called
a neomodernism – that would recuperate the failings of modernist
abstraction by means of a referential supplement (Peter Halley's
"cell," for example). Even more recently, however, a kind of "new
modernist" painting has reared its head, one whose apparent in-
nocence actually shows rather more sophistication than what I have
called neomodernist work, thanks to its acknowledgment that
merely patching up the holes in modernist ideology with hetero-
genous matter under a banner of allegory will never do. This "new
modernism" (examples might be found in the paintings of Carl
Ostendarp or Fabian Marcaccio, or the three-dimensional work of
Jessica Stockholder) attempts instead to actively reengage aspects
of the modernist project in a relatively disillusioned way.

Likewise, the work of Rainer Ganahl, an Austrian-born artist
living in New York, represents not another neo-conceptualism but
rather a kind of "new conceptualism," as unrestricted by the invei-
glements of commodification as anything Lawrence Weiner or Jo-
seph Kosuth were doing in 1969. A work by Ganahl may be
embodied in an object (a doormat, a compact disk, a shopping bag)
or as a slide projection, a wall painting, and so forth, but subsists
just as well in the form of information; compare Weiner's program-
matic dictum that "1. The artist may construct the work; 2. the
work may be fabricated; 3. the work need not be built." But this is
no reprise of an already defined project. Whereas a single work by
Weiner may be variously realized, for Ganahl different realizations
of the same information represent distinct works. Further, Ganahl's
work succeeds in defining something as *missing* in classic conceptual
art, an absence we could never have noticed until Ganahl elicited
it. If the notion of information was a metaphorical crux of early

208

conceptualism, Ganahl shows us that what was missing then was precisely the metaphor of this metaphor, that is, the metaphor that would conceptualize conceptualization, and that today this metaphor must be that of the computer.

And here it should be emphasized that in Ganahl's work the computer *is* a metaphor. The artist explains that he does not actually use a computer in the production of his work; his "windows" may resemble but do not correspond to Microsoft windows; this has nothing to do with "computer art" or other vulgar-futurist romanticizations of "new technologies." Instead, Ganahl uses the *language* of the computer as a means to mobilize elements of pictorial structure and its ideological and economic context as abstract schemata. Ganahl's work, like that of the most significant first-generation conceptualists, does not propose to add "content" to the formalism of abstract painting as one might add water to dehydrated milk but achieves its social content (in the midst of what Mark Poster has described, in *The Mode of Information*, as a "social scene . . . increasingly composed of electronically mediated communications that expand upon and magnify the self-referential aspects of language")⁵ through an idiosyncratic hyper-formalization of abstraction.

Always alluding back to a notional total system which always remains under construction, each work by Ganahl falls into one of a number of series, such as *Files*, *Windows* (Fig. 28), *Samples*, or *Markers*. Each refers, either directly or through the intermediary of one of the other series (namely, the *Windows*), either to a (fictive) database that consists of materials derived from published books, or else to operational commands, the instrumental language of the system itself. However, the book material seen through any *Window* is never the actual text of the book. Instead, Ganahl draws exclusively on certain "marginal" or, so to speak, parergal portions of

**Figure 28.** Rainer Ganahl, installation view, Galerie Roger Pailhas, Marseilles. Left: *window, ind. soja rac & ethn . . .* , 1993. Wall painting, certificate of authenticity, dimensions variable. Right: *couper, coller, copier, effacer,* 1993. Wall painting, inlaid wood; certificate of authenticity, dimensions variable. Photo: Fred Pedram. (Courtesy of Galerie Roger Pailhas, Marseilles-Paris)

the book, such as the index, the notes, and the copyright page. Thus, although books by such authors as Mike Davis, Gayatri Spivak, Manfredo Tafuri, or (for that matter) Slavoj Žižek may be considered as referents of Ganahl's artworks, in his use of them they merely defer or relay any referentiality. Derrida has pointed out that the use of computers in writing "makes for reversibility and easy supplementarity of insertion of texts; yet, the computer protects linear writing by expanding its capacity for integration (that is, the ability to erase annotation, and thus other voices, from the principal text)."[6] By reducing his material to solely these traces

of otherness at the boundaries of texts, Ganahl disperses the linearity of writing across a multiplanar, layered space which is closer to that of the conceptual space of abstract painting than it is to familiar textual forms. This becomes explicit through the *Samples*, which excerpt close-up swatches of particular *Windows* in such a way as to mimic works of modernist abstract painting or graphic design, that is, the actual historical source of the design of the computer graphics from which they "abstract."

In fact, it makes sense to see what Ganahl is doing as a hyper-abstraction of the history of picture making – an abstraction pursued so far that the topical content that abstraction necessarily eliminated has begun to seep back in from the edges. In a typical Ganahl Window onto the index of Herbert I. Schiller's *Culture Inc.*, the simple alphabetical range from *"Labor, division of. See also Organized labor"* through *"Massachusetts Institute of Technology (MIT)"* to *Media power: and accountability; and the active audience; and audience power/ preferences; and audiences as producers or* [sic] *meaning"* montages a surprisingly wide-ranging cross-section of elements of contemporary social structures: persons, institutions, issues. But of course we are told nothing about them; they are merely indexed. It is precisely here that we find the "indelible mark of failure" that Žižek wrote of, the work's ethical core. It is the source, as well, of the scathing irony which always lurks somewhere in the work, most clearly in the "special note" portion of certain of the Files: for the File *100% Silk*, for instance, a work projected to consist of the materials "silk, text, graphics, plus a copy of the book cited" (Antonio Gramsci's *Quaderni del Carcere*), the note specifies that "the acquisition of this luxury product will serve as a substitute for not finding the time to study Gramsci." Unlike much political art that relies on didacticism, Ganahl's work bears the knowledge that art is *not* a form of political knowledge, let alone political instruction.

211

This art inevitably refers to the social, to the political – but just as that which can only be known socially, politically, through research and through action, just outside the margin of the aesthetic, beyond the direct reach of art.

# NOTES

## Preface and Acknowledgments

1. Benjamin H. D. Buchloh, "The Allegories of Painting," in *Gerhard Richter: Documenta IX, 1992/Marian Goodman Gallery, 1993* (New York: Marian Goodman Gallery, 1993), 12.
2. George Steiner, *Real Presences* (Chicago: University of Chicago Press, 1989), 83.
3. Fairfield Porter, "Class Content in American Abstract Painting," in *Art in Its Own Terms: Selected Criticism, 1935–1975* (Cambridge: Zoland, 1993), 249–57.
4. Fairfield Porter, "The Short Review," in *Art in Its Own Terms*, 168.

## PART I. ABSTRACTION, REPRESENTATION . . .
### Chapter 1. The Widening Circle

1. Istvan Deak, "Survivors," *New York Review of Books*, March 5, 1992, 49.
2. Arno Borst, *Medieval Worlds: Barbarians, Heretics, Artists*, tr. Eric Hanson (Chicago: University of Chicago Press, 1992), 193.
3. Donald Judd, "Barnett Newman," in *Modern Art and Modernism: A Critical Anthology*, ed. Francis Frascina and Charles Harrison (New York: Harper & Row, 1982), 129–30.
4. Willem de Kooning, *Collected Writings* (Madras: Hanuman, 1988), 82–3.

5. "Carl Ostendarp," *Arts Magazine*, February 1992, 59; "David Row," *Arts Magazine*, May 1991, 76; "Suzanne McClelland," *Arts Magazine*, December 1991, 63. For more on Row, see chapter 10 in the present volume, "The Rustle of Painting."
6. Clement Greenberg, "Intermedia," *Arts Magazine*, October 1981, 92.
7. Mark Stevens, "Thin Gray Line," *Vanity Fair*, March 1989, 56.

## Chapter 2. "The Real Situation"

1. "Philip Guston Talking," in *Philip Guston: Paintings, 1969–1980* (London: Whitechapel Art Gallery, 1982), 49.
2. Harold Rosenberg, "On Art Movements," in *The Anxious Object* (Chicago: University of Chicago Press, 1982), 240.
3. Dore Ashton records this remark both in *Yes, but . . . : A Critical Study of Philip Guston* (New York: Viking, 1976), 133, and in *About Rothko* (New York: Oxford University Press, 1983), 167. In the former it is attributed to an interview with Karl Fortess in the Archives of American Art; in the latter, to "a conversation with the author." Generally, my debt to Dore Ashton's writings on both of these artists goes far beyond what can be indicated by these notes.
4. Brian O'Doherty, "Rothko's Endgame," in *Rothko: The Dark Paintings, 1969–1970* (New York: Pace Gallery, 1985), 6.
5. Sam Hunter, quoted in Ross Feld, *Philip Guston* (New York: George Braziller, 1980), 14.
6. Max Kozloff, *Renderings* (New York: Simon & Schuster, 1969), 149.
7. Quoted by Dore Ashton, *The New York School* (New York: Penguin, 1979), 189.
8. John Willett, ed., *Brecht on Theatre* (New York: Hill & Wang, 1964), 8n.
9. Russell, quoted by Ashton, in *Yes, but . . .* , 134–5.
10. "Philip Guston Talking," 50.

## Chapter 3. Norman Bluhm and the Eternal Feminine

1. See my essay "After the Great Separation: On One Tendency in Recent American Abstract Painting and Its Background," *Arts Magazine*, November 1985, 22–5.

2. Donald Kuspit, "Norman Bluhm at SUNY," *Art in America*, February 1985, 196–7, is the source for all citations from Kuspit in this essay.
3. Clement Greenberg, "The School of Paris: 1946," in *Art and Culture* (Boston: Beacon, 1961), 120–3.
4. Kenneth Baker, "Second Generation: Mannerism or Momentum?" *Art in America*, June 1985, 104.
5. Caylus, quoted by Edmond and Jules Goncourt, in *French Eighteenth-Century Painters*, tr. Robin Ironside (Oxford: Phaidon, 1948), 26.
6. Arthur Danto, "François Boucher," *The Nation*, April 5, 1986, 499.
7. Lisa Liebmann, "The Imagination in Sheep's Clothing," *Artforum*, April 1986, 81.
8. Paul Schimmel, "The Lost Generation," in *Action/Precision* (Newport Beach, CA: Newport Harbor Art Museum, 1984), 28.

## Chapter 4. Color Field and Caro

1. Brian O'Doherty, *Inside the White Cube: The Ideology of the Gallery Space* (Santa Monica, CA: Lapis, 1986), 26. First published in *Artforum*, March, April, and November 1976.
2. See Anna C. Chave, "Minimalism and the Rhetoric of Power," *Arts Magazine*, January 1990, 44–63. Of Caro, Noland, and Olitski, by contrast, Charles Harrison has suggested that "we might wish to acknowledge that their work is in certain respects free from implication in the manipulative and managerial aspects of that culture which puts them to use," in *Essays in Art & Language* (Cambridge: Blackwell, 1991), 260, n. 23.
3. Donald Judd, "Specific Objects," 1965, republished in *Complete Writings, 1959–1975* (Halifax: Press of the Nova Scotia College of Art and Design, 1975), 184.
4. Michael Fried, "Art and Objecthood," in *Minimal Art: A Critical Anthology* ed. Gregory Battcock, (New York: Dutton, 1968), 12. First published in *Artforum*, Summer 1967.
5. "Caro Noland Olitski," Joseloff Gallery, University of Hartford, April 28–June 15, 1994; "Anthony Caro: A Major Survey of Recent Sculpture on the Occasion of the Artist's Seventieth Birthday," Andre Emmerich Gallery, April 14–May 27, 1994; "Larry Poons," Salander O'Reilly Galleries, April 5–30, 1994.

6. Donald Judd, "Complaints," pt. 1, *Studio International*, April 1969, 183.
7. Leo Steinberg, "Other Criteria," in *Other Criteria: Confrontations with Twentieth Century Art* (New York: Oxford University Press, 1972), 79.
8. Odilon Redon, *To Myself: Notes on Art, Life, and Artists*, tr. Mira Jacob and Jeanne L. Wasserman (New York: Braziller, 1986), 148.
9. Sidney Tillim, "Ideology and Difference: Reflections on Olitski and Koons," *Arts Magazine*, March 1989, 51.
10. Max Kozloff, "The Inert and the Frenetic," in *Renderings* (New York: Simon & Schuster, 1969), 254. First published in *Artforum*, March 1966.
11. My account assumes that the later (1958) version of Greenberg's 1948 essay "The New Sculpture," published in *Art and Culture* (Boston: Beacon, 1961), preprogrammed the "formalist" reception of Caro's sculpture. Fried has subsequently directed attention to the notion of "syntax," also taken up by Greenberg, as more central to Greenberg's understanding of Caro than that of "opticality." See "Theories of Art after Minimalism and Pop: Discussion," in *Discussions in Contemporary Culture*, ed. Hal Foster, no. 1 (Seattle: Bay Press, 1987), 71–2. In relation to Caro, though, the term "syntax" remains more a suggestive metaphor than a substantive concept.
12. Karen Wilkin, *Caro* (Munich: Prestel, 1991), n.p. Interestingly, Thierry de Duve lists "sculptecture" (without the *i*) among the neologisms coined in the 1960s for what came to be known as Minimalism. See his "The Monochrome and the Blank Canvas," in *Reconstructing Modernism: Art in New York, Paris, and Montreal, 1945–1964*, ed. Serge Guilbaut, (Cambridge, MA: MIT Press, 1990), 269.
13. Robert Smithson, "Letter to the Editor, *Artforum*, October 1967," in *The Writings of Robert Smithson*, ed. Nancy Holt (New York: New York University Press, 1979), 38.

## Chapter 5. Larry Poons

1. Archie Rand, "Archaeologist: Larry Poons Reconsidered," *Arts Magazine*, January 1991, 51.

2. Aristotle, *Metaphysica*, 1.1, tr. W. D. Ross, in *The Basic Works of Aristotle*, ed. Richard McKeon (New York: Random House, 1941).
3. Jean-Paul Sartre, *Being and Nothingness*, tr. Hazel E. Barnes (London: Methuen, 1958), 578.
4. It was Jeff Perrone who first cited Still's "sluggishness" in reference to Poons, in a review, "Larry Poons," *Artforum*, December 1979, 76.
5. Thierry de Duve, "The Monochrome and the Blank Canvas," in *Reconstructing Modernism: Art in New York, Paris, and Montreal ,1945–1964*, ed. Serge Guilbaut (Cambridge, MA: MIT Press, 1990), 283.
6. Donald Kuspit, "Larry Poons," *Artforum*, May 1983, 98.
7. De Duve, "Monochrome," 260, 283.

## Chapter 6. Gesture Revisited

1. Bochner, quoted by Roberta Smith in "Conceptual Art," in *Concepts of Modern Art*, 2nd ed., ed. Nikos Stangos (New York: Harper & Row, 1981), 259.
2. Bochner, quoted by Elaine A. King in *Mel Bochner: 1973–1985* (Pittsburgh: Carnegie-Mellon University Art Gallery, 1985), 11.
3. Carter Ratcliff, "How to Study the Paintings of Brice Marden," *Parkett* 7 (January 1986), 22.
4. Marden, quoted by Ratcliff, ibid., 24.

## Chapter 7. Mary Heilmann's Ceramics and Paintings

1. The literature on still life is, of course, voluminous, but any theoretical consideration of the genre now begins with Norman Bryson, *Looking at the Overlooked: Four Essays on Still Life Painting* (Cambridge, MA: Harvard University Press, 1990).
2. Matthew Weinstein, "Mary Heilmann/Pat Hearn Gallery," *Artforum*, September 1991, 127.
3. Pat McCoy, "A Modern Lexicon," *Arts Magazine*, November 1989, 49.
4. *Mary Heilmann: A Survey* (Boston: Institute for Contemporary Art, 1990), n.p.
5. Roland Barthes, *The Pleasure of the Text*, tr. Richard Miller (New York: Hill & Wang, 1975), 9–10.

## Chapter 8. Porfirio DiDonna

1. Charles Baudelaire, "The Salon of 1846," in *Selected Writings on Art and Literature*, tr. P. E. Charvet (New York: Penguin, 1992), 101–2.
2. Joseph Masheck, *Historical Present: Essays of the 1970s* (Ann Arbor: UMI Research Press, 1984).
3. Lenore Malen, "Porfirio DiDonna: Nielsen," *Art News*, February 1988, 147, 149.
4. Georges Bataille, *Manet*, tr. Austryn Wainhouse and James Emmons (New York: Rizzoli, 1983), 95–6.
5. See, for instance, Michael Brenson, "Porfirio DiDonna," *New York Times*, November 20, 1987, C36; Addison Parks, "Into the Garden: The Paintings of Porfirio DiDonna," *Arts Magazine*, January 1989, 28–31; Nancy Stapen, "Abstract Expressionism of the '60s revisited," *Boston Globe*, February 28, 1991, 73; William Corbett, "Porfirio DiDonna," *Arts Magazine*, April 1991, 84.
6. Norman Bryson, *Looking at the Overlooked: Four Essays on Still Life Painting* (Cambridge, MA: Harvard University Press, 1990), 12–13.
7. Since most of DiDonna's late work is untitled, I borrow his gallery's system of numeration for convenience.

## Chapter 9. Moira Dryer

1. Joseph Masheck, "Hard-Core Painting," in *Historical Present: Essays of the 1970s* (Ann Arbor: UMI Research Press, 1984), 153–69.

## Chapter 10. The Rustle of Painting

1. Martin Jay, *Downcast Eyes: The Denigration of Vision in Twentieth-Century French Thought* (Berkeley and Los Angeles: University of California Press, 1993).
2. René Girard, *Deceit, Desire, and the Novel: Self and Other in Literary Structure*, tr. Yvonne Freccero (Baltimore: Johns Hopkins University Press, 1965).
3. Barry Schwabsky, "David Row," *Arts Magazine*, May 1991, 76.
4. Barry Schwabsky, "David Row/John Good Gallery," *Artforum*, February 1994, 88.

5. Frege, quoted in Brian Rotman, *Signifying Nothing: The Semiotics of Zero* (Stanford: Stanford University Press, 1993).
6. Jacques Lacan, *The Four Fundamental Concepts of Psychoanalysis*, ed. Jacques-Alain Miller, tr. Alan Sheridan (New York: Norton, 1981), 76–7.
7. Schwabsky, "David Row/John Good Gallery," 88.
8. Jacques Lacan, "The Mirror Stage as Formative of the Function of the I as Revealed in Psychoanalytic Experience," in *Ecrits: A Selection*, tr. Alan Sheridan (New York: Norton, 1977), 4.
9. Lacan, *The Four Fundamental Concepts*, 84.
10. Ibid., 101.
11. Barry Schwabsky, "Brenda Zlamany/E. M. Donahue Gallery," *Artforum*, February 1993, 100.
12. Schwabsky, "David Row/John Good Gallery," 88.
13. Meg O'Rourke, "The Weight of the Word: The Sculpture of Roni Horn," *Arts Magazine*, November 1991, 59.

## PART II. ITALIAN INTERLUDE
### Chapter 11. W De Pisis

1. Anyone who wants to learn more about de Pisis but does not read Italian is in for a hard time. The only previous essay I know of in English is Loredana Parmesani, "Filippo de Pisis," *Flash Art*, January 1983, 110 – but it is excellent. For readers of Italian, on the other hand, there is at this point almost too much material to take in. Aside from the catalogues of the two exhibitions discussed in this essay (Claudia Gian Ferrari, *De Pisis: Mite e mete* [Milan: Mazzotta: 1987], and Dino Tega, *De Pisis: Indedite e opere scelte* [Milan: Tega, 1987]), I have mainly relied on the very informative *De Pisis: Didasclie per un pittore*, ed. Luigi Cavallo (Milan: Mazzotta: 1983). For a curious parallel to de Pisis's use of the *W* symbol, see Marcelin Pleynet's essay on Robert Motherwell in his *Etats-Unis de la Peinture* (Paris: Seuil, 1986).

### Chapter 12. Rotellascope

1. For much of the biographical information as well as the quotations from Rotella and his critics (some of which, however, I have retran-

slated), I have relied on *Rotella: Décollages, 1954–1964,* introduction by Sam Hunter (Milan: Electa, 1986).

## Chapter 13. Michelangelo Pistoletto

1. Pistoletto, quoted by Augusta Monferini in "Percorso di Pistoletto," in *Michelangelo Pistoletto,* ed. Augusta Monferini and Anna Imponente (Milan: Electa, 1990), 11 (my translation).
2. Jan Bialostocki, "Man and Mirror in Painting: Reality and Transience," in *The Message of Images: Studies in the History of Art* (Vienna: IRSA, 1988), 107.
3. See Rosalind E. Krauss, "Sculpture in the Expanded Field" (1978), in *The Originality of the Avant-Garde and Other Modernist Myths* (Cambridge, MA: MIT Press, 1985), 288.
4. Pistoletto, quoted by Germano Celant, "Reflections of Lava," in *Pistoletto: Division and Multiplication of the Mirror,* ed. Germano Celant and Alanna Heiss (New York: Institute for Contemporary Art, 1988), 24.
5. Celant, "Reflections of Lava," 24.
6. Germano Celant, "Arte Povera: Appunti per una guerriglia," *Flash Art* 5, November–December 1967; now in *Flash Art XXI Years: Two Decades of History* (Milan: Giancarlo Politi, 1989), 3; English translation by Henry Martin, 189–91.
7. Marco Meneguzzo, "Towards Arte Povera, 1963–1969: The History between Poetic and Strategy," tr. Howard Rodger MacLean, in *Verso l'Arte Povera: Momenti e aspetti degli anni sessanta in Italia* (Milan: Electa, 1989), 12.
8. The picture-form would be reevoked in the same year as Pistoletto's *Venus of Rags,* 1967, by another artist associated with Arte Povera, Giulio Paolini, with his *Giovane che Guarda Lorenzo Lotto.* In the early 1970s Paolini would also begin using fragments of classical statuary, as would Jannis Kounellis later in the decade. On page 21 of the *Verso l'Arte Povera* catalogue are reproduced some frames of a 1968 film by Luca Patella, showing the Roman artist Pino Pascali up to his neck in a lake or river and kissing on the mouth a likewise submerged classical Venus.
9. Monferini, "Percorso di Pistoletto," 14 (my translation). Meneguzzo, in *Verso l'Arte Povera,* 20, agrees that "Pistoletto . . . , who enjoyed

success before the others did, . . . acted as a catalyst, at least in those first years of the maturing of ideas and the 'coagulation' of a group.

10. Celant, "Arte Povera," 190.
11. Monferini, "Percorso di Pistoletto," 14–16 (my translation).
12. Pistoletto, quoted by Celant, "Reflections of Lava," 27.
13. Krauss, "Sculpture in the Expanded Field," 279.
14. Michelangelo Pistoletto, "Hard Poetry" (1985), from *Pistoletto: Division and Multiplication of the Mirror*, 196.
15. Pistoletto, quoted by Monferini, "Percorso di Pistoletto," 16.
16. Krauss, "Sculpture in the Expanded Field," 280.
17. Albrecht Wellmer, *The Persistence of Modernity: Essays on Aesthetics, Ethics, and Postmodernism*, tr. David Midgley (Cambridge, MA: MIT Press, 1991), 25.

## PART III. . . . AND INSCRIPTION
### Chapter 15. Thomas Chimes

1. Roger Shattuck, *The Banquet Years: The Origins of the Avant Garde in France 1885 to World War I*, rev. ed. (New York: Vintage, 1968), 34. This remains the best general introduction to Jarry and his milieu. See also *Selected Works of Alfred Jarry*, ed. Roger Shattuck and Simon Watson Taylor (New York: Grove, 1965).
2. Stephen Berg, "Framed Faces, Infinite White," in *Tom Chimes, A Compendium: 1961–1986* (Philadelphia: Goldie Paley Gallery, Moore College of Art, 1986), 14.
3. Eileen Berger, "A Conversation with Tom Chimes," *Arts Exchange*, March/April 1978, 26.
4. Jane Livingston, *Thomas Chimes: The Hermes Cycle Paintings* (Philadelphia, Locks Gallery, 1992), n.p.
5. Frances A. Yates, *The Art of Memory* (Chicago: University of Chicago Press, 1966); *Theatre of the World* (Chicago: University of Chicago Press, 1969).
6. "A Conversation with Thomas Chimes and Marian Locks," *Thomas Chimes* (Philadelphia: Marian Locks Gallery, 1990), n.p.
7. Chimes was one of six artists, three from Philadelphia, three English, featured in "Conversation Pieces" (May 13–July 17, 1994), organized by Patrick T. Murphy at the Institute for Contemporary Art, Philadelphia.

## Chapter 16. Cy Twombly

1. "Cy Twombly: A Retrospective," curated by Kirk Varnedoe, Museum of Modern Art, New York, September 24, 1994–January 10, 1995.
2. Kirk Varnedoe, "Inscriptions in Arcadia," in *Cy Twombly: A Retrospective* (New York: Museum of Modern Art, 1994), 9.
3. Rosalind Krauss, "Cy's Up," *Artforum*, September 1994, 70–5, 118. An exchange between me and Krauss on the subject of her text appeared in *Artforum*, November 1994, 7.
4. Varnedoe, "Inscriptions," 24.
5. Robert Motherwell, "Notes," in *Cy Twombly* (Chicago: Seven Stairs Gallery, 1951), quoted by Varnedoe, "Inscriptions," 55, n. 44.
6. Entitled "The Wisdom of Art," the essay has been collected in *The Responsibility of Forms: Critical Essays on Music, Art, and Representation*, tr. Richard Howard (New York: Hill & Wang, 1985), 177–94.
7. Fairfield Porter, "Class Content in American Abstract Painting" (1962), in *Art in Its Own Terms: Selected Criticism, 1935–1975*, ed. Rackstraw Downes (Cambridge, MA: Zoland, 1993), 249–57.
8. John Hawkes, *The Blood Oranges* (New York: New Directions, 1971), 271.
9. Varnedoe, "Inscriptions," 44.

## Chapter 17. Bruce Conner's Inkblot Drawings

1. Rebecca Solnit, *Secret Exhibition: Six California Artists of the Cold War Era* (San Francisco: City Lights, 1990), 60. Despite my demurral here, this is the best source for biographical background on Conner, and I have relied on it at many points in this essay.
2. Thierry de Duve, "Ryman Irreproducible," in *Essais datés I: 1974–1986* (Paris: Editions de la Différance, 1987), 139.
3. Solnit, *Secret Exhibition*, 59.
4. Ron Padgett, *Ted: A Personal Memoir of Ted Berrigan* (Great Barrington, MA: The Figures, 1993), 8.
5. Solnit, *Secret Exhibition*, 118.
6. A different view of the engraving collages was recently presented by Greil Marcus, "Bruce Conner: The gnostic strain," *Artforum*, December 1992, 74–9.
7. Solnit, *Secret Exhibition*, 119.

8. Marcus, "Conner," 75.
9. Quoted by Anson Rabinbach, introduction to *The Correspondence of Walter Benjamin and Gershom Scholem, 1932–1949*, ed. Gershom Scholem (New York: Schocken, 1989), xxx. A recent reexamination of Scholem's reading of Kafka is Robert Alter, "Kafka as Kabbalist," *Salmagundi* 98–9, Spring–Summer 1993, 86–99.
10. Scholem, *Correspondence of Benjamin and Scholem*, 142.

## Chapter 18. Reverse Continuity

1. Betsy Senior Gallery, New York, November 6–December 31, 1993.
2. Sol LeWitt, "Paragraphs on Conceptual Art," *Artforum*, Summer 1987, 80.
3. Bochner, quoted by Elaine A. King in "Building a Language," *Mel Bochner: 1973–1985* (Pittsburgh: Carnegie-Mellon University Press, 1985), 10.
4. "About My Prints: A Conversation between Mel Bochner and Richard Field," Betsy Senior Gallery, December 2, 1993, typescript, 2. My thanks to Betsy Senior and Mel Bochner for arranging that I see this unpublished discussion.
5. King, "Building a Language," 12.
6. Bochner, "About My Prints," 8.
7. Bochner, quoted by King in "Building a Language," 11.
8. I discuss my criticisms of Bochner's work of the early to mid-1980s in Chapter 6 of the present volume, "Gesture Revisited."
9. Bochner, "About My Prints," 9.
10. Bochner, "Excerpts from Writing, 1966–1967," in *Photo Pieces, 1966–1967* (New York: David Nolan Gallery, 1991), 6.
11. Erwin Panofsky, *Perspective as Symbolic Form*, tr. Christopher S. Wood (New York: Zone , 1991), 47.

## Chapter 19. Rubble

1. "Mel Bochner: Thought Made Visible, 1966–1973," Yale University Art Gallery, Oct. 14–Dec. 31, 1995; Palais des Beaux-Arts, Brussels, Mar. 1–May 12, 1996; Stätdische Galerie im Lenbachhaus, Munich, June 26–Sept. 8, 1996.

2. Mel Bochner, "Excerpts from Speculation (1967–1970)," *Artforum*, May 1970, 70.

3. Robert Pincus-Witten, "Mel Bochner: The Constant as Variable," in *Postminimalism* (New York: Out of London Press, 1977), 109. This essay was first published in *Artforum*, December 1972.

4. Mel Bochner, "Ten to 10," catalogue statement, in *Some Recent American Art* (New York: International Council of the Museum of Modern Art, 1974).

5. Bochner, *Arts Magazine*, May 1966, quoted by Pincus-Witten in "Mel Bochner," 110.

6. Mel Bochner, "Serial Art – Systems: Solipsism," *Arts Magazine*, Summer 1967, 40.

7. *Mel Bochner*, exhibition brochure, Tokyo, Gallery 360°, 1993.

8. Bochner, quoted by Brenda Richardson in *Mel Bochner: Number and Shape* (Baltimore: Museum of Art, 1976), 12.

9. Mel Bochner, "Thoughts Reinstalling *A Theory of Sculpture*," Rome, 1990, unpublished typescript.

10. The fresco may possibly be a rarer scene, *The Foundation of the Church*. Given the fresco's state of deterioration, it is difficult to tell from the photographs. In any case, the distinction would only be between two successive verses from Matthew, either 16.18 or 16.19.

11. Personal communication, August 1994.

12. The critic William Wilson has pointed out to me that the central figure of *Four, Four, Four, Four* is not necessarily a zero, since it is circular rather than ovoid, and thus closer to the standard typographic representation of the letter "o" than to the numerial "0."

13. See Brian Rotman, *Signifying Nothing: The Semiotics of Zero* (Stanford: Stanford University Press, 1993), 1–14.

14. Gottlob Frege, *The Foundations of Arithmetic*, tr. J. L. Austin (Oxford: Blackwell, 1974), quoted by Brian Rotman in *Signifying Nothing: The Semiotics of Zero* (Stanford: Stanford University Press, 1993), 7.

15. Mel Bochner, "Serial Art – Systems: Solipsism," 40, quoted in "Excerpts from Writings, 1966–1967," in *Mel Bochner: Photo Pieces, 1966–1967* (New York: David Noland Gallery, 1990), 5.

16. Personal communication, August 1994. If the identification of the fresco as *The Giving of the Keys* is correct, then it would be more accurate to say that Christ had made this statement at the moment just *before* the one depicted.

17. Carolyn Christov-Bakargiev, "With Mel Bochner," in *Mel Bochner: Fontana's Light/Omaggio a Lucio Fontana* (Milan: Studio Casoli, 1991), 21.
18. "Goings on about Town," *New Yorker*, December 13, 1993, 28.
19. Mel Bochner, unpublished interview with Elayne Varian, March 1969.
20. Robert Smithson, *The Writings of Robert Smithson*, ed. Nancy Holt (New York: New York University Press, 1979), 24–31.
21. Mel Bochner, typescript of lecture delivered at the Institute of Contemporary Art, London, June 1971.

## Chapter 20. Ross Bleckner

1. Thomas Crow, "Surface Tension: Ross Bleckner and the Conditions of Painting's Reincarnation," in *Ross Bleckner* (New York: Guggenheim Museum/Abrams, 1995), 102, 101. Crow refers to Brooks Adams, "Ross Bleckner at Mary Boone/Michael Werner," *Art in America*, March 1984, 159–60.
2. Stephen Melville, "Dark Rooms: Allegory and History in the Paintings of Ross Bleckner," *Arts Magazine*, April 1987, 58.
3. The literature on Poussin's two versions of *The Arcadian Shepherds* and its inscription, "Et in Arcadia ego," is voluminous. The locus classicus is a 1936 essay by Erwin Panofsky, subsequently revised for republication in his *Meaning in the Visual Arts* (Garden City, NY: Doubleday, 1955), 295–320. Two recent contributions are Louis Marin, *To Destroy Painting* (1977), tr. Mette Hjort (Chicago: University of Chicago Press, 1995), and David Carrier, *Poussin's Painting: A Study in Art-Historical Methodology* (University Park: Pennsylvania State University Press, 1993).
4. Peter Halley, "Ross Bleckner: Painting at the End of History," *Arts Magazine*, May 1982, 132–3.
5. Michael Kimmelman, "Bleckner's Melodrama; A Minimalist's Quietude," *New York Times*, March 10, 1995, C23. For more on Bleckner's "sentimentality," see Grace Glueck, "Bleckner's Turn at the Guggenheim: Kitsch as kitsch can?" *New York Observer*, March 13, 1995, 18.
6. Susan Sontag, "Notes on 'Camp'" (1964), in *Against Interpretation* (New York: Farrar, Straus & Giroux, 1966), 281, 287.
7. Ibid., 290.

## Chapter 21. L. C. Armstrong

1. Israel Rosenfield, "A Hero of the Brain," *New York Review of Books*, November 21, 1985, 49–55.
2. Friedrich Nietzsche, *"On the Genealogy of Morals" and "Ecce Homo,"* tr. Walter Kaufmann (New York: Vintage, 1967), 61.
3. De Man, quoted by Jacques Derrida, *Mémoires: For Paul de Man* (New York: Columbia University Press, 1986), 67.

## Chapter 22. Rainer Ganahl

1. Slavoj Žižek, *For they know not what they do: Enjoyment as a Political Factor* (New York: Verso, 1991), 109–10.
2. Ibid., 110.
3. Ibid.
4. Ibid., 101–2.
5. Mark Poster, *The Mode of Information: Poststructuralism and Social Context* (Chicago: University of Chicago Press, 1990), 7.
6. Paraphrased by Poster in ibid., 100–1, from a conference at the University of California at Irvine, April 10, 1988.

# INDEX